◂SPECTRUM 2▸

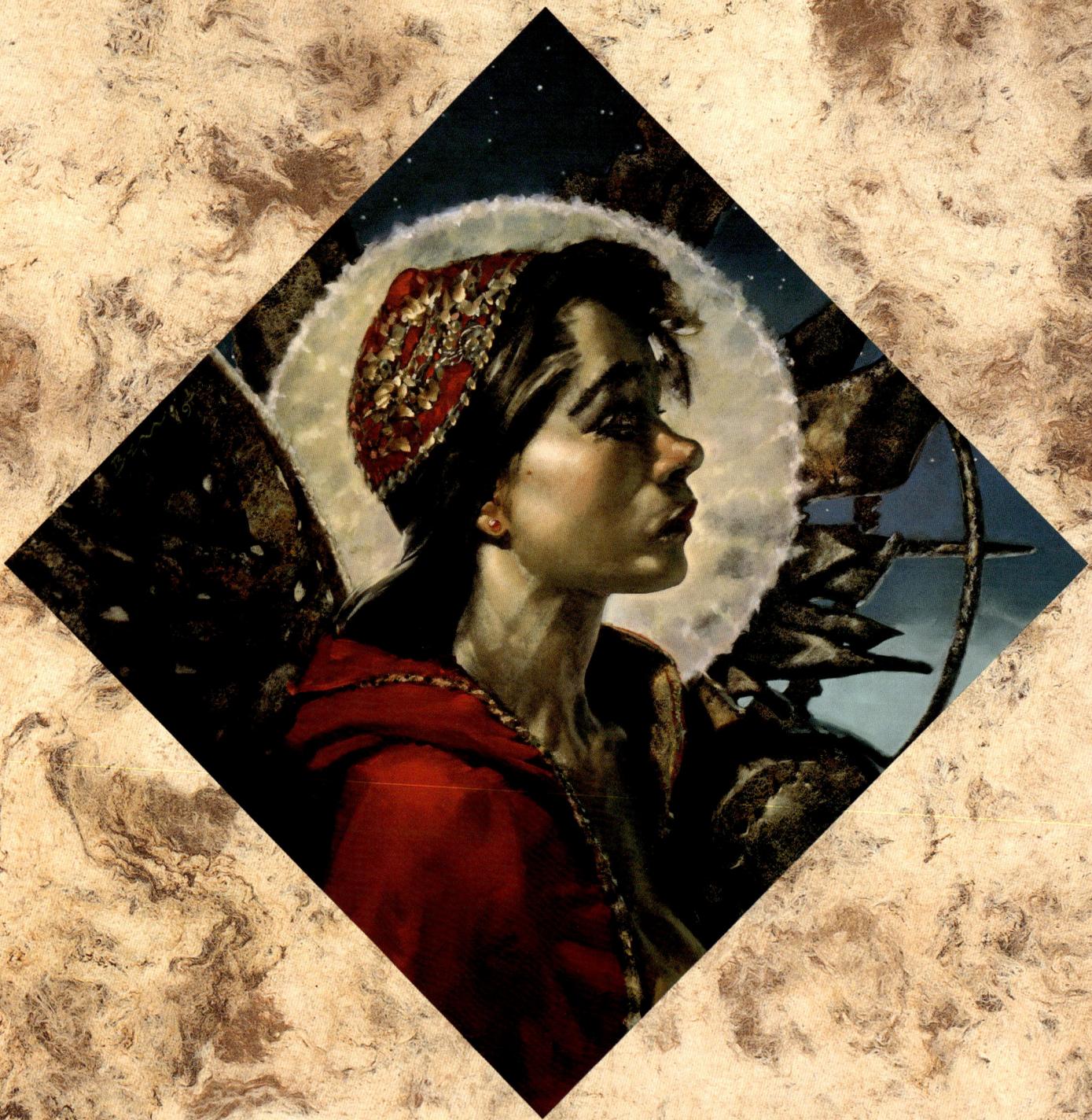

SPECTRUM 1994
Call for Entries Poster
by Rick Berry
Oil on board
20x20

SPECTRUM 2

THE BEST IN CONTEMPORARY FANTASTIC ART

edited by

▼

Cathy **B**urnett & **A**rnie **F**enner

▼

with **J**im **L**oehr

UNDER
WOOD
BOOKS

GRASS VALLEY, CA
1995

Trade Softcover Edition ISBN 1-59929-005-7
10 9 8 7 6 5 4

Special thanks to Rick Berry and Bud Plant for their continued help and enthusiasm.

Advisory Board: Rick Berry, Brom, Leo & Diane Dillon, Harlan Ellison, Iren Gallo, Bud Plant, Don Ivan Punchatz, Tim Underwood, Michael Whelan

Artists, art directors, and publishers interested in receiving entry information for the next Spectrum competition should send their name and address to:
Spectrum Design, P.O. Box 4422, Overland Park, KS 66204 or visit the official website: **www.spectrumfantasticart.com**
Call For Entries posters (which contain complete rules, list of fees, and forms for participation) are mailed out in October each year.

Published by **UNDERWOOD BOOKS**, P.O. BOX 1919, NEVADA CITY, CA 95959
Tim Underwood/Publisher

▼

CONTENTS

▲

SPECTRUM 2
chairman's message
cathy burnett & arnie fenner

This is the golden age of fantastic art.

For anyone who doubts it, just look around. The bookshelves are full of titles sporting magnificent covers of sf, fantasy, and horror in all styles and mediums and there are glorious compilations of the art of contemporary and past masters alike. Advertising, greeting cards, c.d.s, games, and toys capture our attention with skillfully created images of heroes and monsters and alien invaders. Galleries have embraced the fantastic with traveling exhibitions and fine art prints. Statues, sculptures, and model kits featuring popular genre heroes, heroines, and villains are appearing with increased frequency and comic characters from Batman to Tank Girl make the transition from panel to screen more and more regularly.

And you have *Spectrum 2*.

When we decided to organize a "year's best" competition there were no guarantees that we would be successful. Without corporate backing or a dues-paying membership, the whole concept was a calculated risk. That the creative community, distributors, booksellers and readers welcomed and supported *Spectrum* says more about people's love for fantastic art than it does about our marketing skills. This volume reflects some of the suggestions made by readers of the first collection: artwork sizes(in inches, unless otherwise indicated), mediums employed, and titles are listed in the credits when they were provided and the jury's selection of awarded-winning entries are high-lighted at the beginning of each category. *Spectrum 2* also inaugurates the Grand Master Award, intended to be presented annually to an active artist whose work has has had a positive effect on fellow creatives and the field of fantastic art as a whole.

And we're just getting started.

A friend of one of the board members was thumbing through the first book and commented off-handedly, "This is nice, but who's going to really care if this comes out every year?"

Speaking collectively for other artists and connoisseurs of fantastic art the answer is:

We will.

rick berry
artist

terri windling
artist/editor

charles vess
artist

david cherry
artist

kerig pope
art director/designer Playboy Magazine

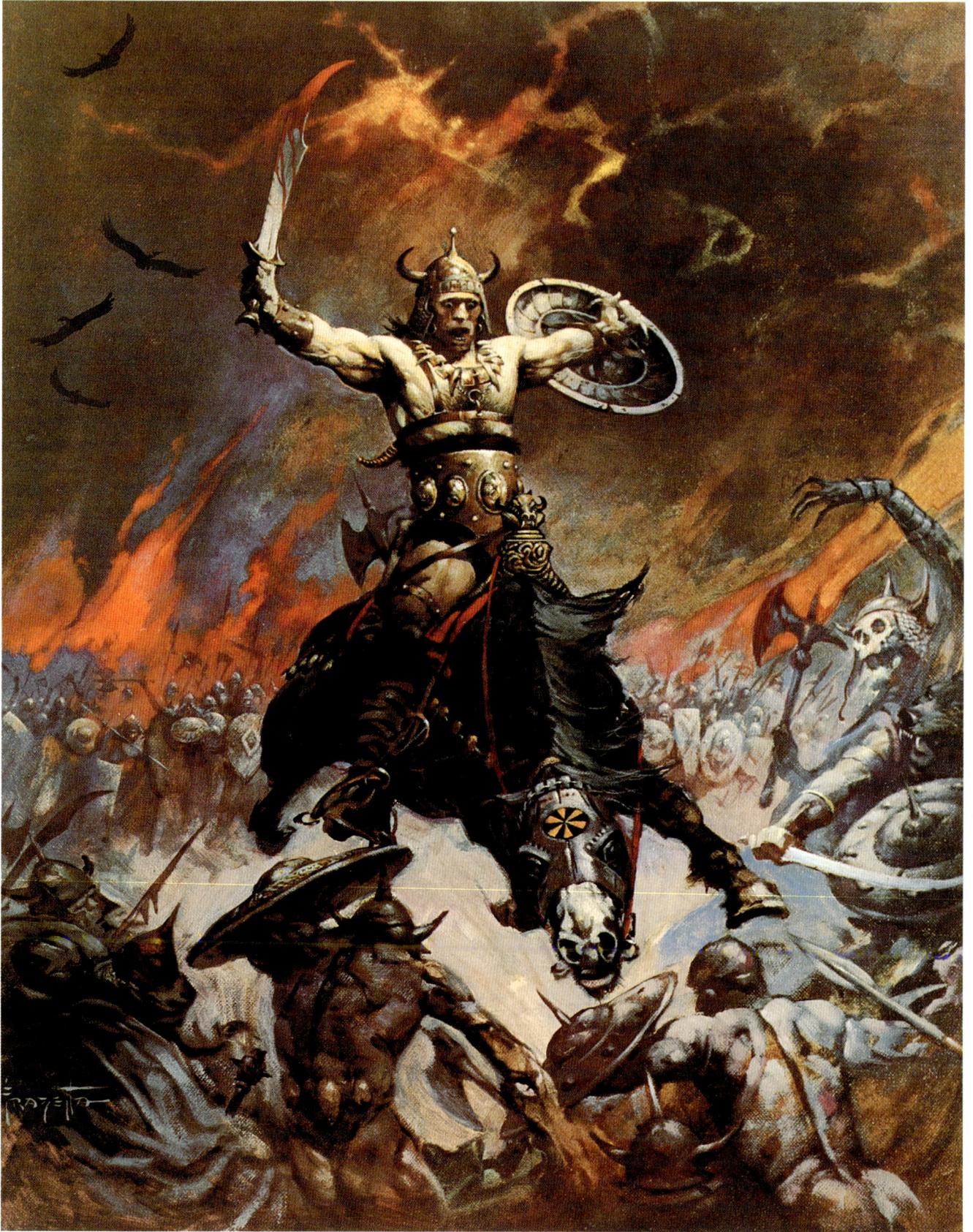

Breath-taking and chilling, sinister and sensuous, moody and exhilarating. Choose an adjective and it probably applies to the art of Frank Frazetta; applies and yet somehow falls short of adequately describing the work of the most influential creator of fantastic art of the last half century.

Born February 9, 1928, in Brooklyn, NY, Frazetta literally started drawing before he could walk. Enrolled in the Brooklyn Academy of Fine arts at the age of 8, he learned classical painting, anatomy and composition from Michael Falanga. By his 16th birthday Frazetta had embarked on a career in commercial art as assistant to cartoonist John Giunta and it was through Giunta's studio that he saw publication of his first comics story, "Snowman" in *Tally-Ho Comics* #1 [December, 1944.]

Throughout the '40s and 50s Frazetta was active in the comics field, producing exemplary work for all of the major publishing houses, including the legendary E.C. He also produced a short-lived syndicated newspaper strip, *Johnny Comet*, which caught the attention of *Li'l Abner*'s creator Al Capp. Joining Capp's studio in 1954, Frazetta was one of the ghost artists for the series for almost 9 years.

In the 1960s he embarked on a career painting book covers and it was here that Frazetta stretched his artistic muscles and changed, pretty much single-handedly, people's perceptions of what fantasy art was, is, could and should be. Frazetta's skill and imagination elevated pulpish prose to near-mythic heights. His heroes were tougher and his villains more dastardly; his mountains were more foreboding, his jungles lusher, and his swamps more abundant with reptilian life; his monsters were scarier, his wildlife more animated, and his women were, well, the most erotic creatures ever to roam a fantasy landscape.

And still are, as his most recent work attests.

There was only one logical choice for the first Spectrum Grand Master Award. Mostly, of course, because of the profound impact Frank Frazetta has had on several generations of artists and readers, but also, more than a little because, as Ray Bradbury has written, "Young boys would like to look like his heroes, or, failing that, draw and shape dreams as well as Frazetta does."

That desire doesn't diminish with age.

FRANK FRAZETTA
born Brooklyn, NY, 1928

THE SHOW

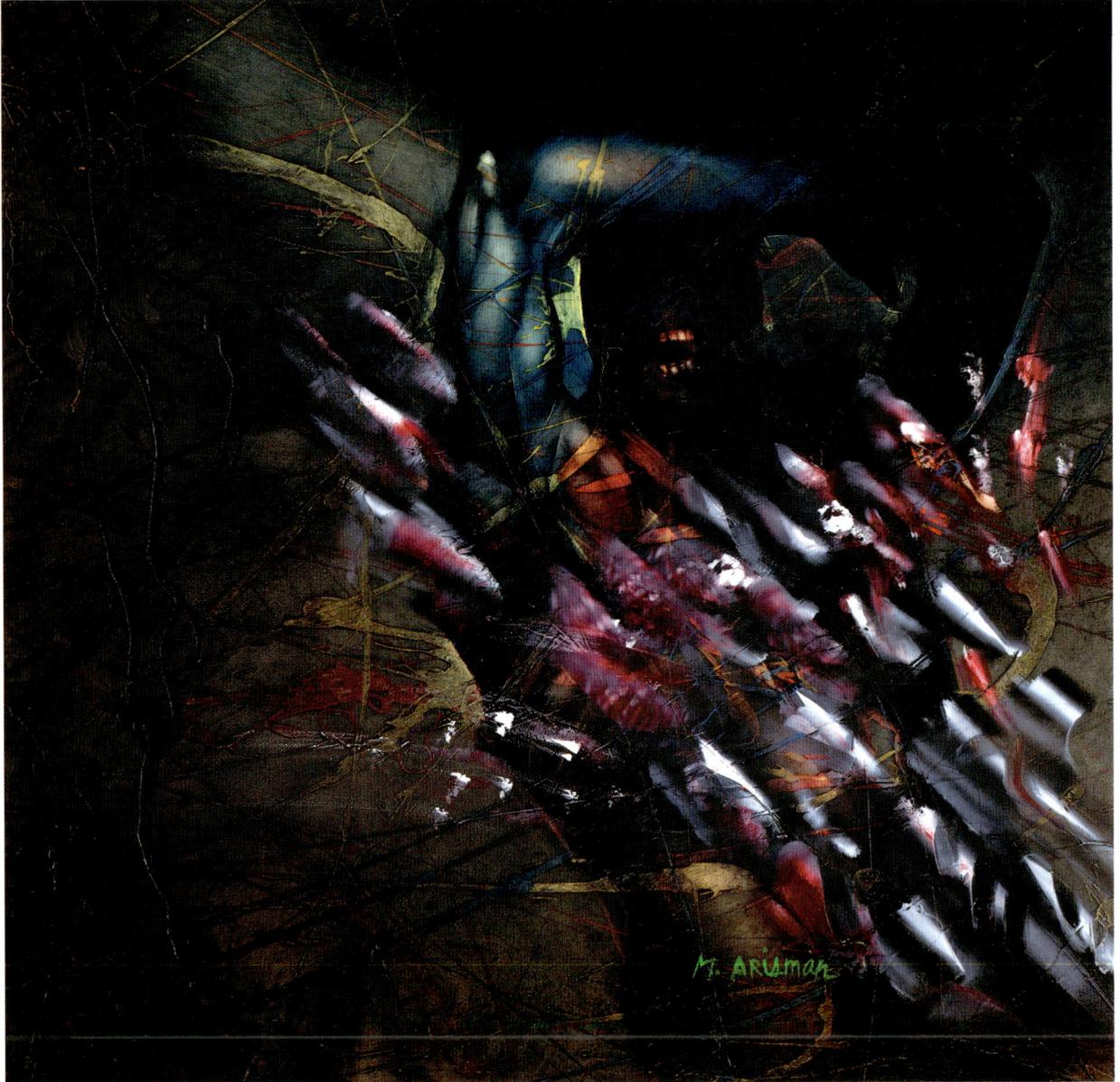

1
artist: **MARSHALL ARISMAN**
art director: Tom Staebler
designer: Kerig Pope
client: Playboy
title: The Scariest Criminal in America
medium: Oil on rag board
size: 23x23

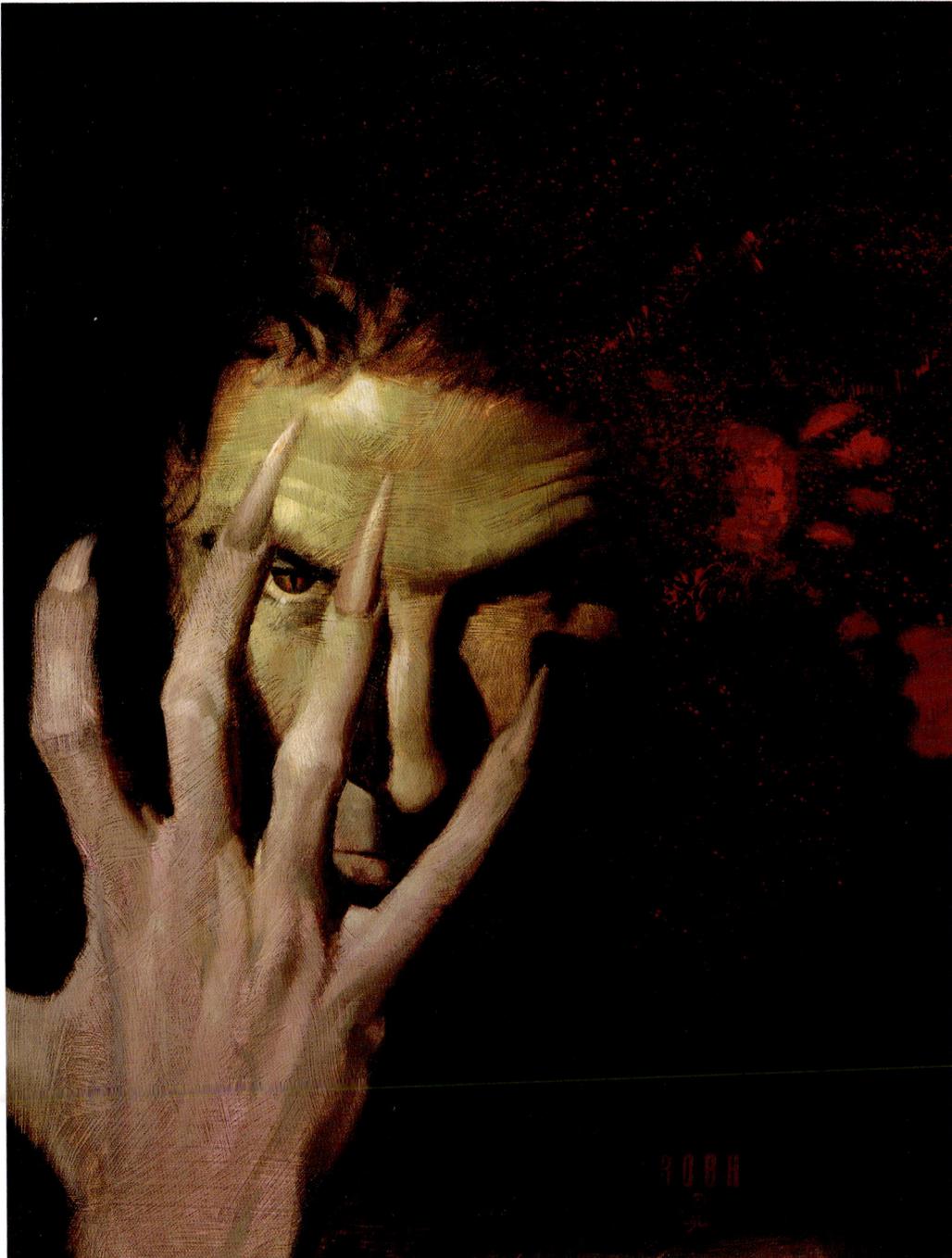

2
artist: **ROBH RUPPEL**
art director: Larry Smith
client: Dungeon Magazine
medium: Oil on panel
size: 15x20

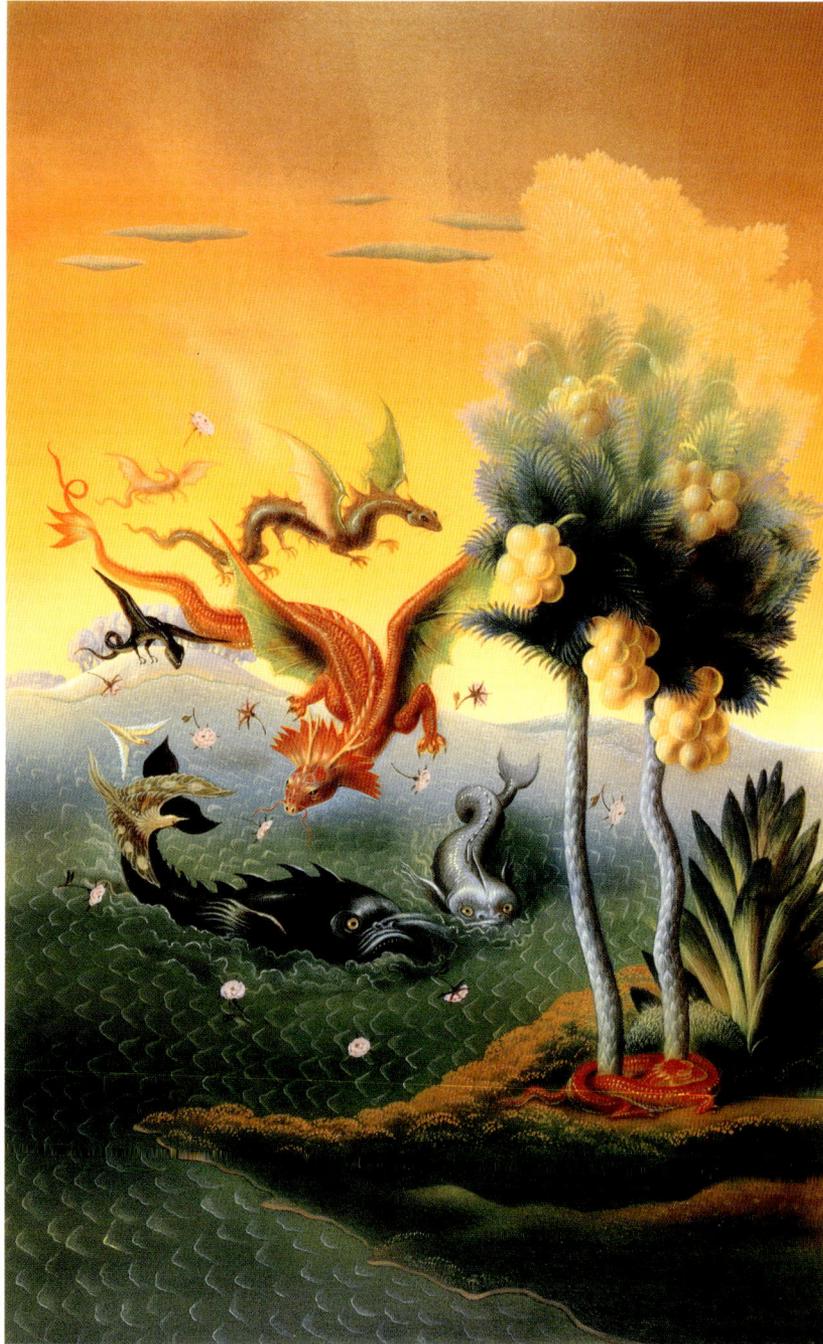

3
artist: **KINUKO CRAFT**
art director: Terri Czeczko
designer: Terri Czeczko
client: Asimov's Science Fiction
title: Les Fleurs du Mal
medium: Mixed
size: 15x18

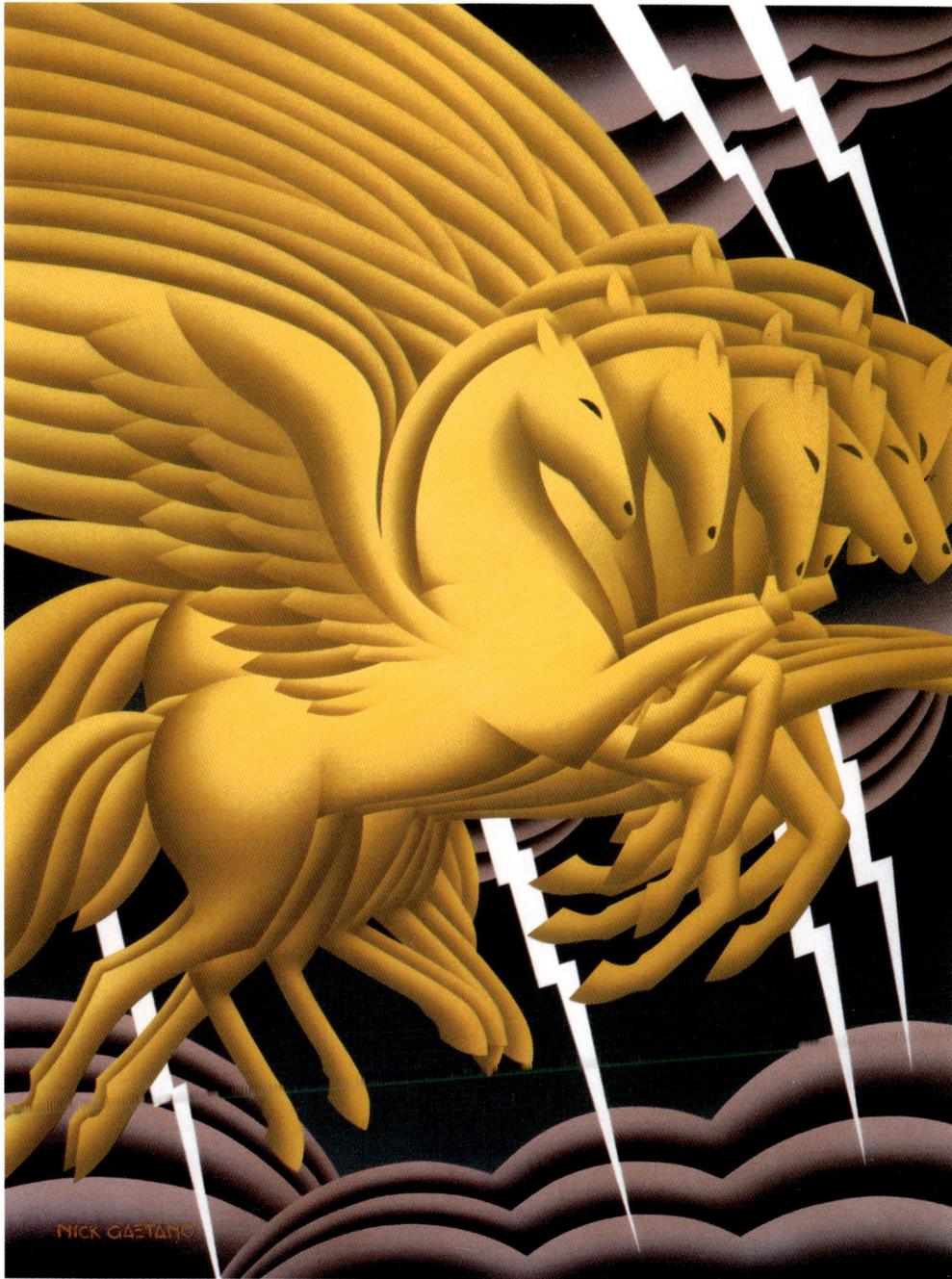

4
artist: **NICK GAETANO**
art director: Ron Stucki
client: Wordperfect Magazine
title: Winged Speed
medium: Acrylic
size: 17x12.75

5

6

5
artist: **SCOTT BURDICK**
art director: Larry Smith
client: Dragon Magazine
medium: Watercolor
size: 20x30

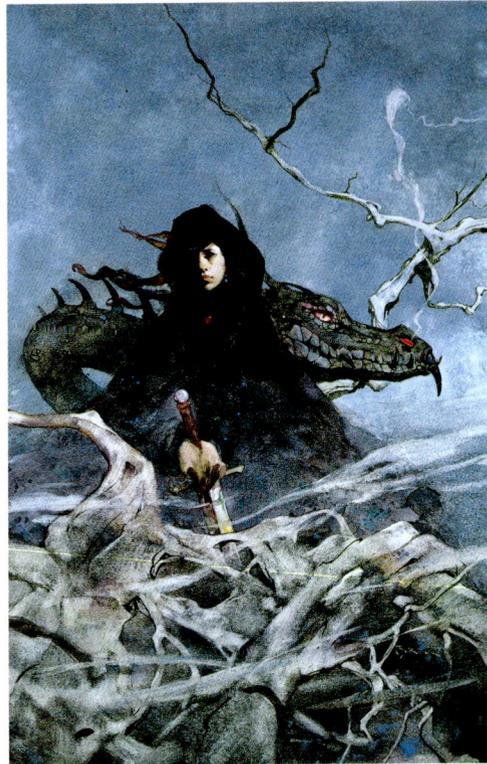

6
artist: **KEITH PARKINSON**
art director: Terri Czeczko
designer: Terri Czeczko
client: Asimov's Science Fiction
title: Cold Iron
medium: Mixed
size: 18x24

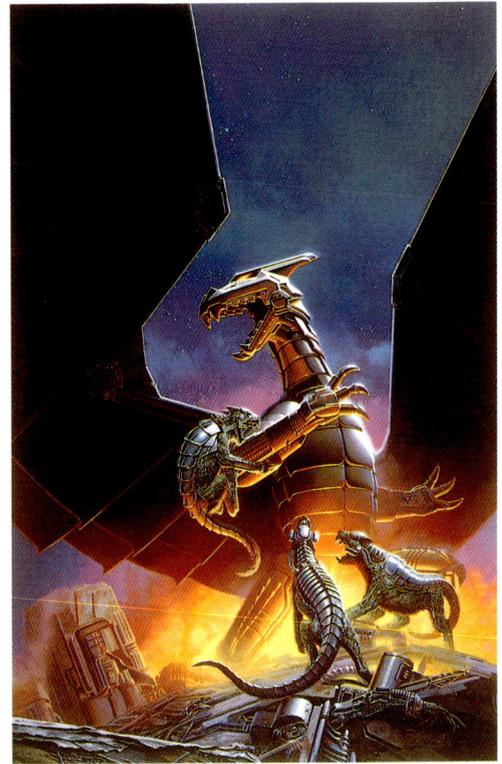

7
artist: **THOMAS O. MILLER**
art director: Thomas O. Miller
designer: Thomas O. Miller
client: PBS/TheAstonomers

8
artist: **IAN MILLER**
client: Headline (U.K.)
title: The Wolf King of Tara
medium: Inks and watercolor
size: 9x14

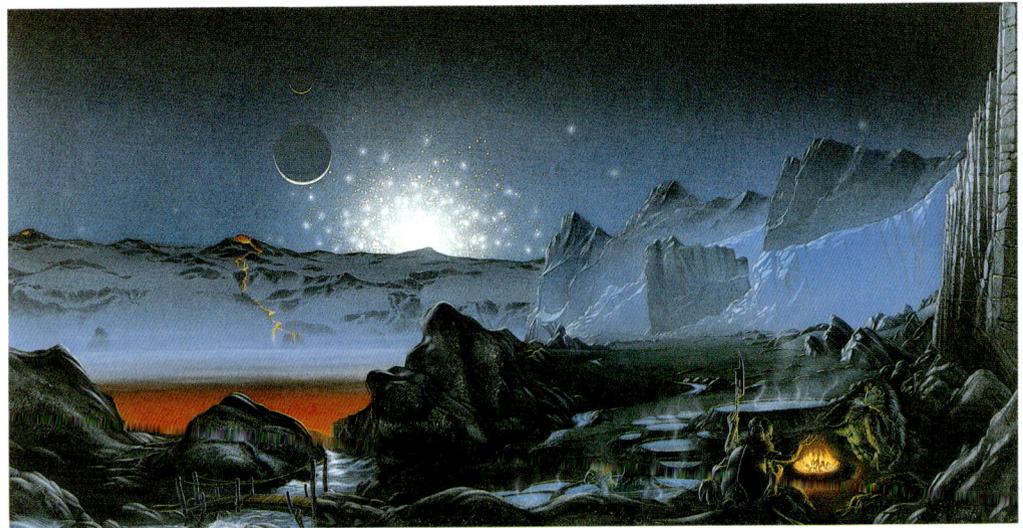

7

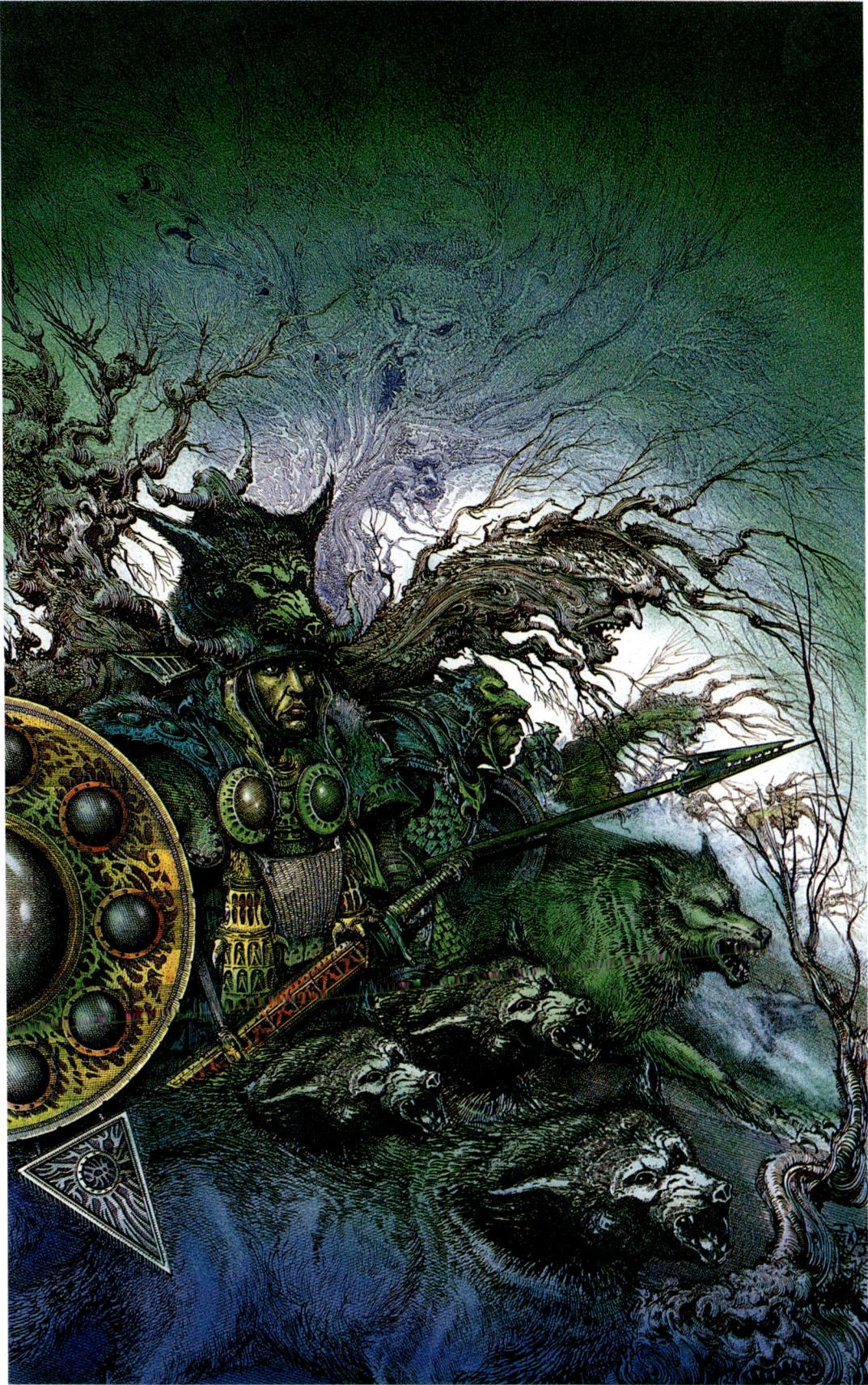

9

10

9
artist: **GREG WEBER**
art director: S. Patrick Brown
client: SF Eye
title: Get the Hell Out of My Belly
medium: Mixed assemblage
size: 15x16.5x3.5

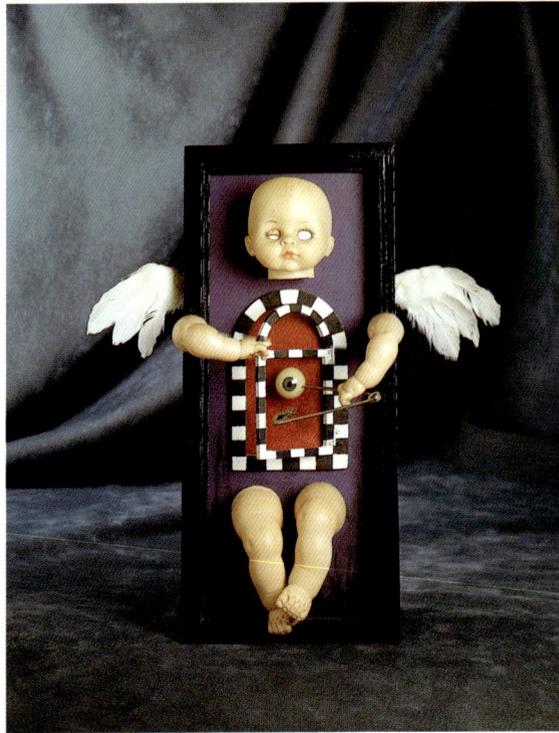

10
artist: **STU SUCHIT**
art director: John Gibson
client: The Weekly Reader
title: Lethal Injections
medium: Watercolor, oil, and collage
size: 8.5x13.5

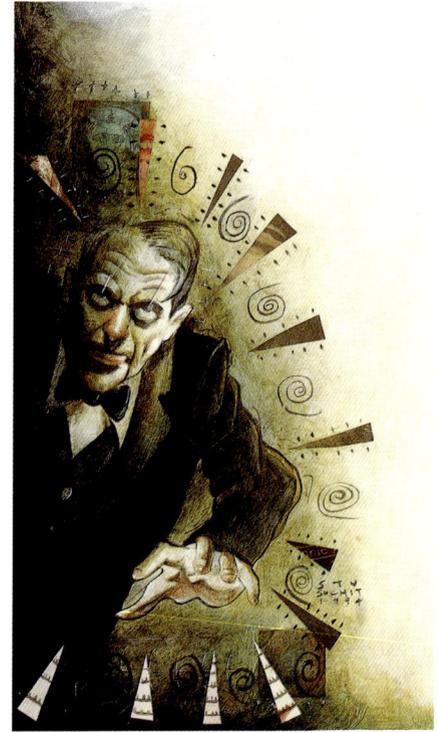

11
artist: **TOM TAGGART**
art director: Grendel
photographer: Gavin Wilson
client: Blur Magazine
title: Angel 69
medium: Assemblage
size: 4.5ft.

12
artist: **BARCLAY SHAW**
art director: Kevin Eastman
client: Metal Mammoth
title: Work in Progress
medium: Mixed
size: 48x64

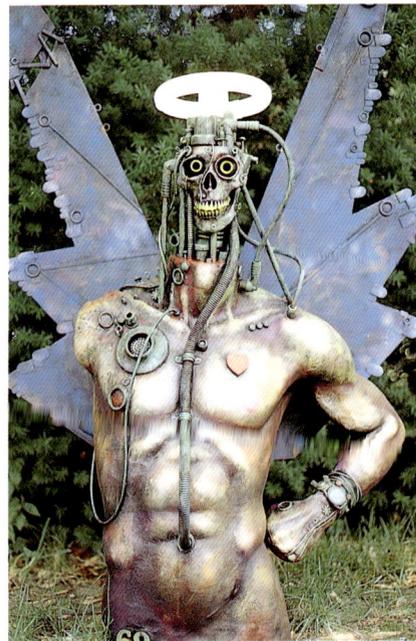

13
artist: **JOHN BERKEY**
art director: Stephen Vann
designer: Stephen Vann
client: Science Fiction Age Magazine
title: Entering Protected Zone
medium: Casein & acrylic
size: 16x21

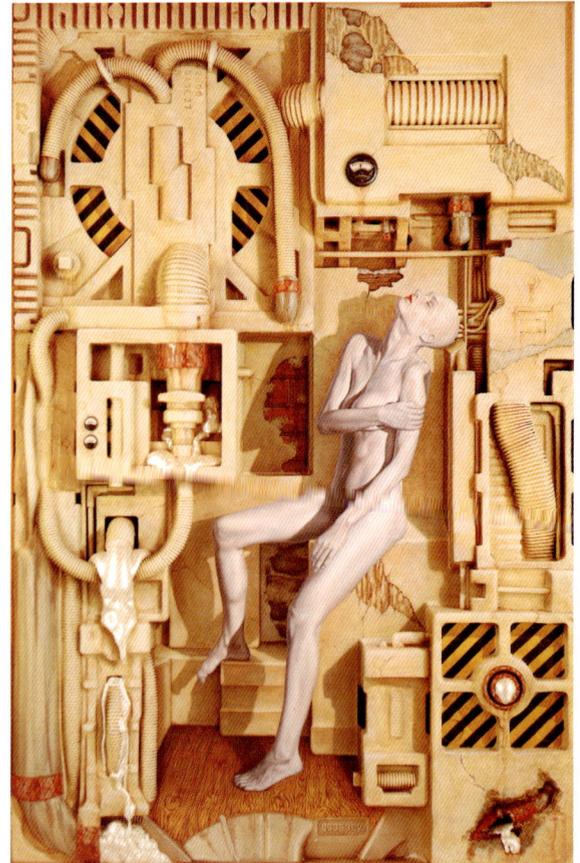

11

12

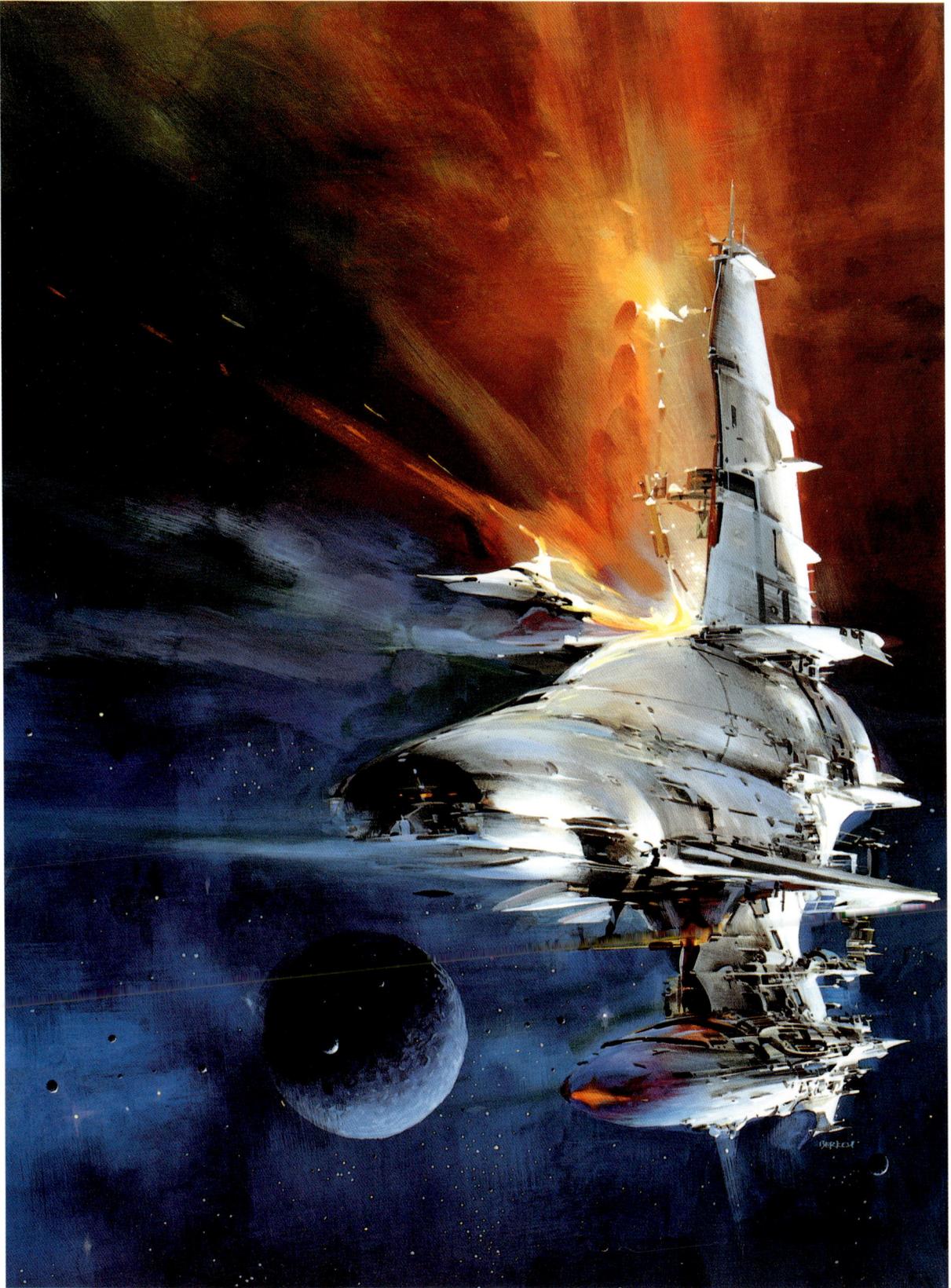

14
artist: **WILSON McLEAN**
art director: Tom Staebler
designer: Kerig Pope
client: Playboy
title: What's the Deal With the Millennium?
medium: Oil on canvas
size: 26x26

15
artist: **GREGORY MANCHESS**
art director: Dwayne Flinchum
client: Omni Magazine
title: Einstein's Law
medium: Pastel
size: 20x28

16
artist: **OMAR RAYYAN**
art director: Ron McCutchan
client: Spider Magazine
title: Rhino-Tooth Fairy
medium: Ink & watercolor
size: 8x10

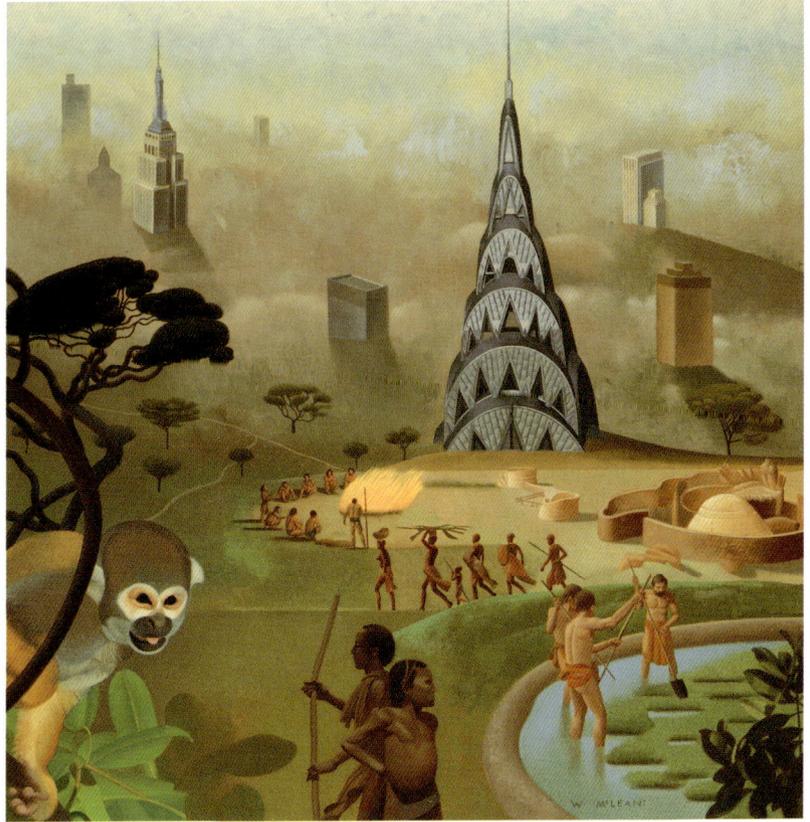

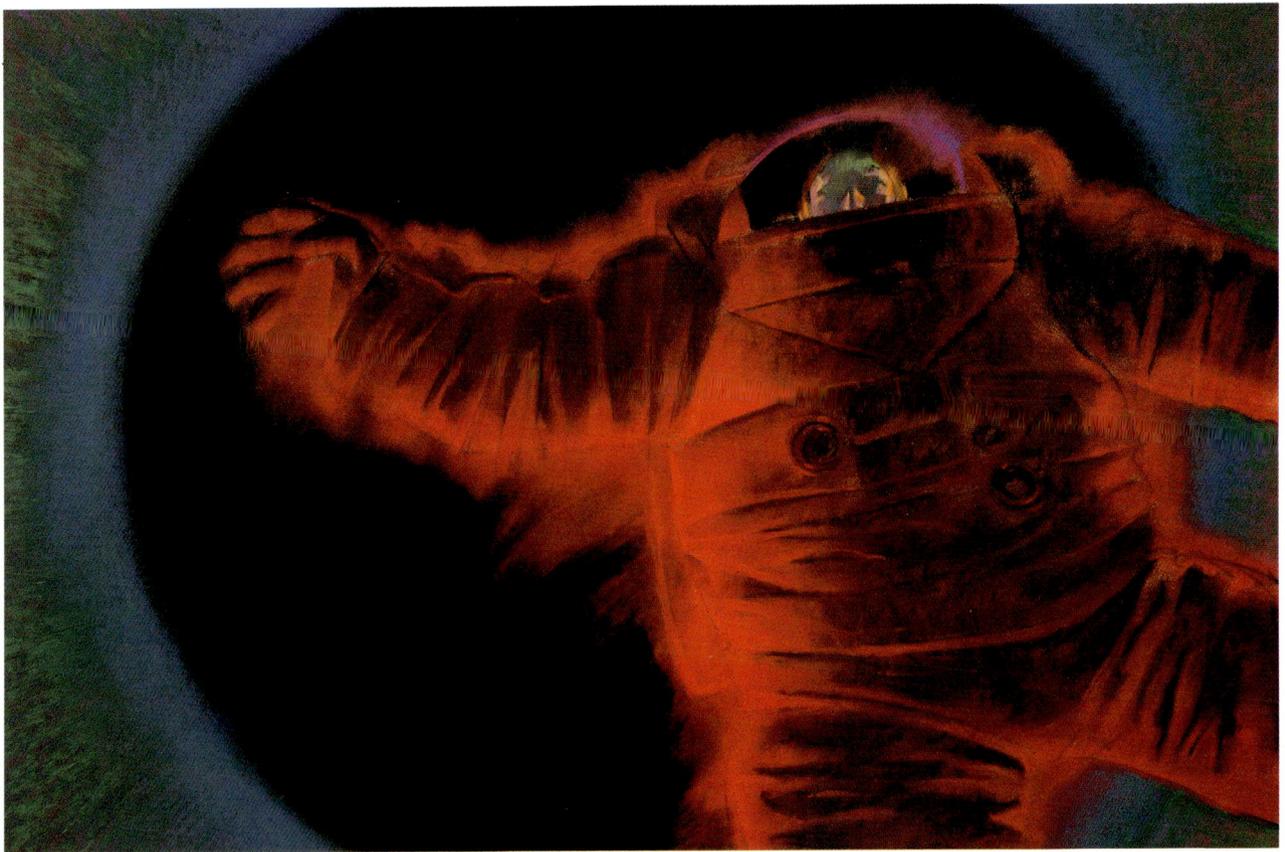

15

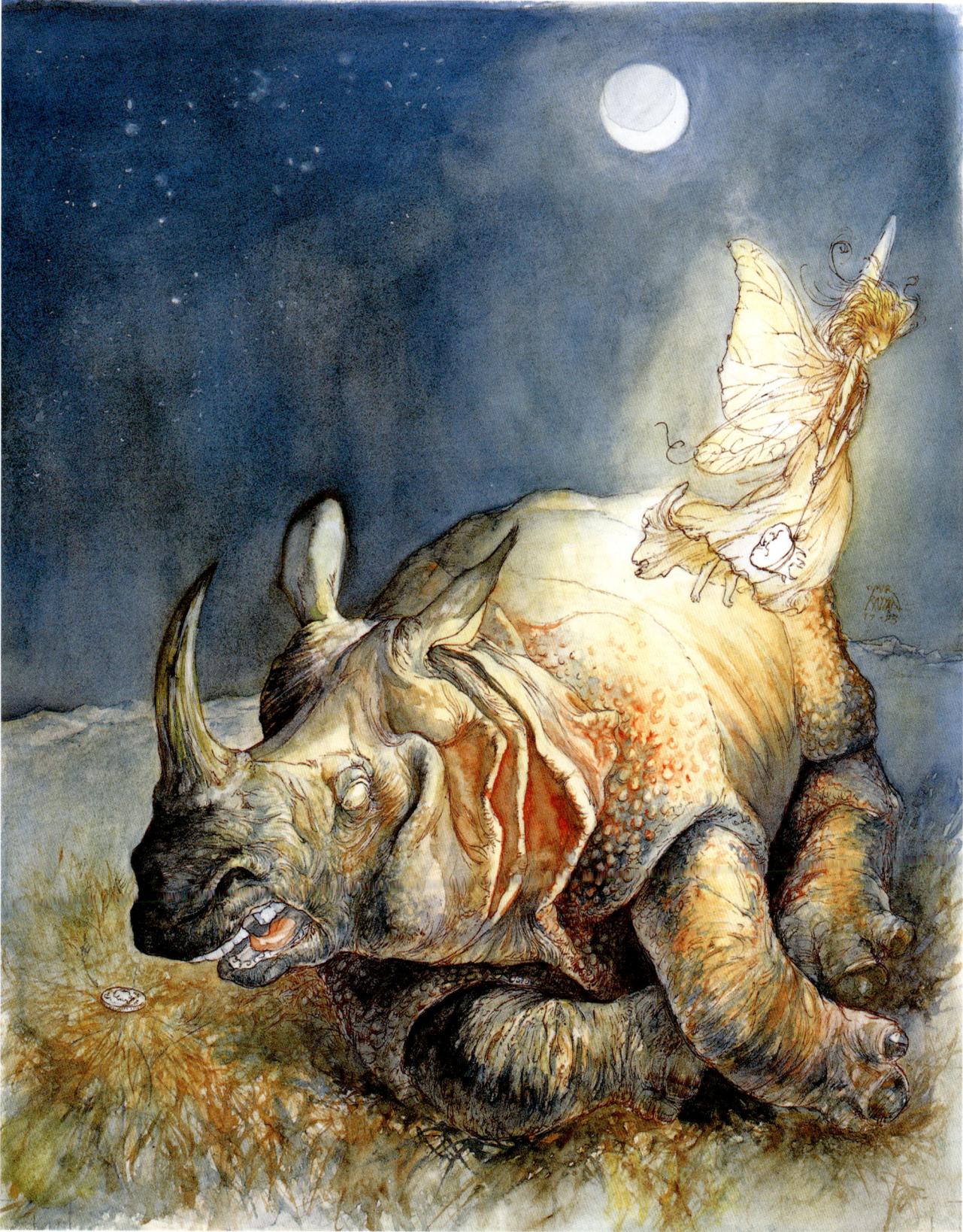

17
artist: **GARY KELLEY**
art director: Tom Staebler
designer: Kerig Pope
client: Playboy
title: Clarissa Explains It All
medium: Pastel on paper
size: 20x20

18
artist: **KENT WILLIAMS**
art director: Tom Staebler
designer: Kerig Pope
client: Playboy
title: The Village
medium: Mixed
size: 28x28

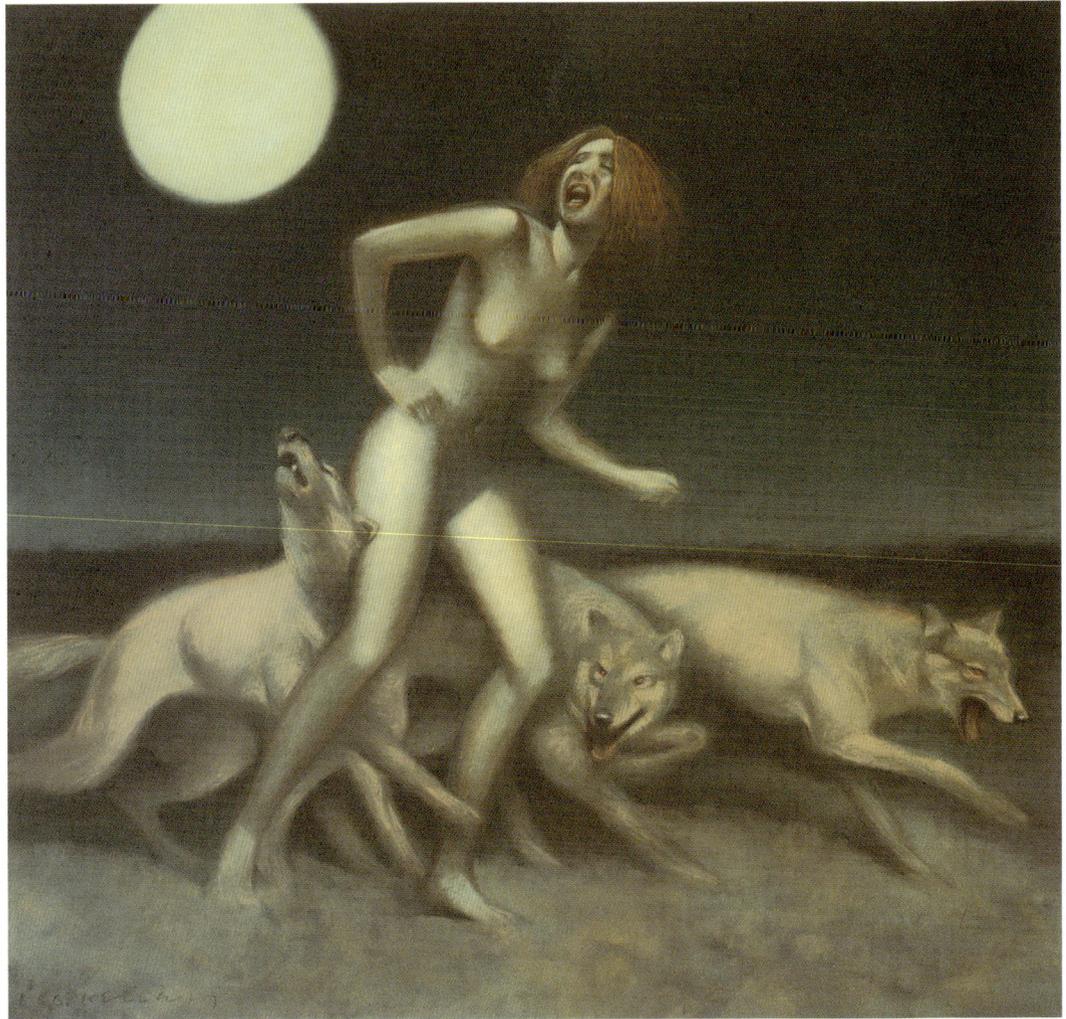

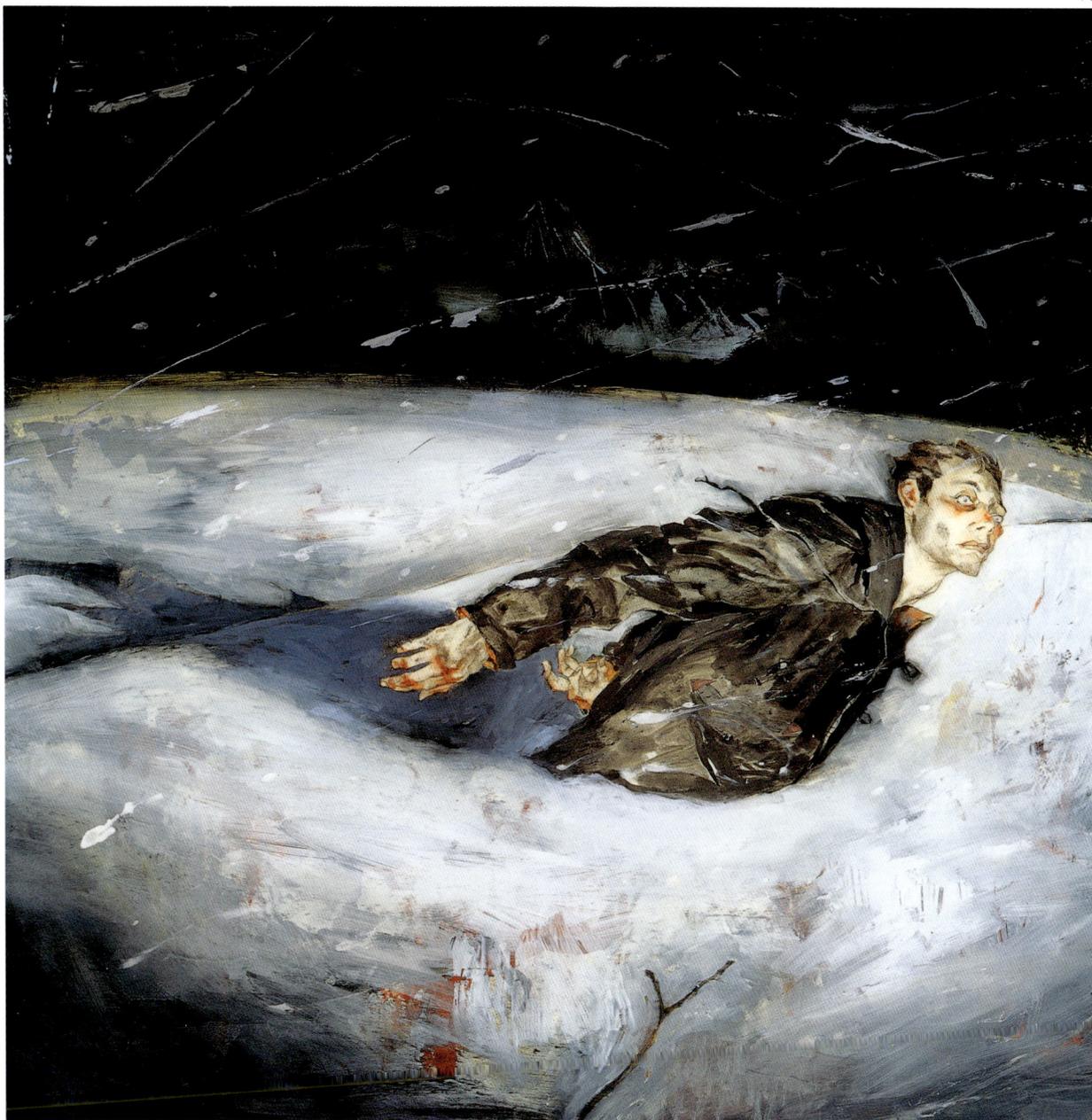

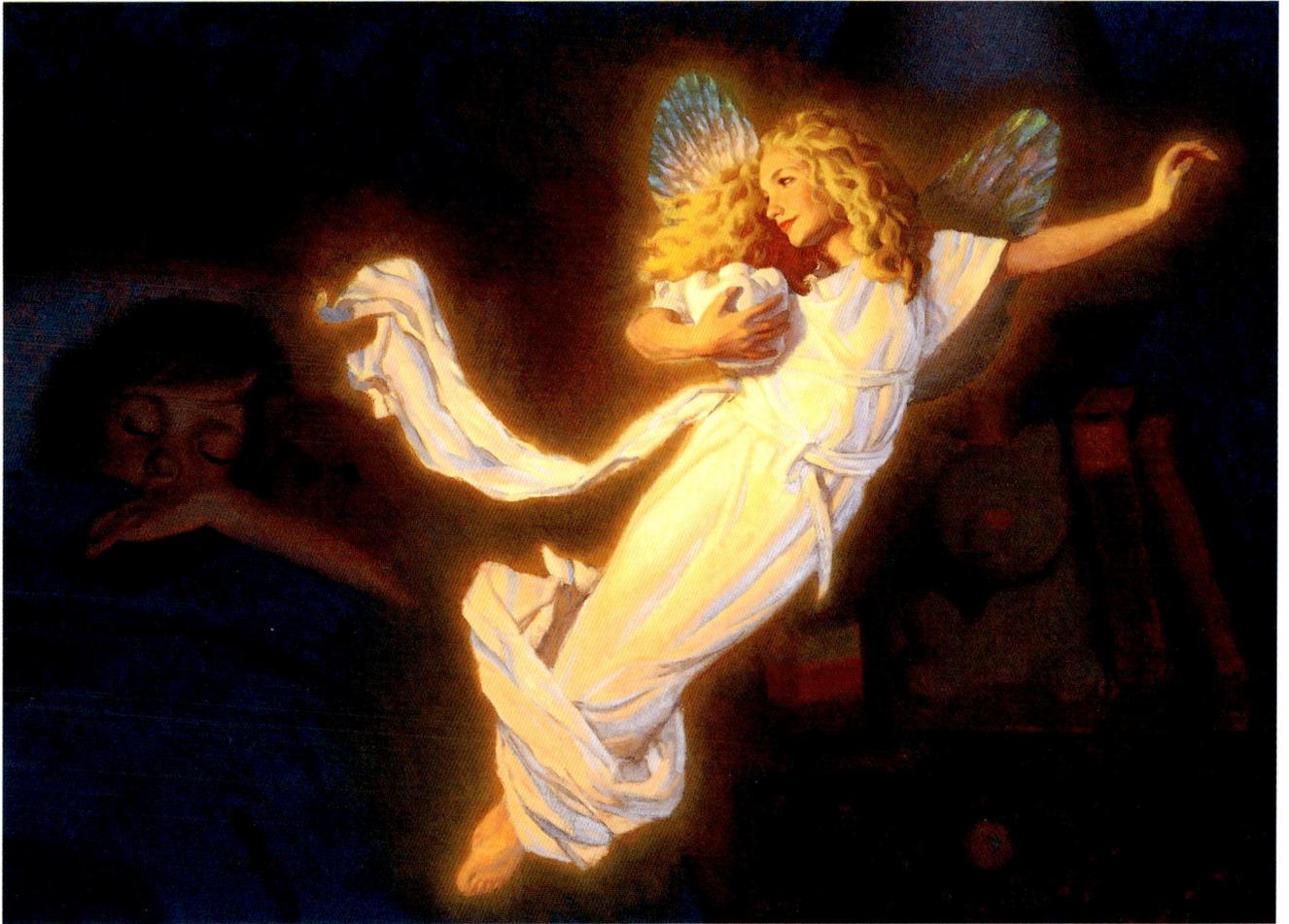

19
artist: **STEVE ARMES**
art director: Tom Marcantel/Bill Kreighbaum
client: Ameritas
title: The Tooth Fairy
medium: Oil
size: 20x30

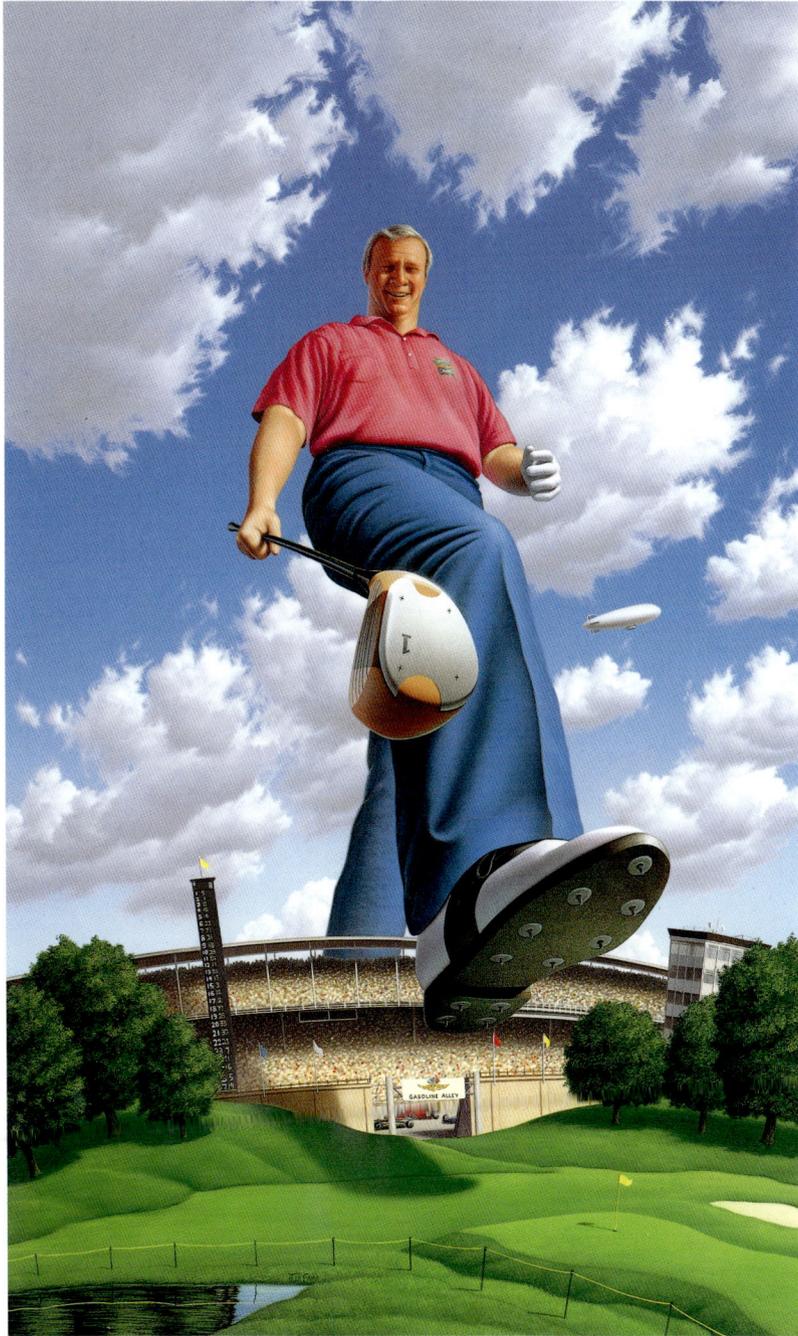

20
artist: **JERRY LOFARO**
art director: Scott Willy
designer: Kirk Nugent
client: G.T.E. North Classic
title: Giants of Golf: Arnold Palmer at the Indianapolis 500
medium: Acrylic: airbrushed & painted
size: 16x24

21
artist: **EZRA TUCKER**
art director: Ezra Tucker
designer: Ezra Tucker
client: Anheuser-Busch
title: Midnite, Bud for Christmas
medium: Acrylic on board
size: 15x20

22
artist: **GARY GLOVER**
art director: Lynn Andreozzi
designer: Gary Glover
client: Bantam/Doubleday/Dell
title: The Flaming Ghost
medium: Acrylic
size: 18x22

23
artist: **HAP HENRIKSEN**
client: Collectable World Studios

24
artist: **SV BELL**
art director: Tim King
designer: SV Bell
client: Red Light Records
title: Journey to the Dark Side
 of the Brain
medium: Acrylic on canvas
size: 18x22

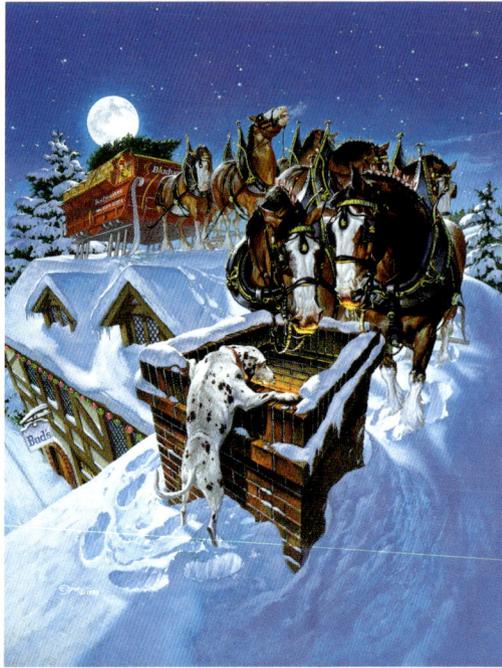

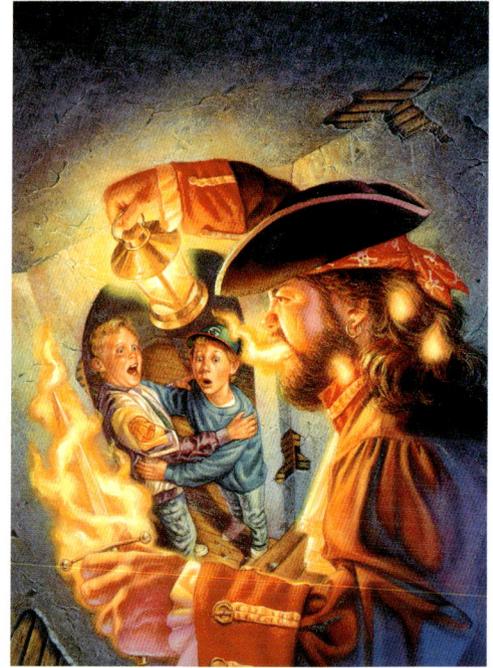

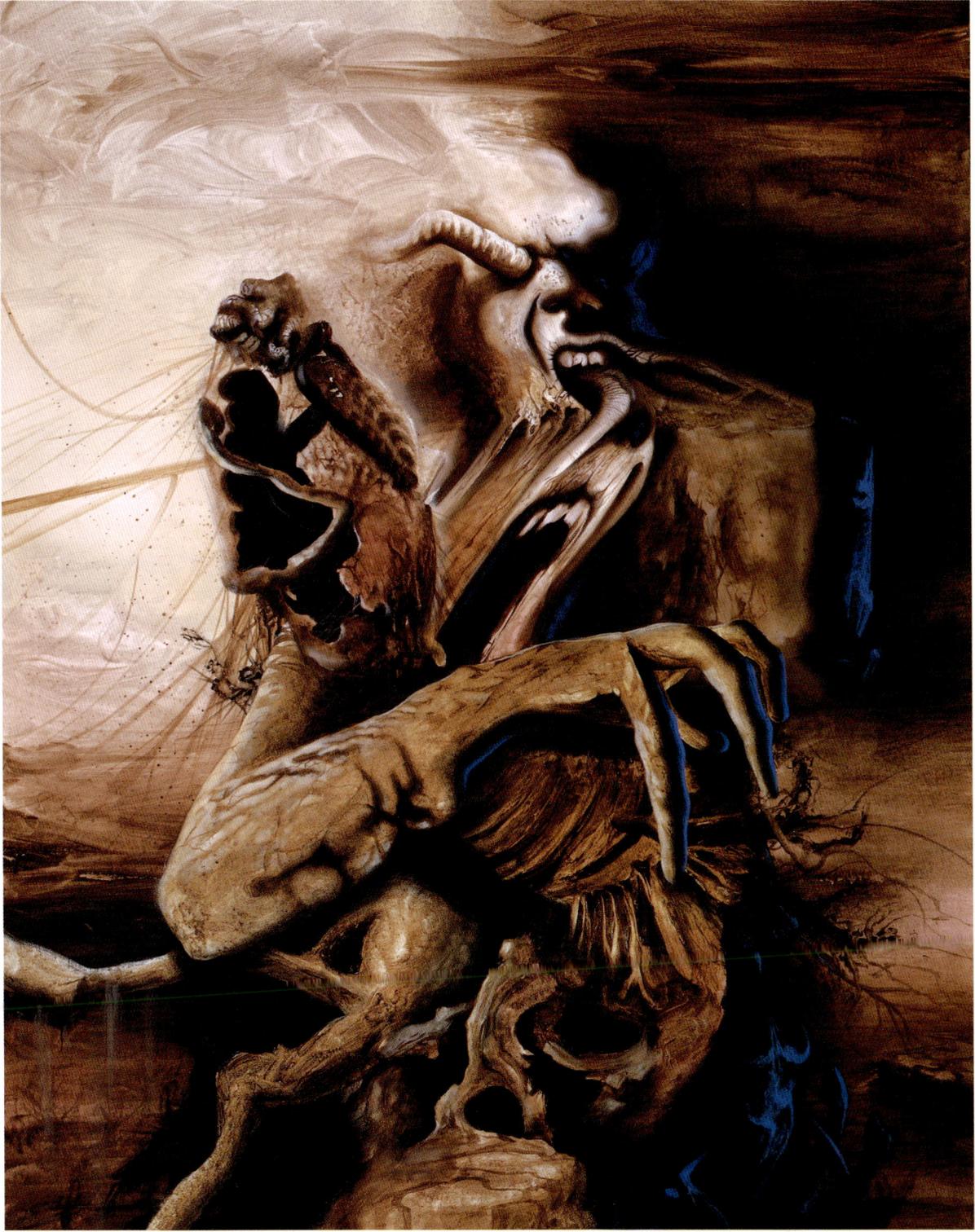

25
artist: **GARY RUDDELL**
art director: Rusty Schwartz
designer: Gary Ruddell
client: Screenies, Inc.
title: Piece of My Heart
medium: Oil on masonite
size: 25x30

26
artist: **JERRY LOFARO**
art director: Scott Brooks
client: Ariel, Inc.
title: How To Be Large Without
 Being Awkward
medium: Acrylic: airbrushed & painted
size: 11x13

27
artist: **J.K. POTTER**
client: Lydia Lunch
title: Strange Contemplation
medium: Mixed
size: 16x20

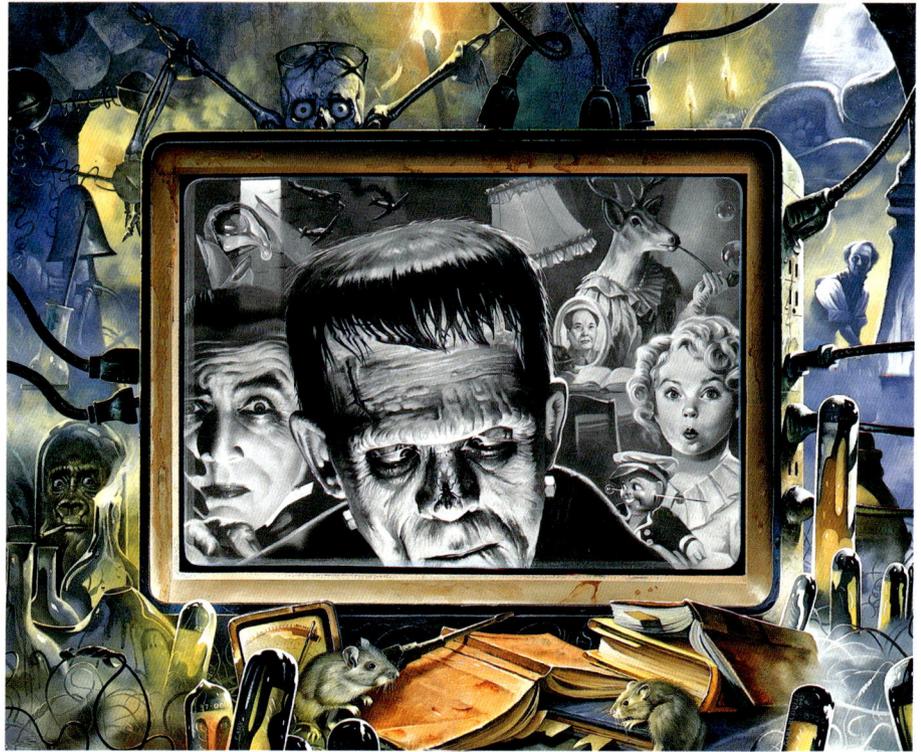

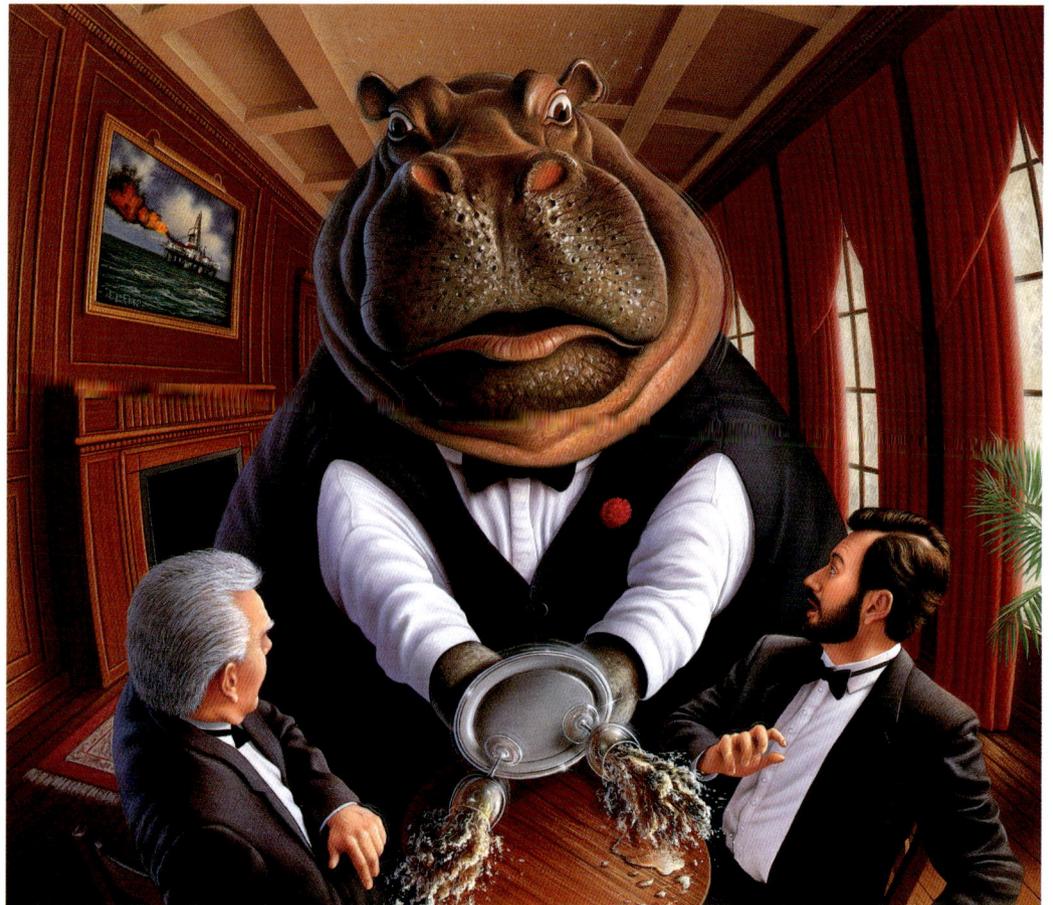

26

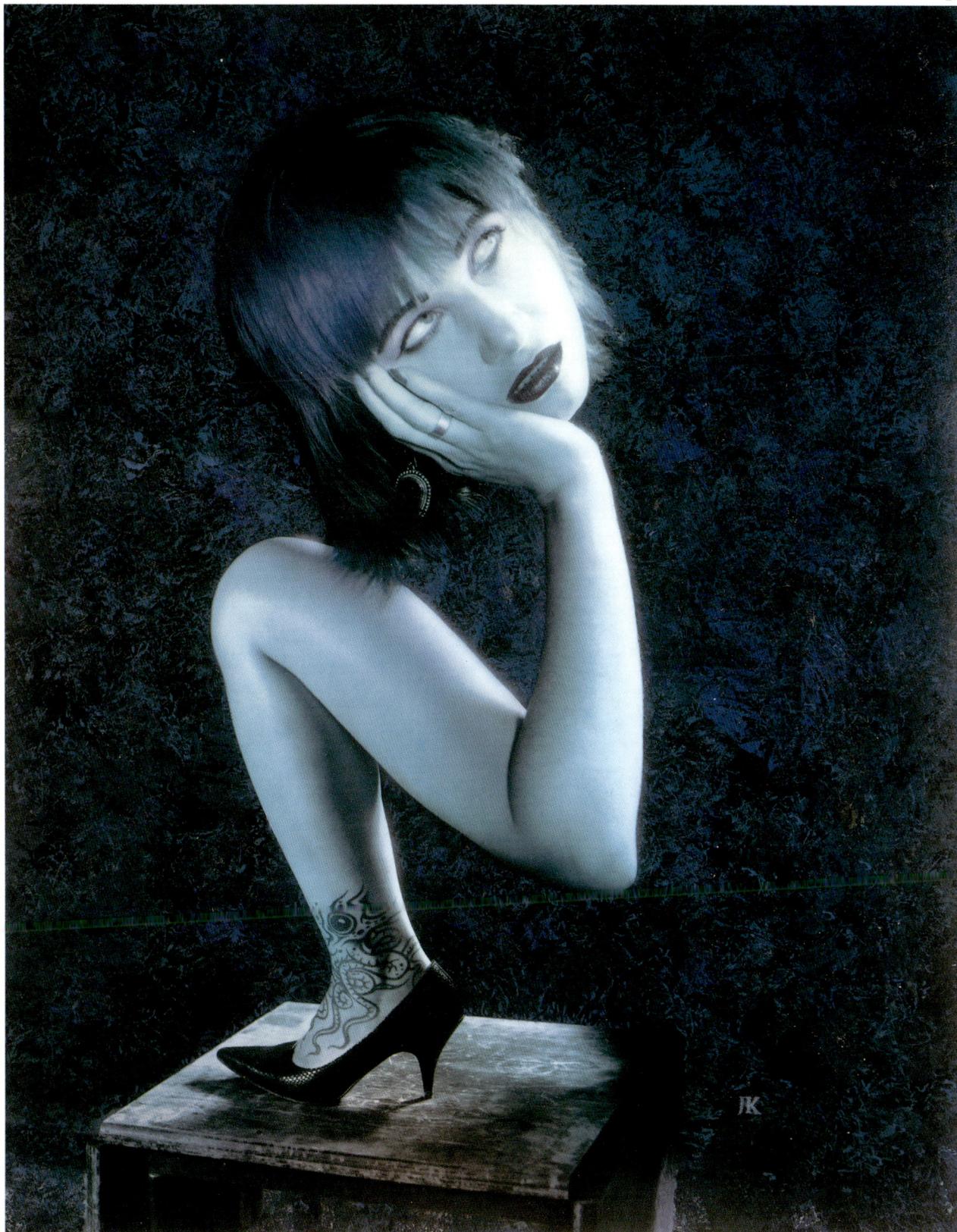

28
artist: **J.K. POTTER**
title: Tame
medium: Mixed
size: 7x20

29
artist: **DON IVAN PUNCHATZ**
art director: Adrian Carmack/Kevin Cloud
designer: Don Ivan Punchatz
client: ID Software
title: Doom
medium: Acrylic
size: 20x26

30
artist: **RICHARD BERNAL**
art director: Richard Bernal
client: The Brighton Agency

31
artist: **DON IVAN PUNCHATZ**
art director: Don Ivan Punchatz
designer: Don Ivan Punchatz
client: Multiple Sclerosis Benefit
title: Snow Princess
medium: Acrylic
size: 16x20

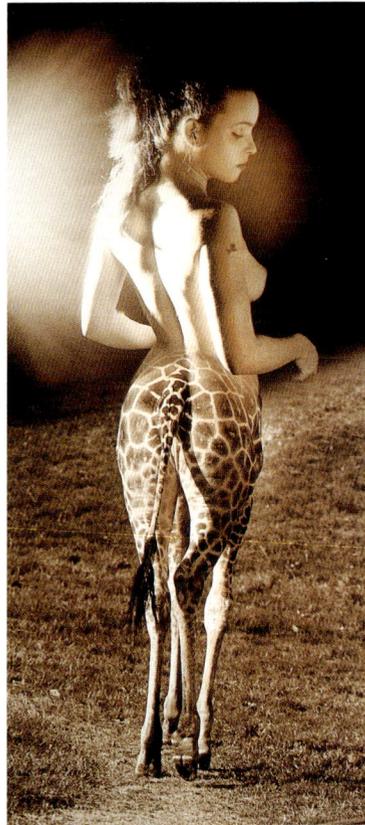
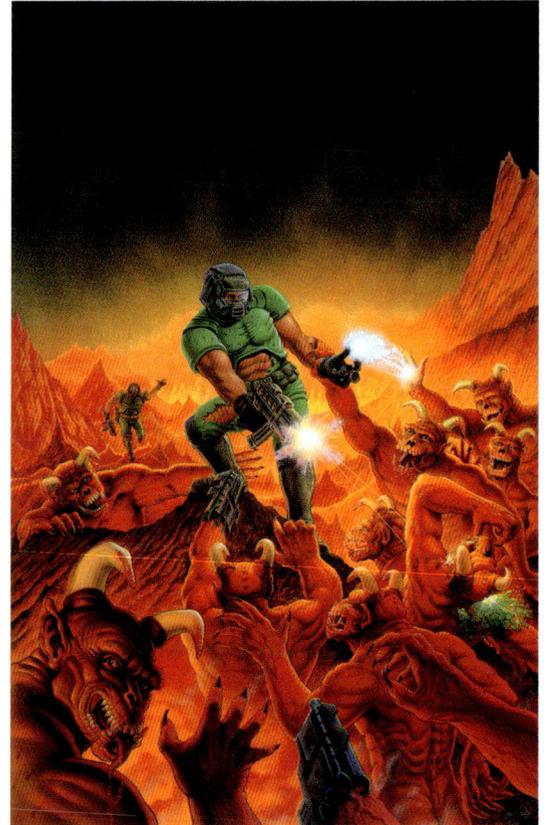

30

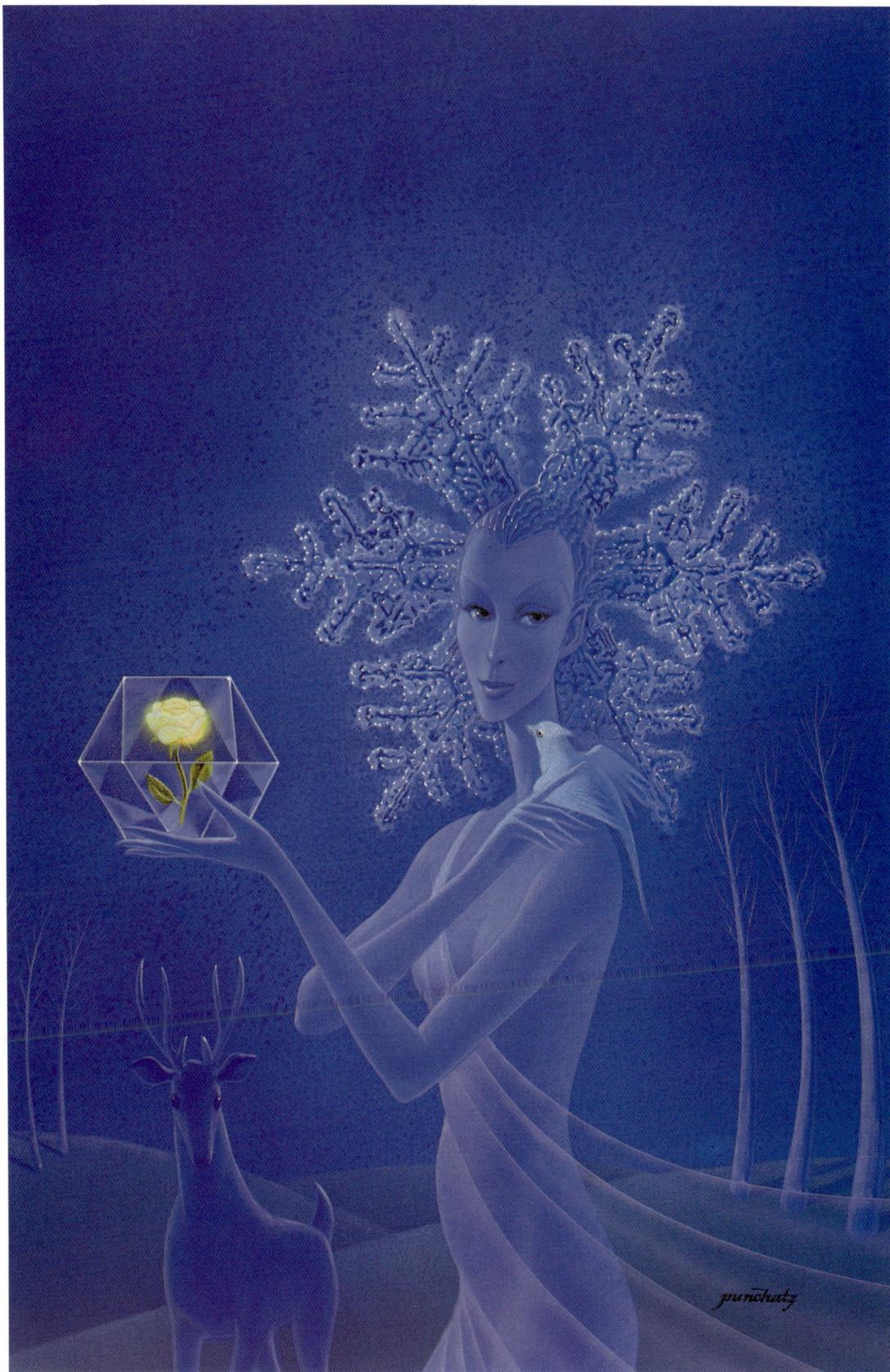

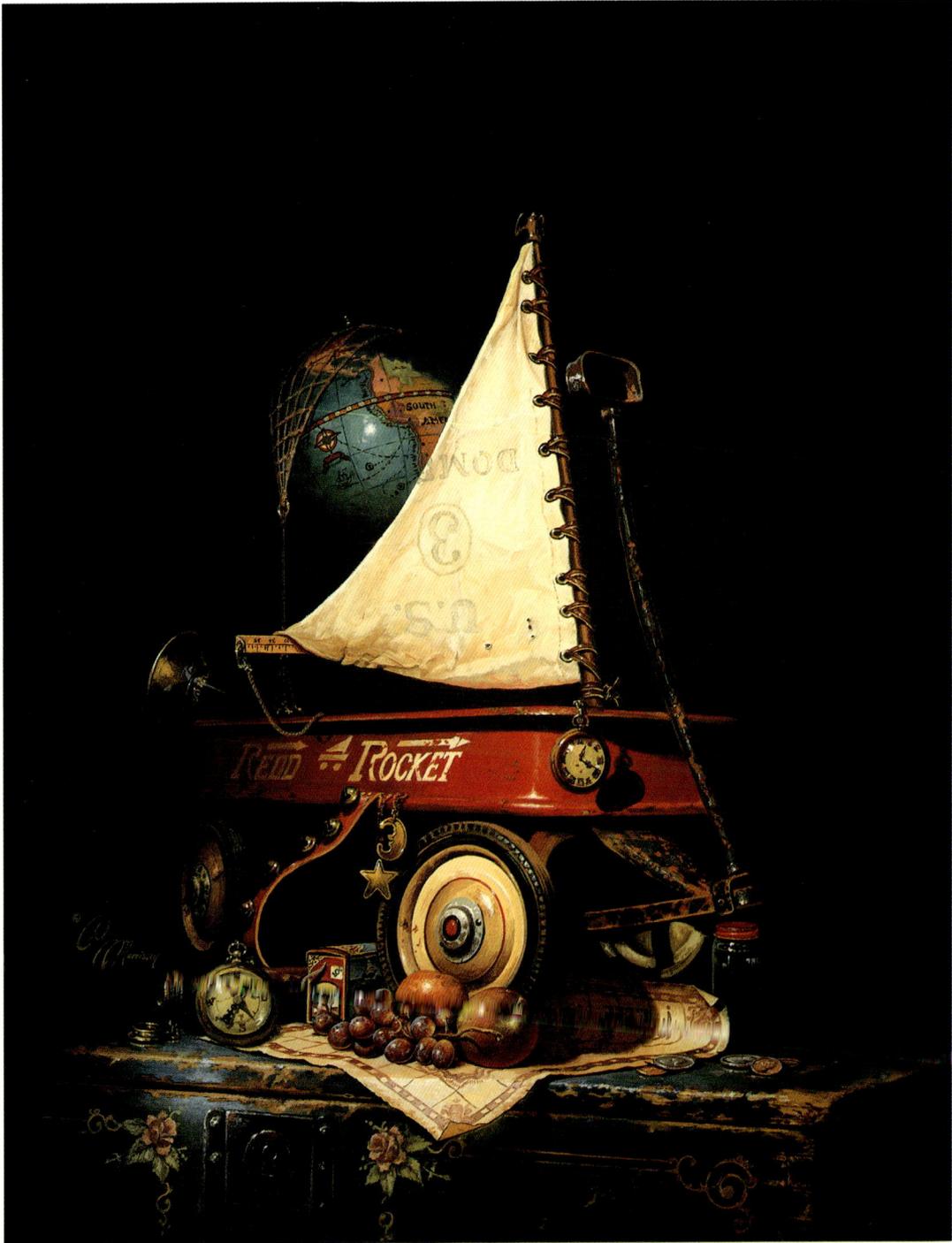

32
artist: **DEAN MORRISSEY**
client: Harry N. Abrams
title: Redd Rocket
medium: Oil on canvas
size: 24x30

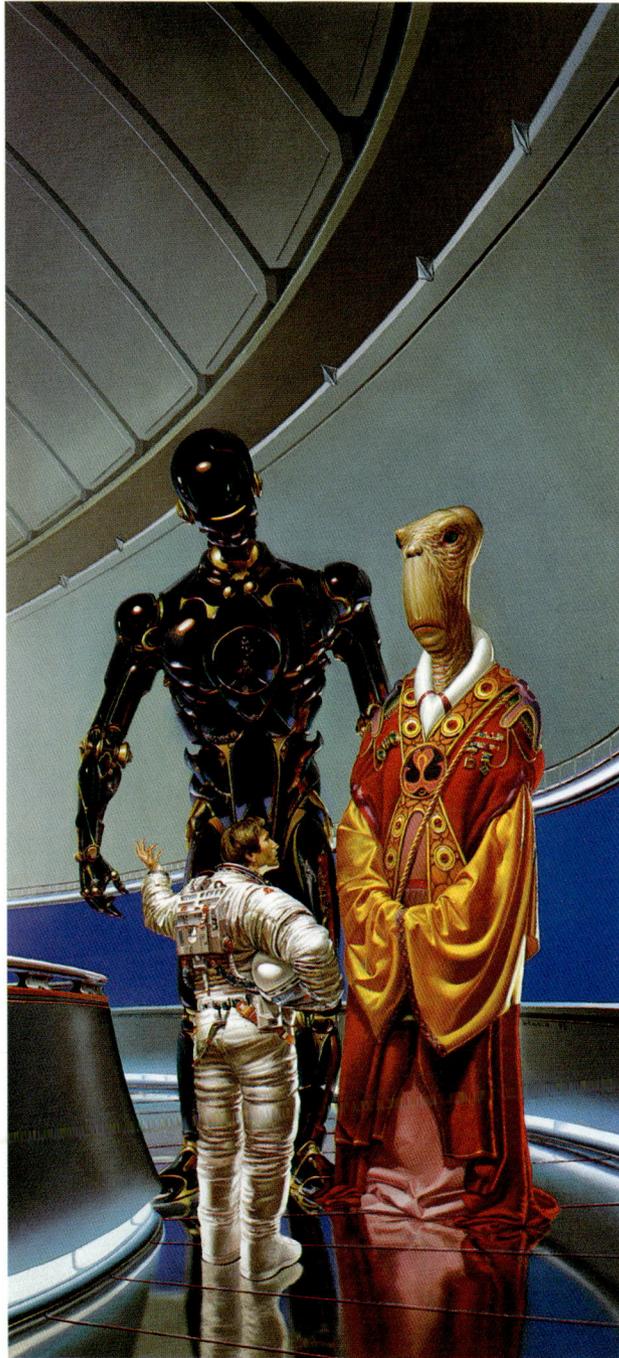

33
artist: **DONATO GIANCOLA**
art director: Jamie Warren Youll
client: Bantam Books
title: Otherness
medium: Oil on paper
size: 15x31

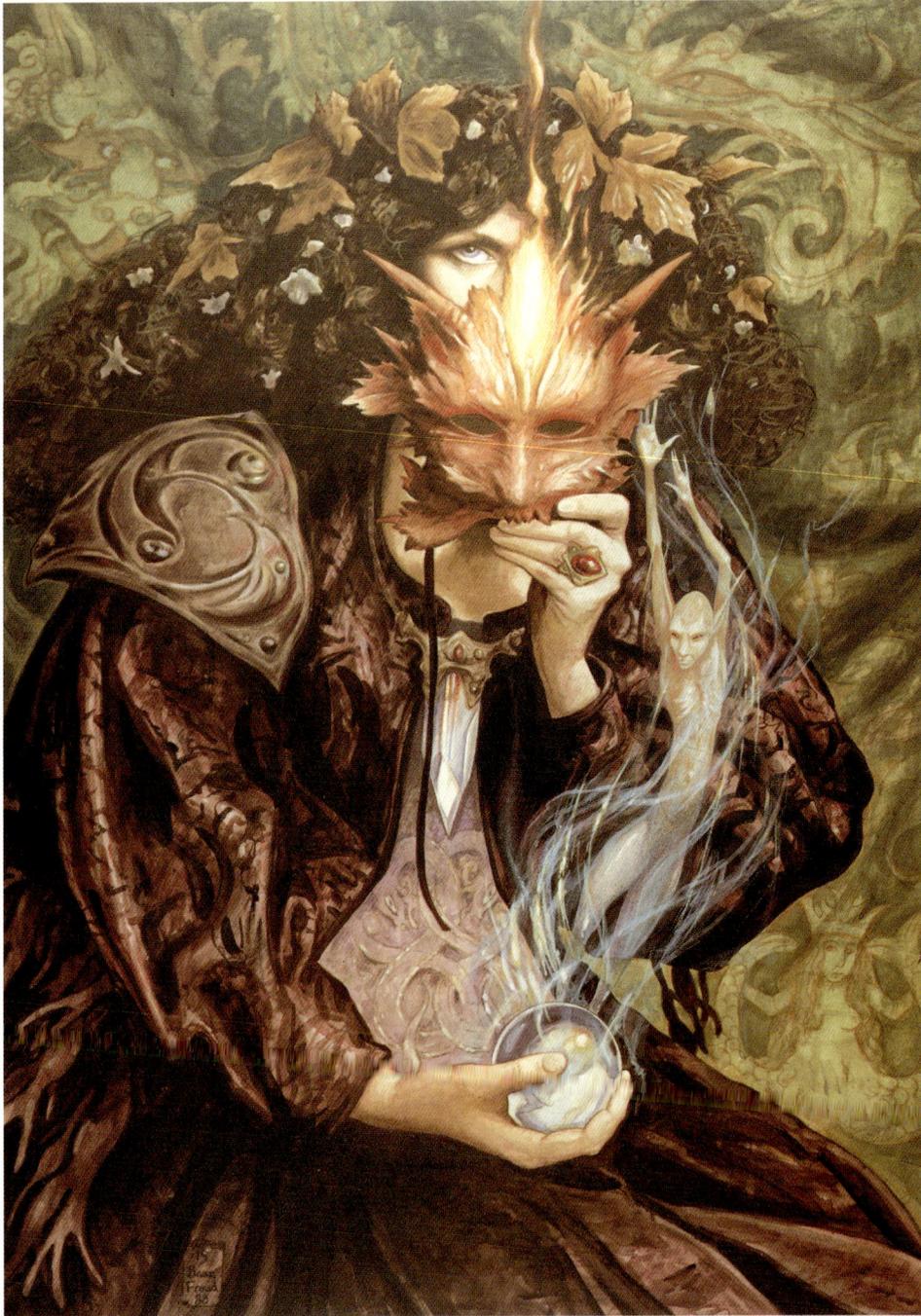

34
artist: **BRIAN FROUD**
art director: Brian Froud
title: The Wise Woman
medium: Acrylic, color pencil, and gouache
size: 16.5x22.5

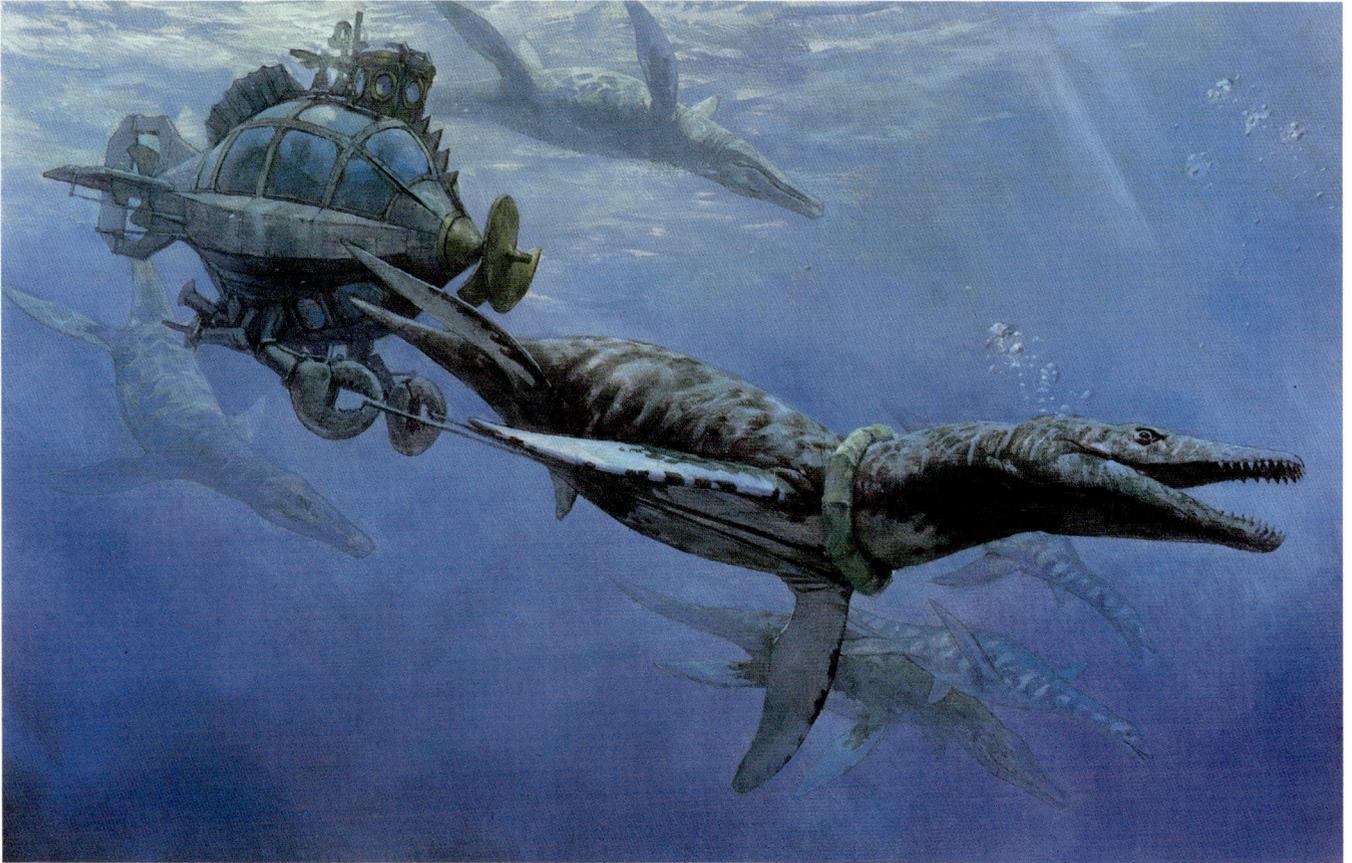

Under Tow by James Gurney. © James Gurney, courtesy of the Greenwich Workshop, Inc.

35
artist: **JAMES GURNEY**
art director: David Usher
client: The Greenwich Workshop and Turner Publishing
title: Under Tow from *The World Beneath*
medium: Oil on board
size: 21x14

36
artist: **STEPHEN YOULL**
art director: Jamie Warren Youll
client: Bantam Books
title: Terminal Cafe
medium: Acrylic
size: 30x40

37
artist: **CORTNEY SKINNER &**
NEWELL CONVERS
art director: Toni Weisskopf
client: Baen Books
title: The Witch and the Cathedral
medium: Oil
size: 21x32

38
artist: **DON MAITZ**
art director: Jamie Warren Youll
client: Bantam Books
title: A Farce to be Reckoned With
medium: Oil on masonite
size: 27x20

39
artist: **NEWELL CONVERS &**
CORTNEY SKINNER
art director: Jim Baen
client: Baen Books
title: The Printer's Devil
medium: Oil
size: 21x32

36

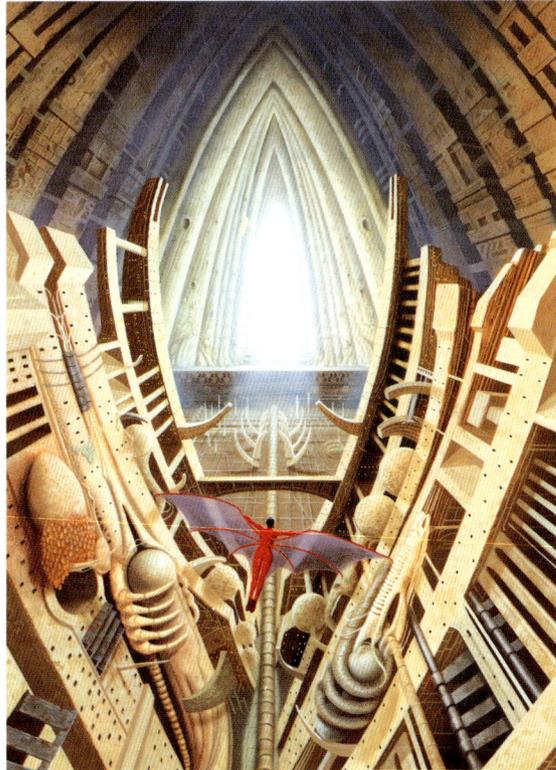

37

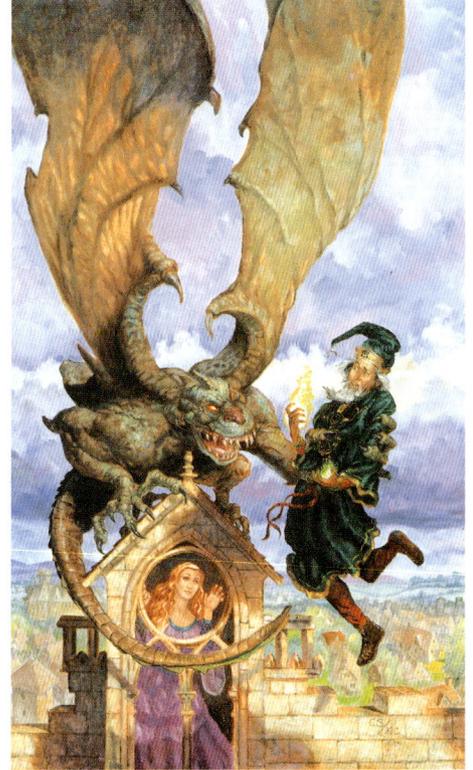

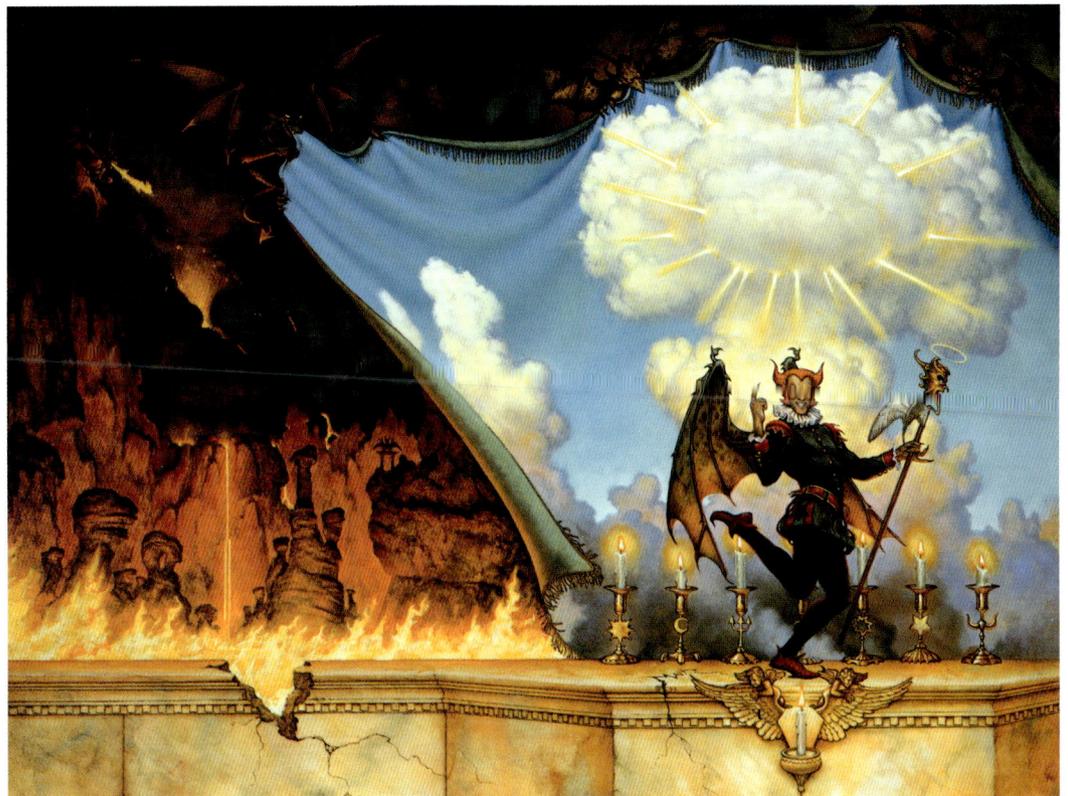

38

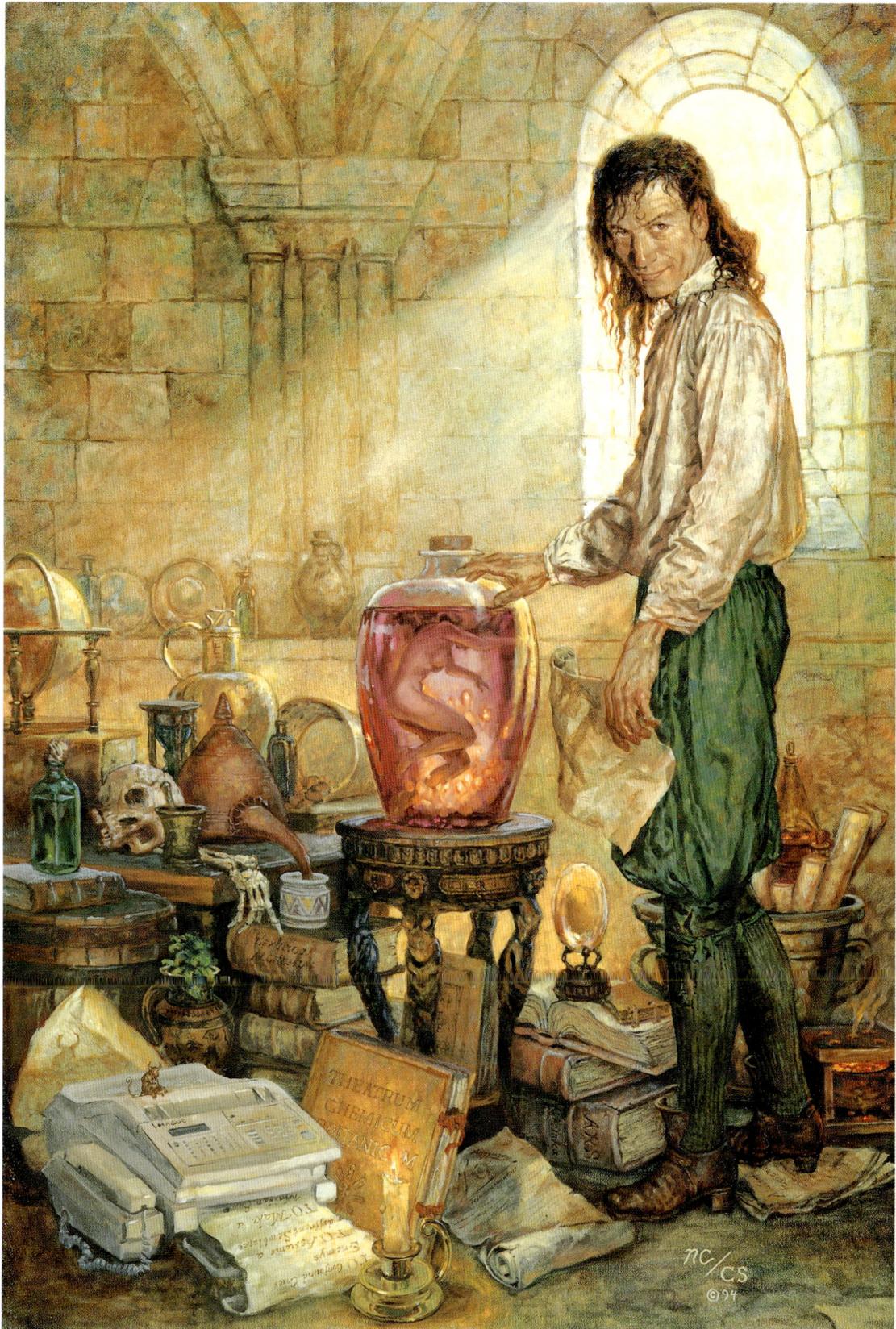

40

artist: **PHIL HALE**
art director: Arnie Fenner
designer: Arnie Fenner & Cathy Burnett
client: Mark V. Ziesing Books
title: Insomnia
medium: Oil

41

artist: **PHIL HALE**
art director: Arnie Fenner
designer: Arnie Fenner &
 Cathy Burnett
client: Mark V. Ziesing Books
title: Insomnia
medium: Oil

42

artist: **PHIL HALE**
art director: Arnie Fenner
designer: Arnie Fenner &
 Cathy Burnett
client: Mark V. Ziesing Books
title: Insomnia
medium: Oil

43

artist: **PHIL HALE**
art director: Arnie Fenner
designer: Arnie Fenner &
 Cathy Burnett
client: Mark V. Ziesing Books
title: Insomnia
medium: Oil

44

artist: **LES EDWARDS**
art director: Bob Hollingsworth
client: Arrow Books
title: The List of Seven
medium: Acrylic
size: 20x30

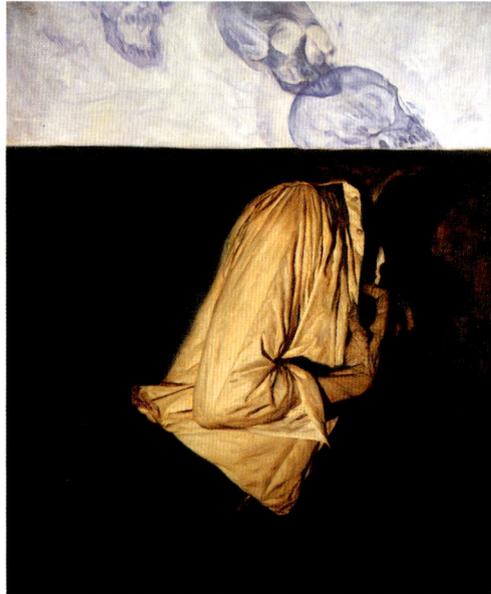

41

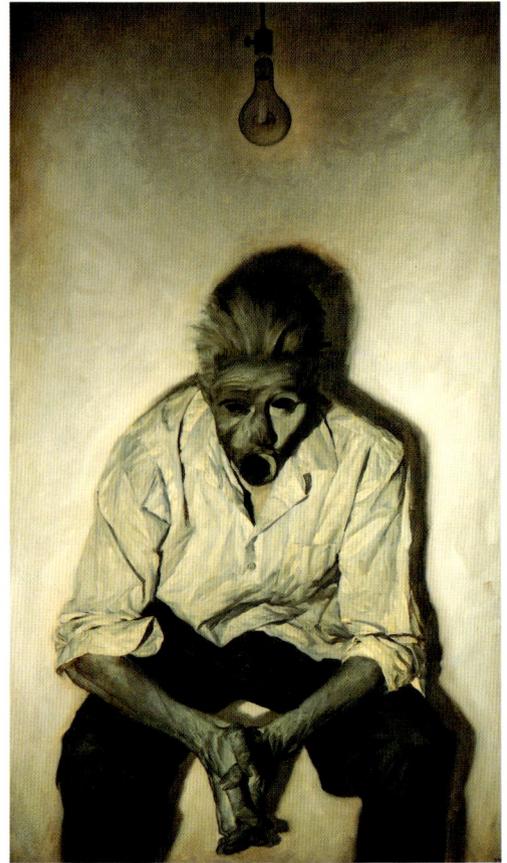

40

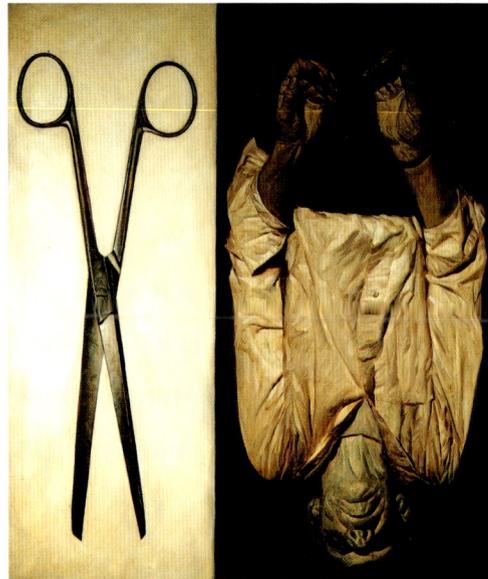

42

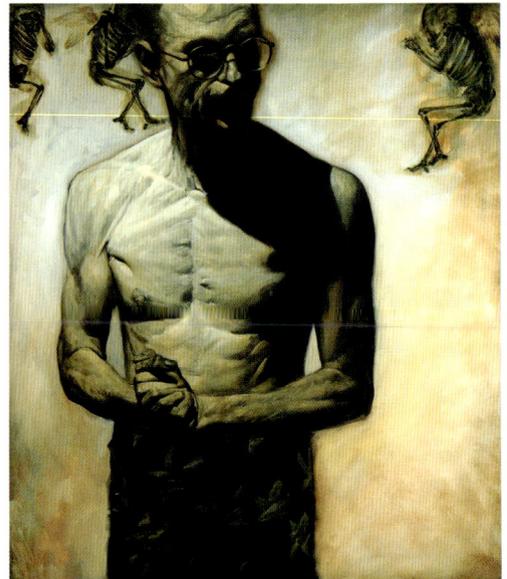

43

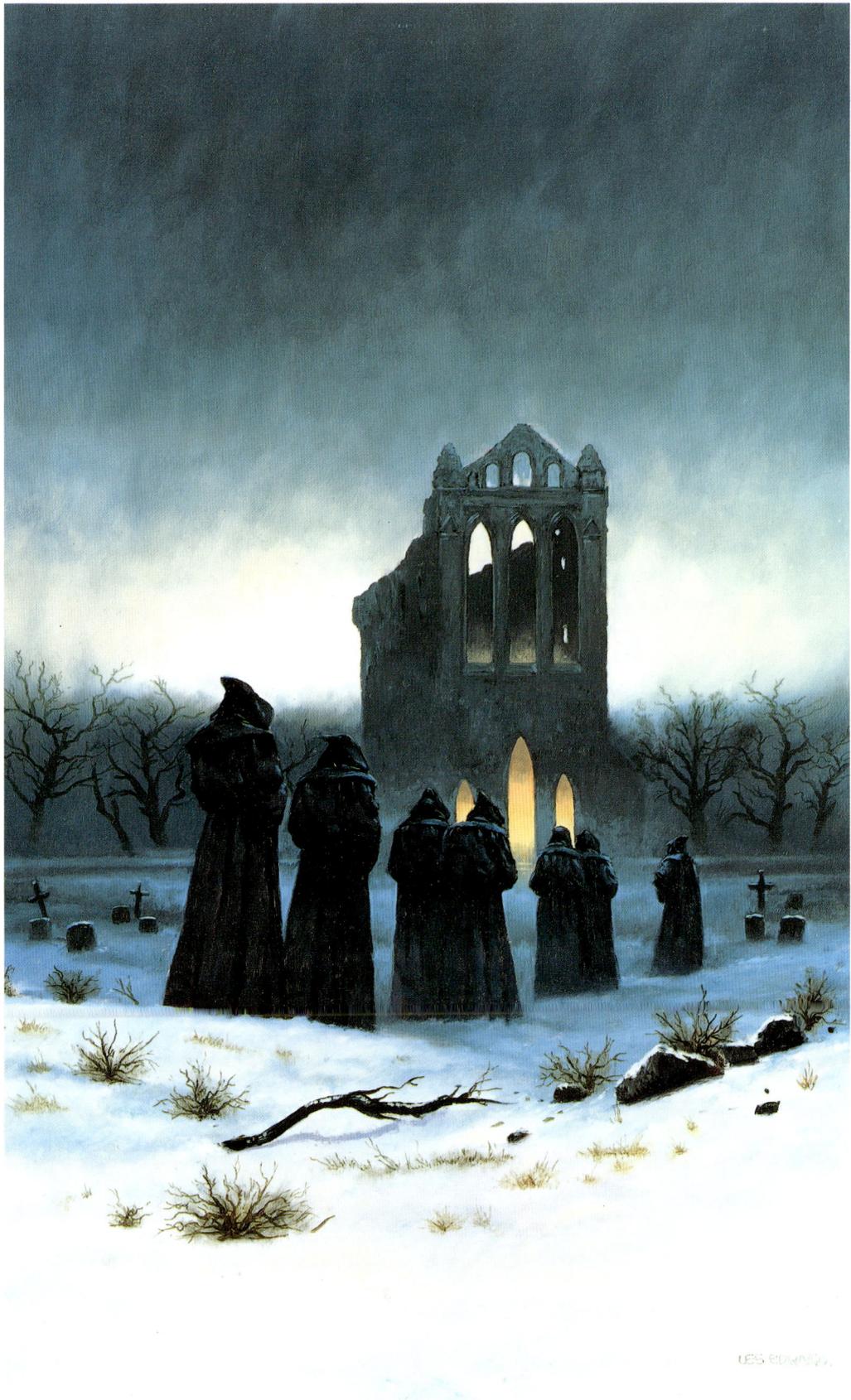

45

46

45

artist: **LEO & DIANE DILLON**
art director: Nick Krenitsky
designer: Nick Krenitsky
client: Harper Collins
title: The Lion, The Witch
 and the Wardrobe
medium: Acrylic
size: 6.5x10

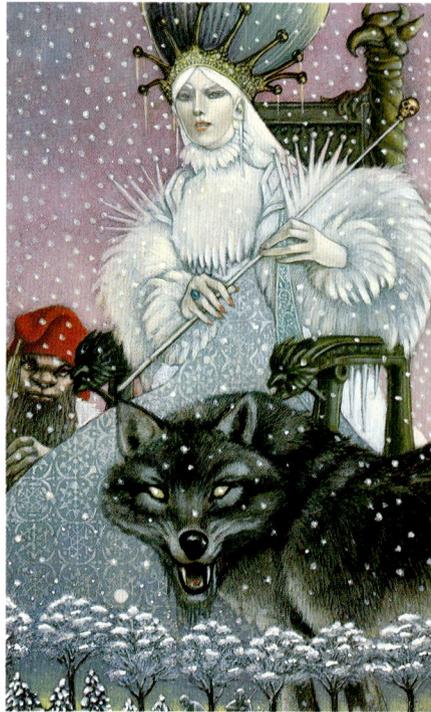

46

artist: **JEAN TARGETE**
art director: Tom Egner
designer: Stephen Bell
client: Avon Books
title: The Guns of Avalon
medium: Oil

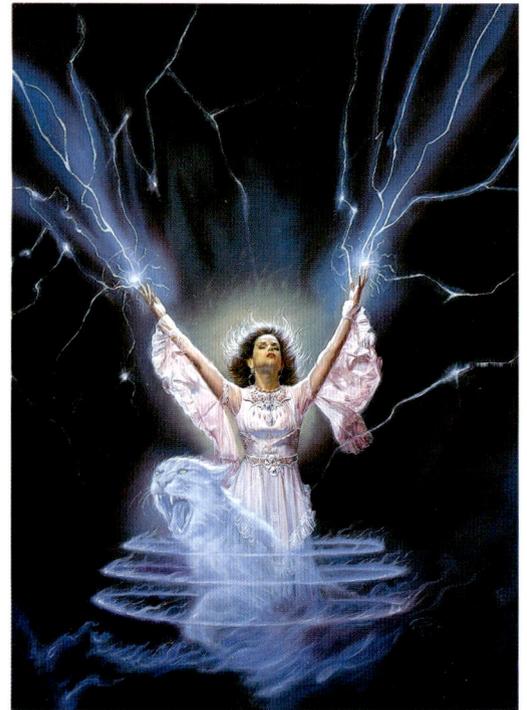

47

artist: **JANNY WURTS**
art director: Gene Mydlowski
client: Harper Collins
title: Ships of Merior
medium: Oil on masonite
size: 36x23.5

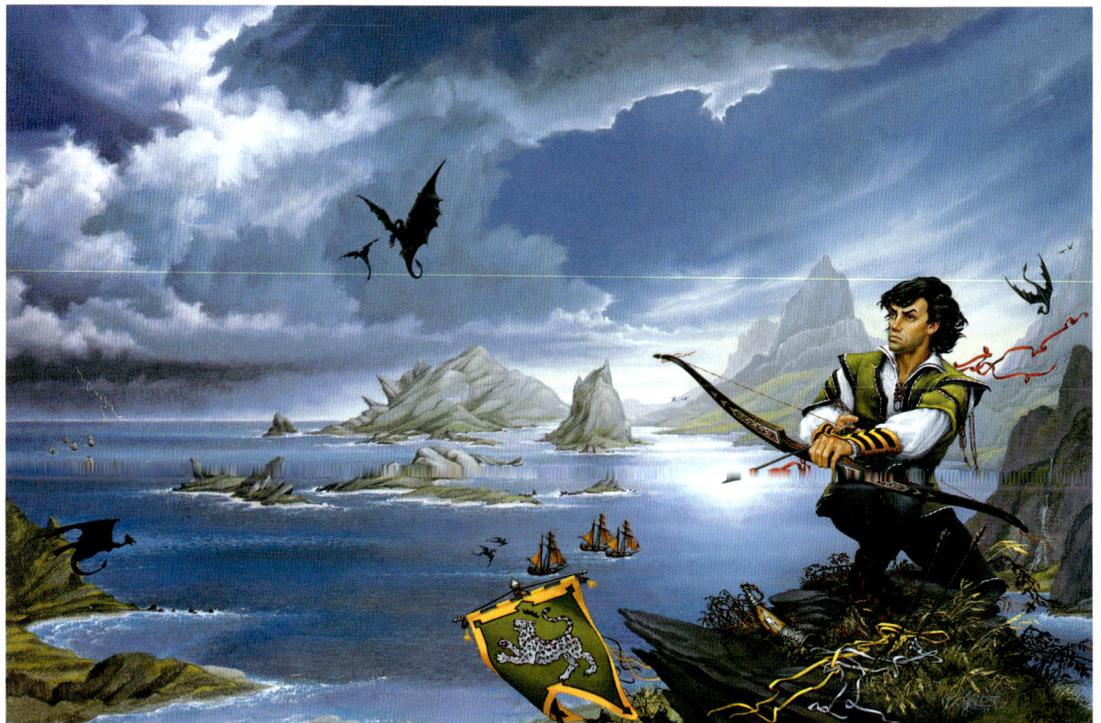

48

artist: **DANIEL HORNE**
art director: Tom Egner
designer: Amy Halperin
client: Avon Books
title: Dreamseeker's Road
medium: Oil

47

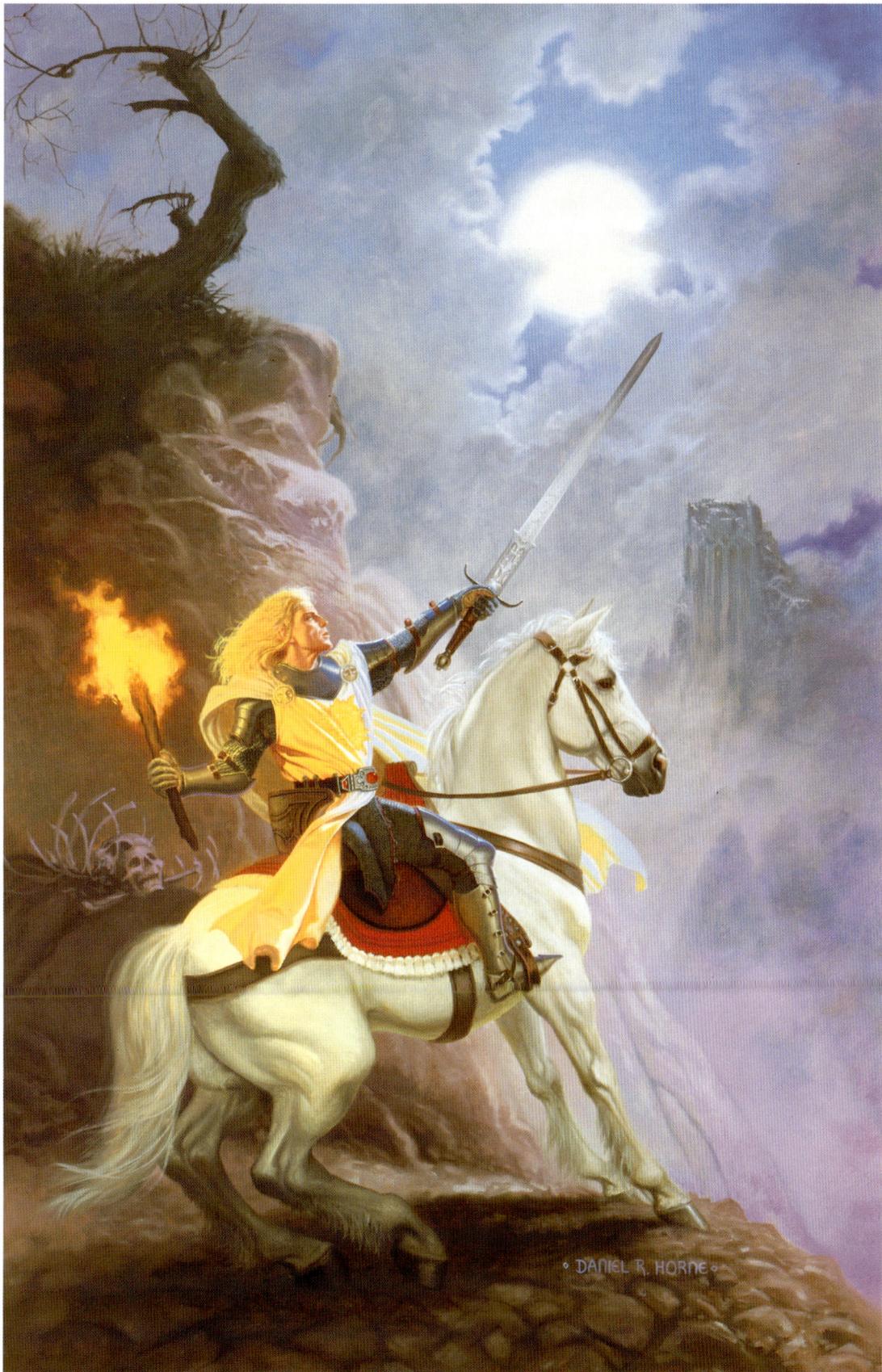

DANIEL R. HORNE

49

50

49
artist: **DAVID CHERRY**
art director: Betsy Wollheim
client: DAW Books
title: Serpent's Waltz
medium: Acrylic
size: 15x22

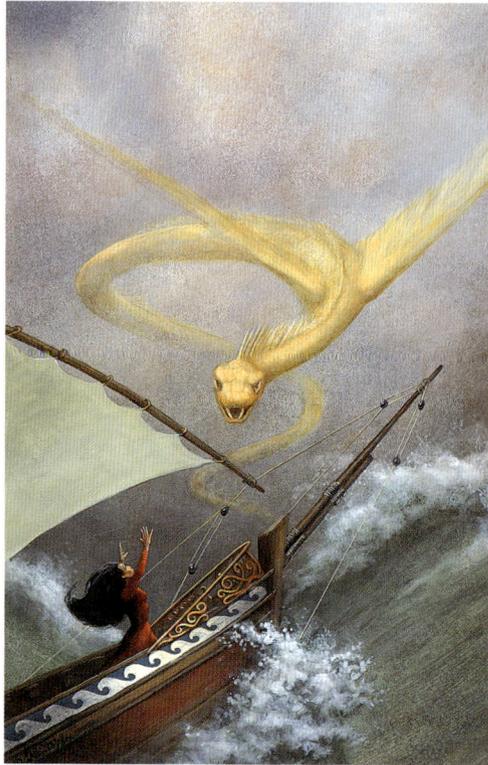

50
artist: **SCOTT McKOWEN**
art director: Tom Egner
designer: Stephen Bell
client: Avon Books
title: Death in Disguise
medium: Scratchboard & gouache

51
artist: **JAMES NELSON**
art director: James Nelson
designer: James Nelson
client: FASA Corporation
medium: Watercolor on paper
size: 11.25x14

52
artist: **WALTER VELEZ**
art director: Maria Mellili
client: Tor Books
title: Split Heirs
medium: Acrylic
size: 18x26

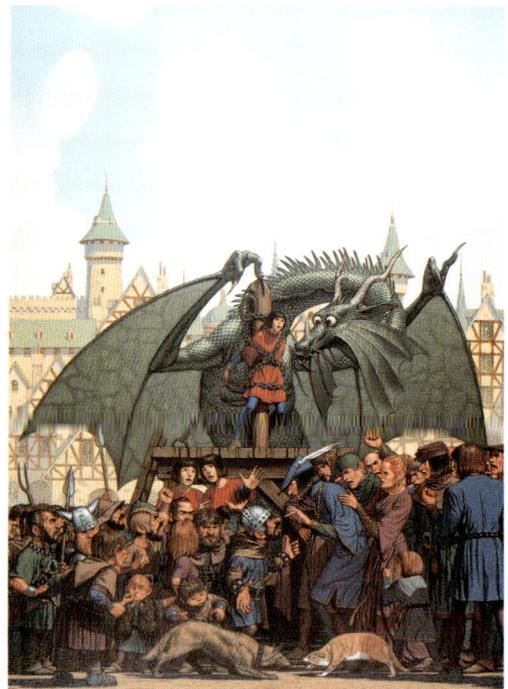

53
artist: **JOHN HOWE**
art director: Jeff Laubenstein
client: FASA Corporation
title: Earthdawn: Terror in the Skies
medium: Watercolor
size: 20x30

51

52

54
artist: **BRUCE JENSEN**
art director: Jamie Warren Youll
designer: Jamie Warren Youll
client: Bantam Books
title: Earth
medium: Acrylic
size: 13x24

55
artist: **BRUCE JENSEN**
art director: Judith Murello
designer: Judith Murello
client: Berkley Publishing Group
title: Superheroes
medium: Acrylic
size: 18x24

56
artist: **NICHOLAS JAINSCHIGG**
art director: Nicholas Jainschigg
client: NESFA Press
title: Danceland
medium: Oil on masonite
size: 30x20

57
artist: **RICK BERRY**
art director: Jeff Laubenstein
client: FASA Corporation
title: Partners
medium: Oil
size: 48x50

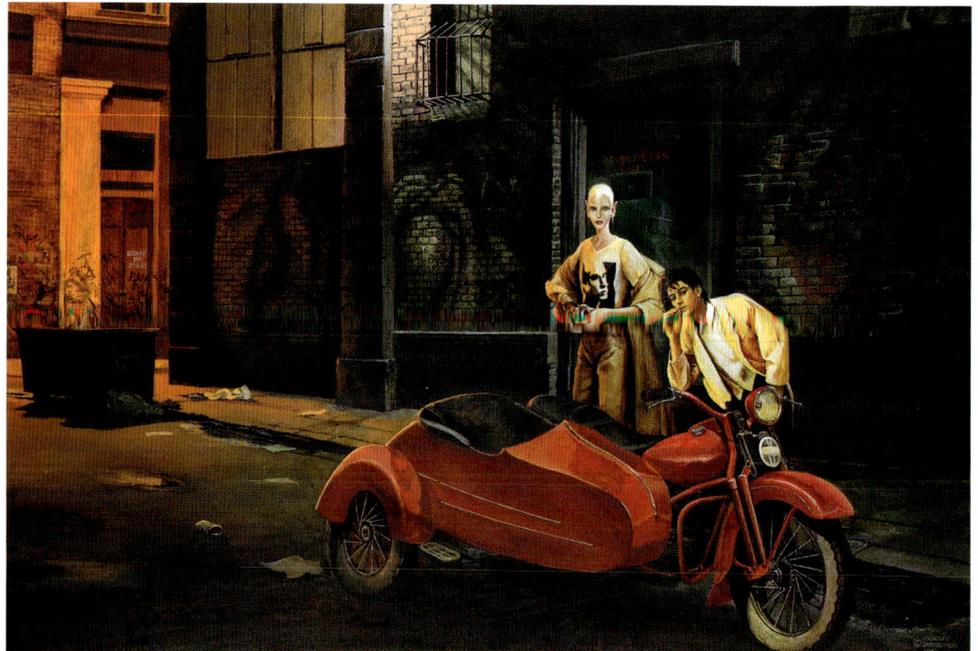

56

58

59

58
artist: **ALAN M. CLARK**
art director: Alan M. Clark
designer: Alan M. Clark
client: Arts Nova Press
title: Darling
medium: Acrylic
size: 16x24

59
artist: **NICHOLAS JAINSCHIGG**
art director: Jerry Tod
client: ROC Books
title: Wild Blood
medium: Oil on masonite
size: 10x16

60
artist: **FRANK MILLER**
art director: Harlan Ellison
designer: Arnie Fenner
client: Mark V. Ziesing Books
title: Mefisto in Onyx
medium: Ink on paper
size: 30x14

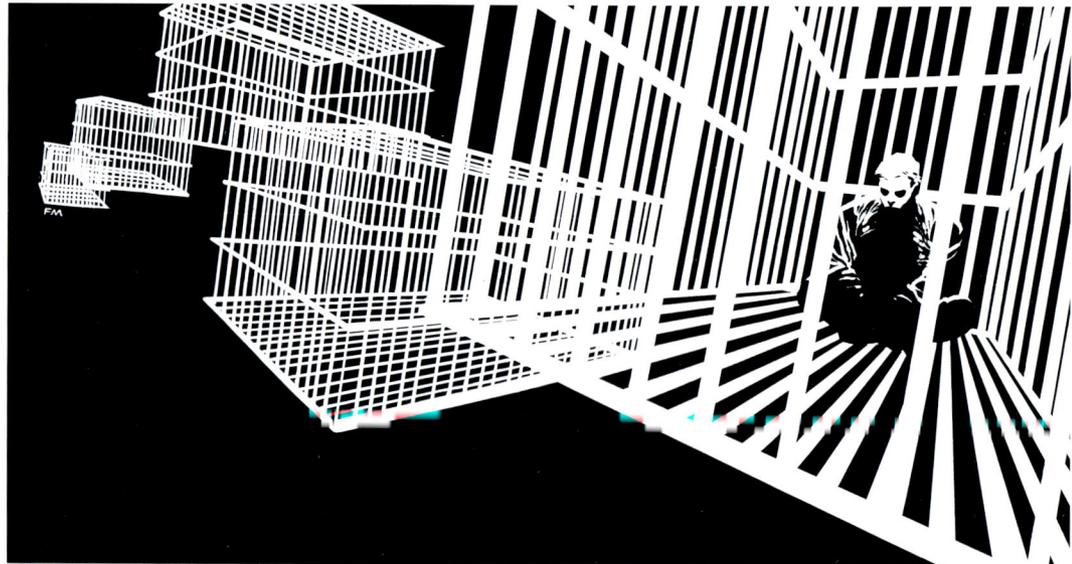

61
artist: **GARY RUDDELL**
art director: Gene Mydlowski
designer: Gary Ruddell
client: Ace Books
title: Campbell Woods
medium: Oil on canvas
size: 15.5x24

60

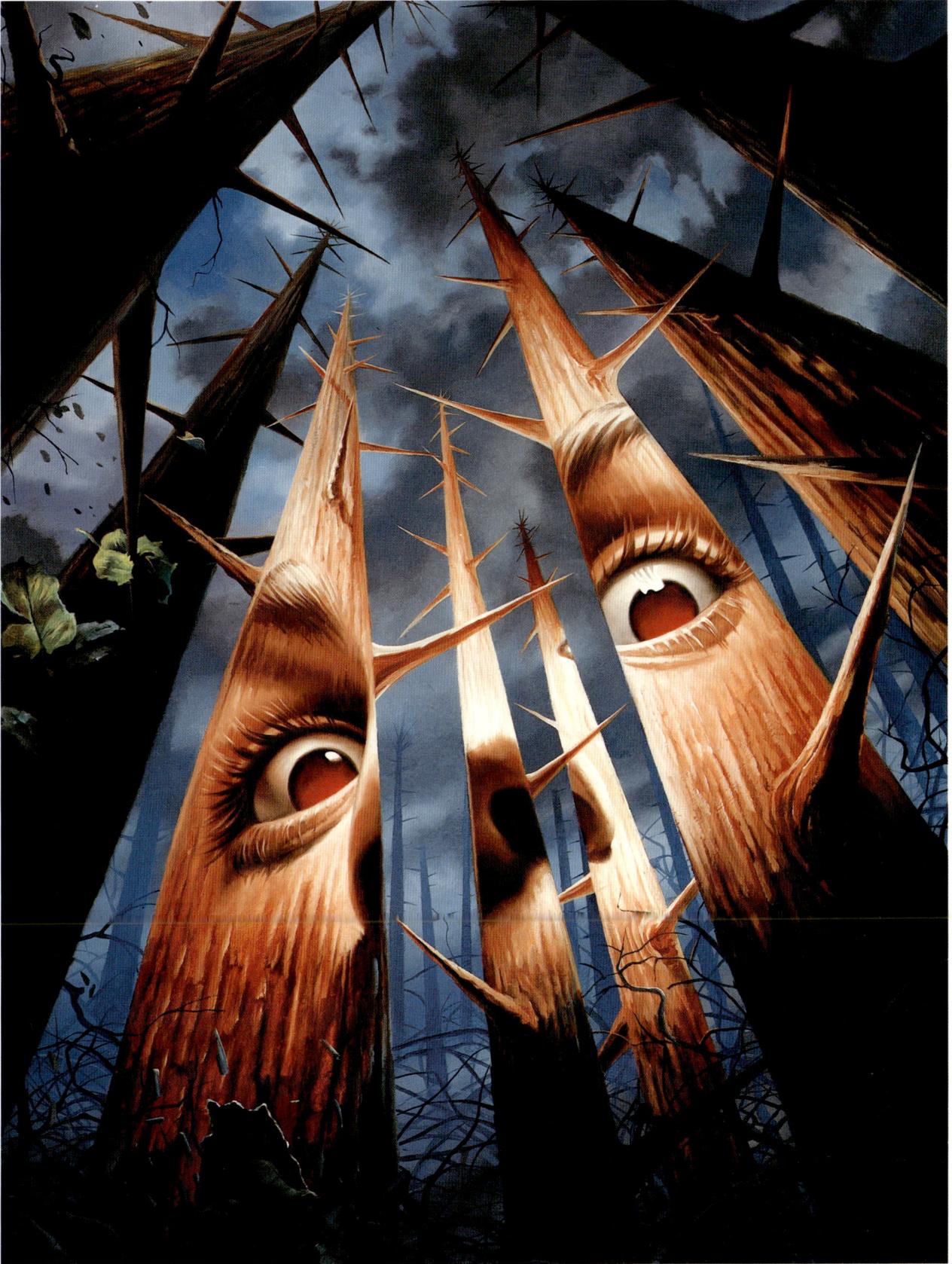

62
artist: **DEAN MORRISSEY**
client: Harry N. Abrams
title: The Dreamer's Trunk
medium: Oil on canvas
size: 47.75x36

63
artist: **DEAN MORRISSEY**
client: Harry N. Abrams
title: Ship of Dreams
medium: Oil on canvas
size: 40.5x30

64
artist: **RON WALOTSKY**
art director: Gordon Van Gelder
designer: Evan Gaffney
client: St. Martin's Press
title: Temporary Agency
medium: Acrylic
size: 15x20

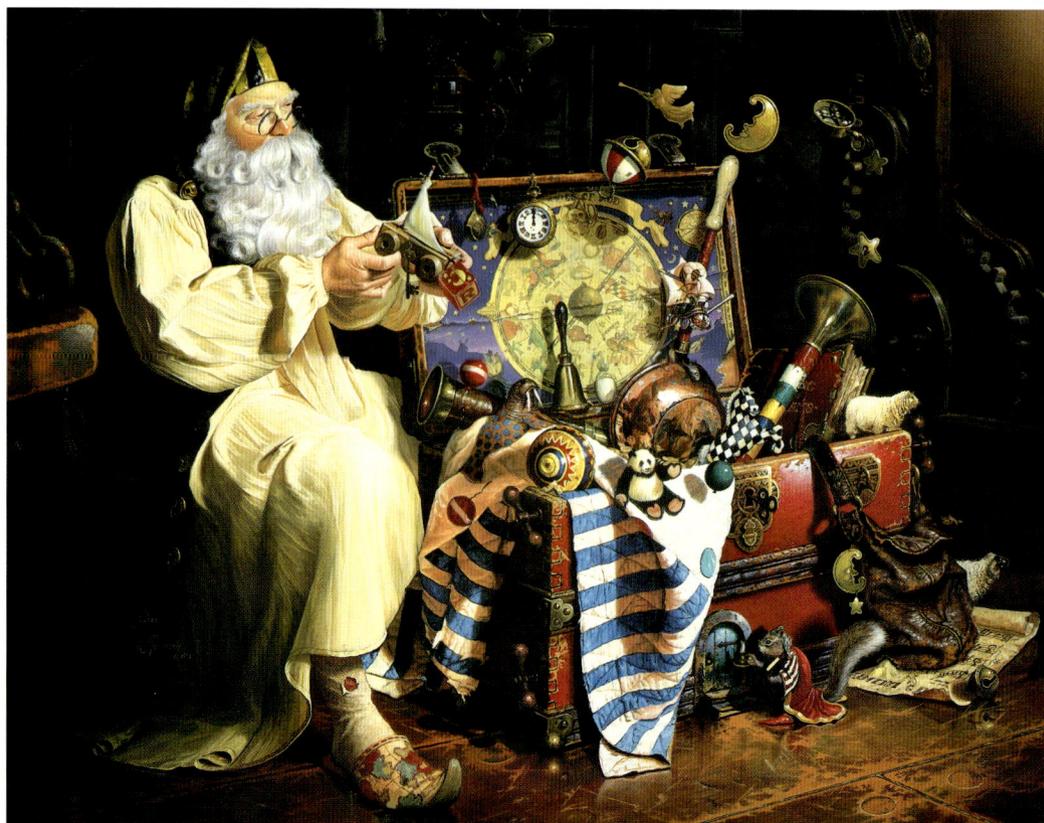

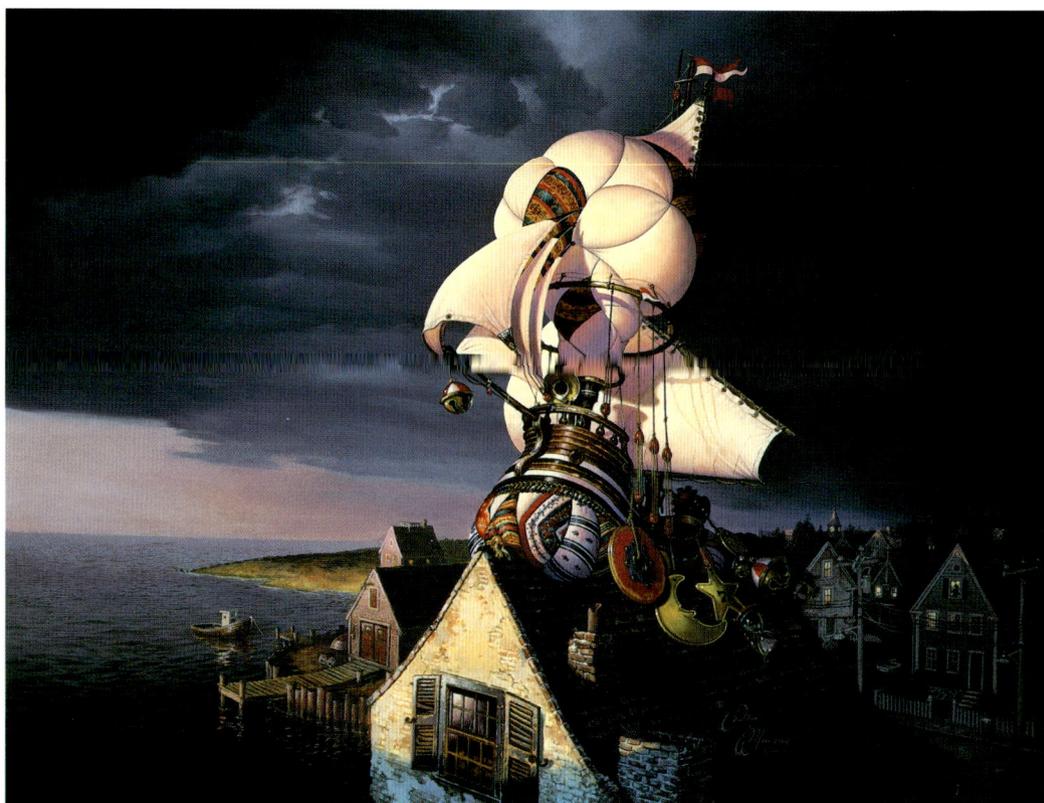

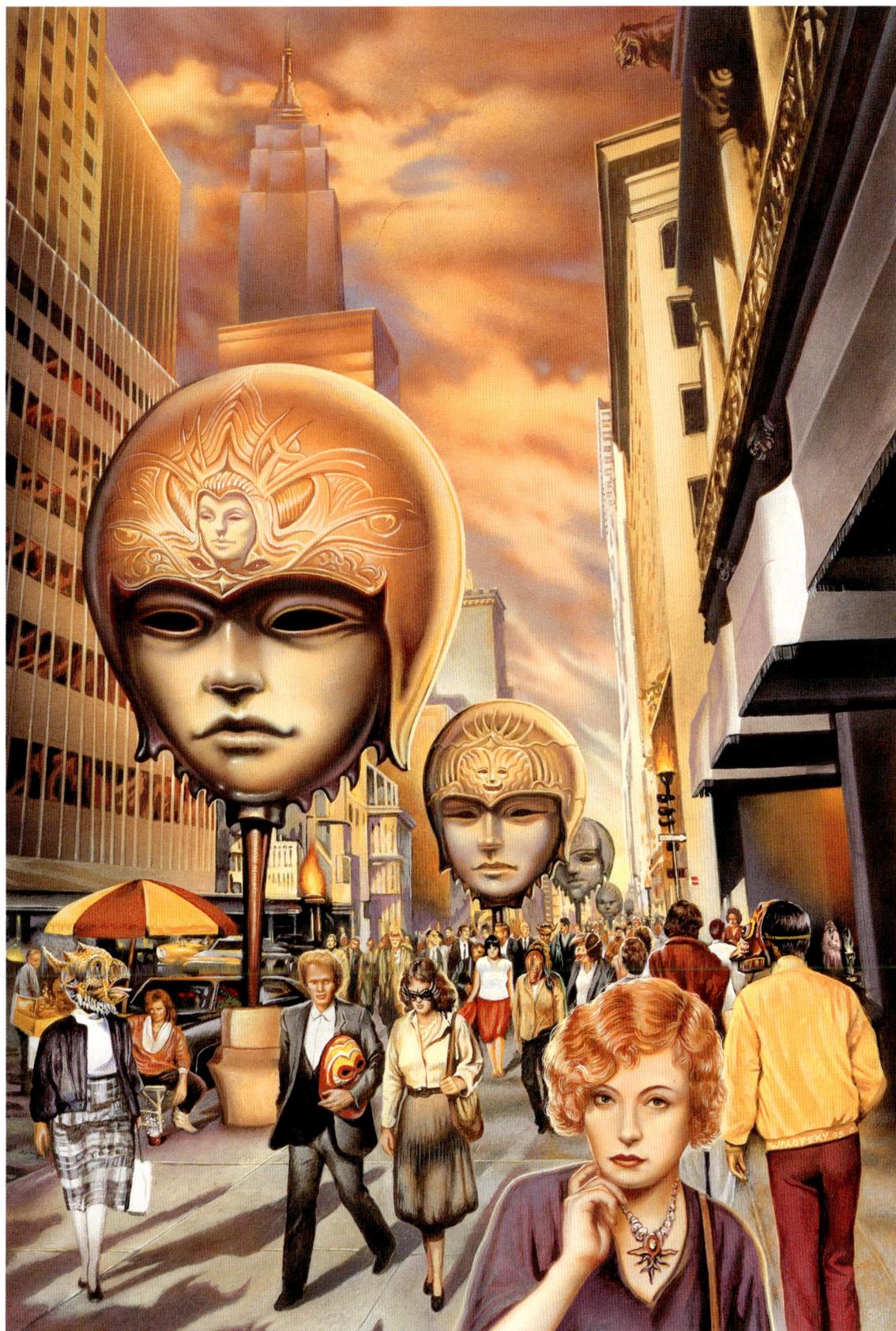

65
artist: **J.K. POTTER**
client: Arkham House
title: The Breath of Suspension
medium: Mixed
size: 16x20

66
artist: **BOB EGGLETON**
art director: Judy Murello
designer: Dave Rheinhardt
client: Ace Books
title: The Engines of God
medium: Acrylic
size: 38x12

67
artist: **DONATO GIANCOLA**
art director: Tom Egner
designer: Nadine Badalaty
client: Avon Books
title: Pasquale's Angel
medium: Oil

68
artist: **PAUL R. ALEXANDER**
art director: Jim Baen
client: Baen Books
title: Bollo 2: The Unconquerable
medium: Gouache
size: 14x23

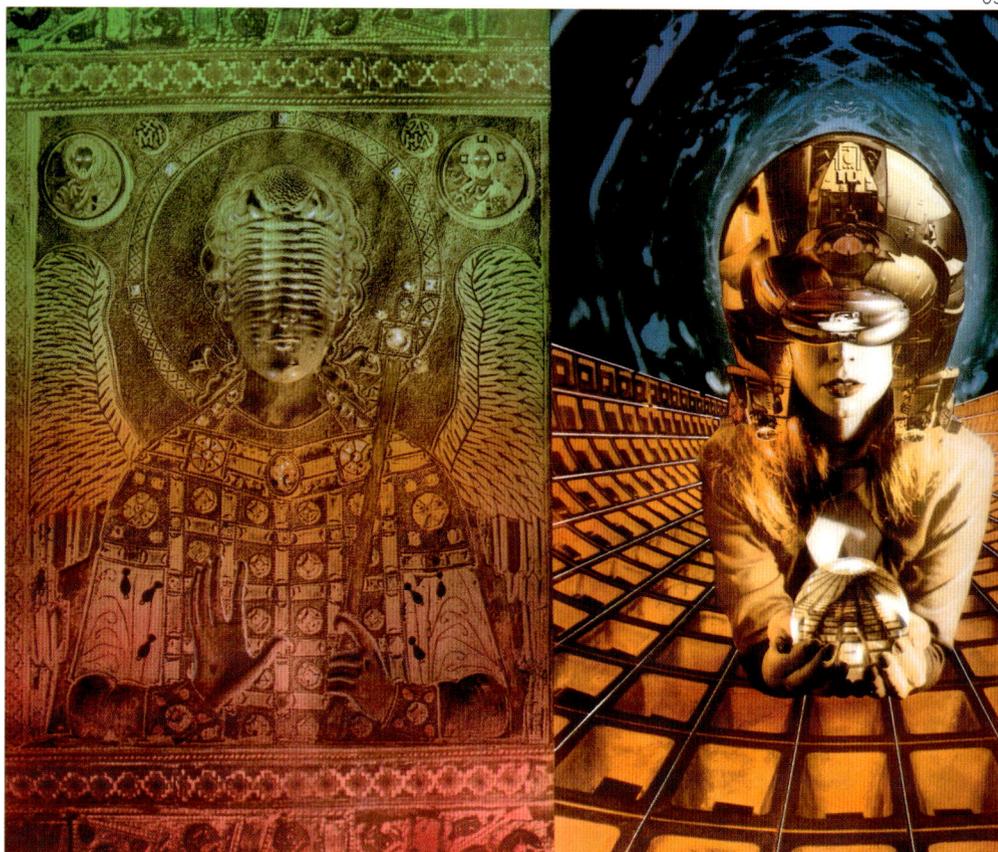

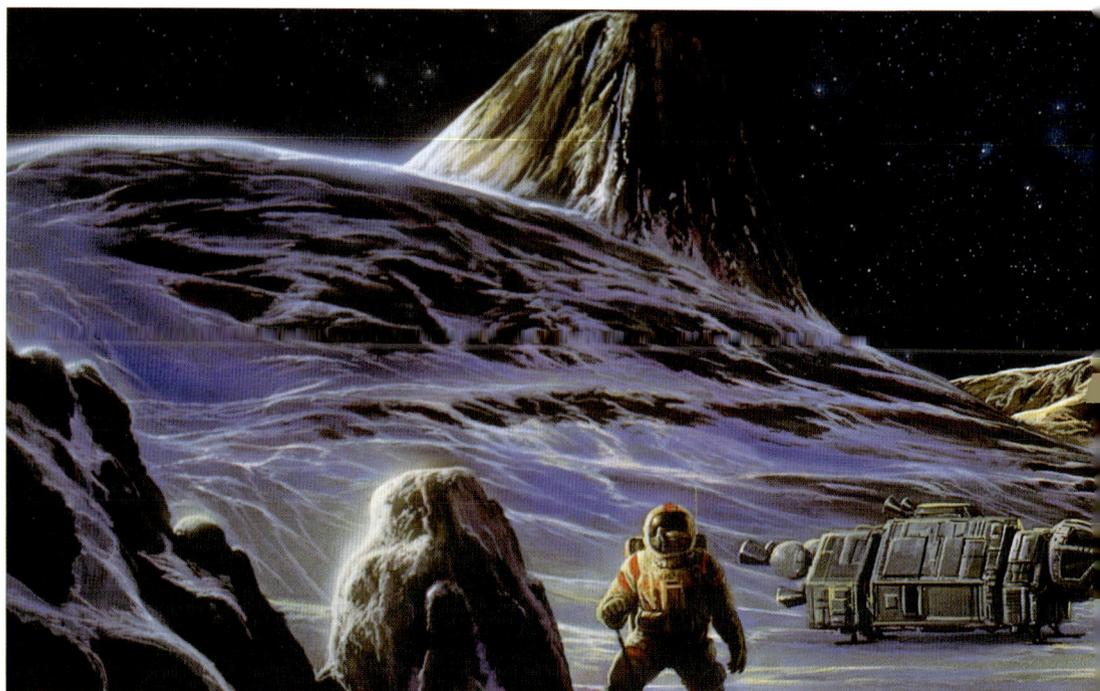

66

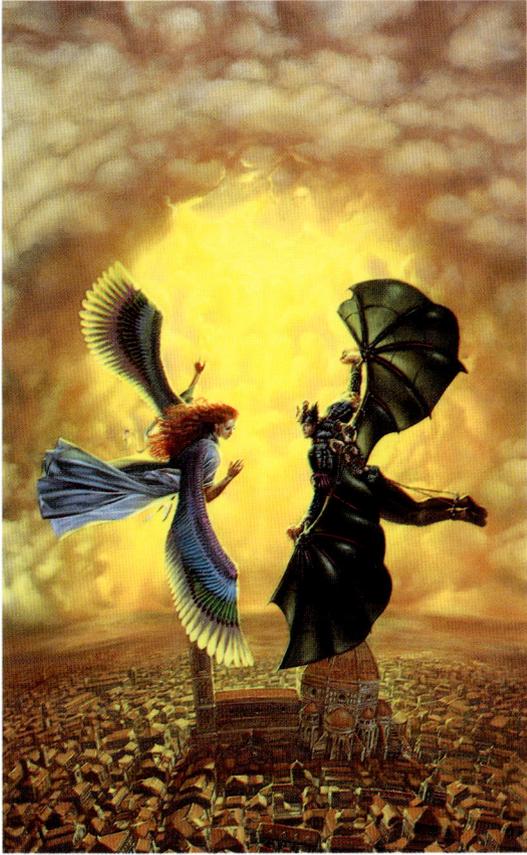

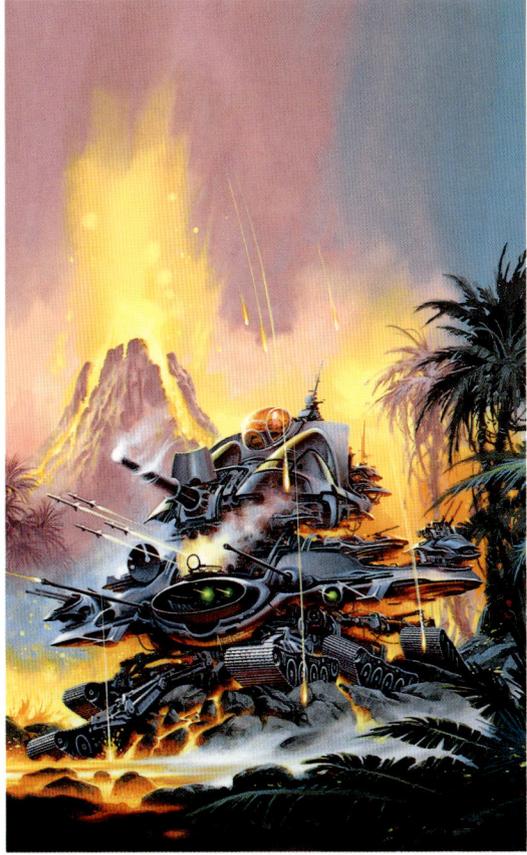

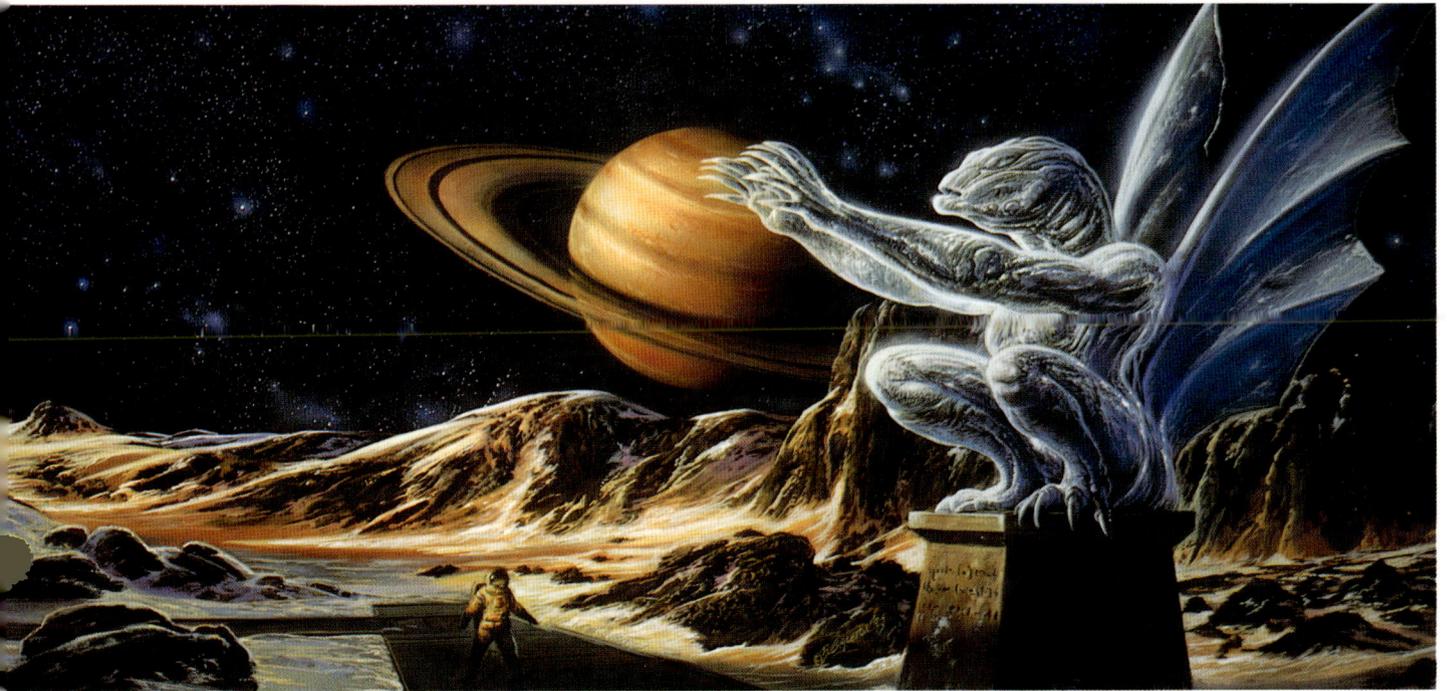

69

artist: **LES DORSCHEID**
art director: Jim Nelson
client: FASA Corporation
title: Parlainth Adventures
medium: Oil
size: 20x27

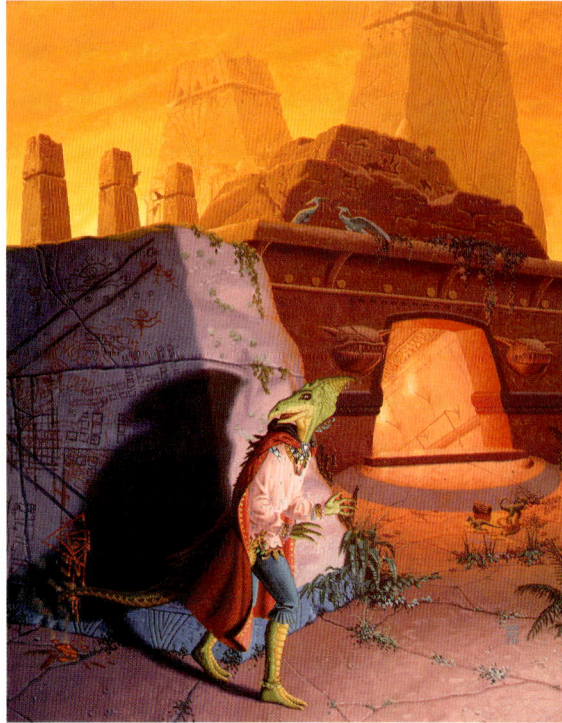

70

artist: **JOHN HOWE**
art director: Betsy Wollheim &
Sheila Gilbert
designer: Miles Long
client: DAW Books
title: The Sword of Maiden's Tears
medium: Watercolor
size: 18x24

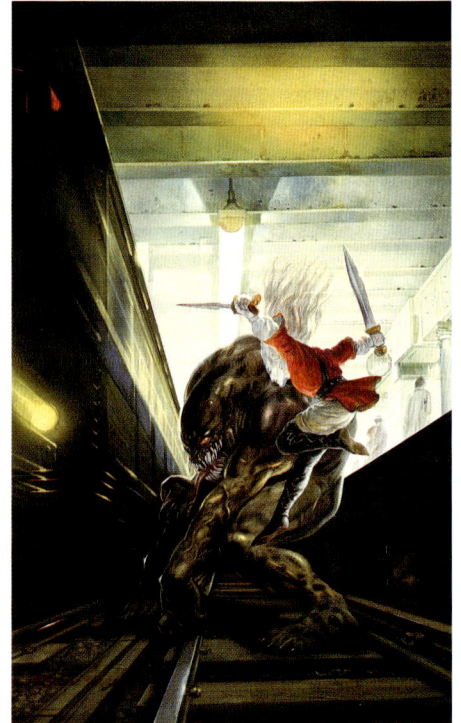

71

artist: **LAUREN MILLS &
DENNIS NOLAN**
art director: Sue Sherman &
Susan Lu Bussard
designer: Lauren Mills &
Dennis Nolan
client: Little, Brown
title: Fairy Wings
medium: Watercolor
size: 8x6

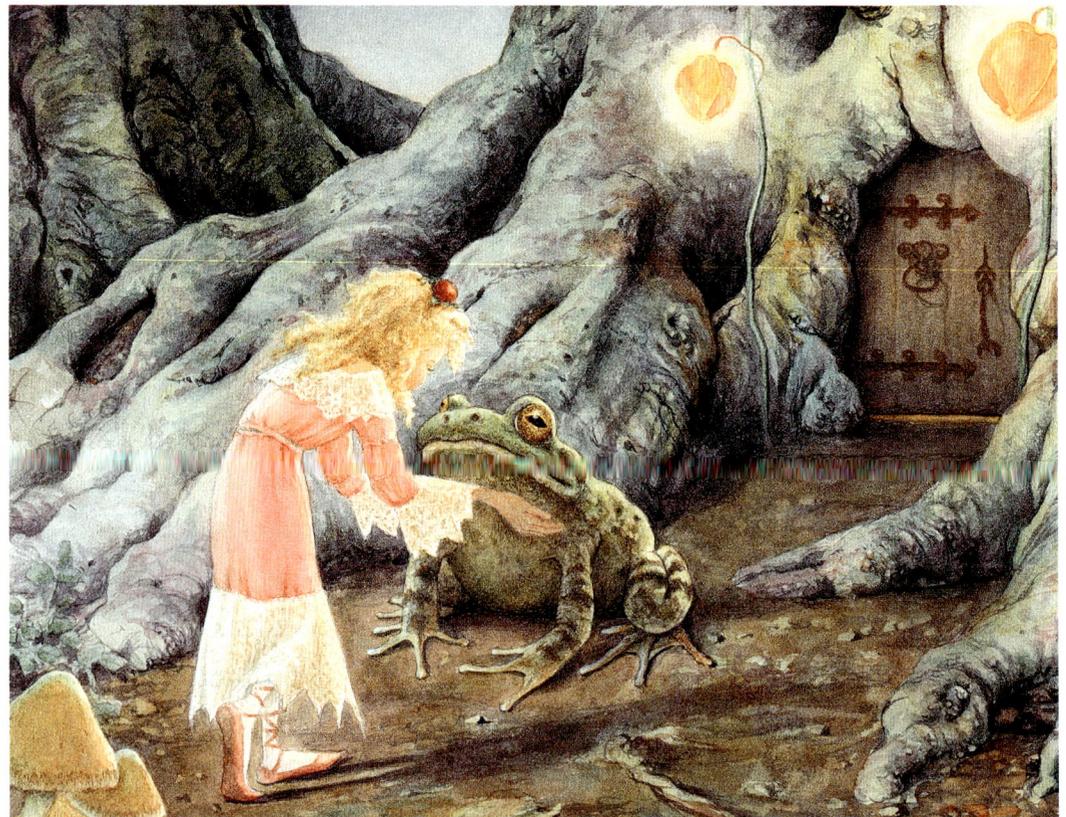

72

artist: **BROM**
art director: Richard Thomas
designer: Brom
client: White Wolf Publishing
title: White Wolf
medium: Oil
size: 17x21

71

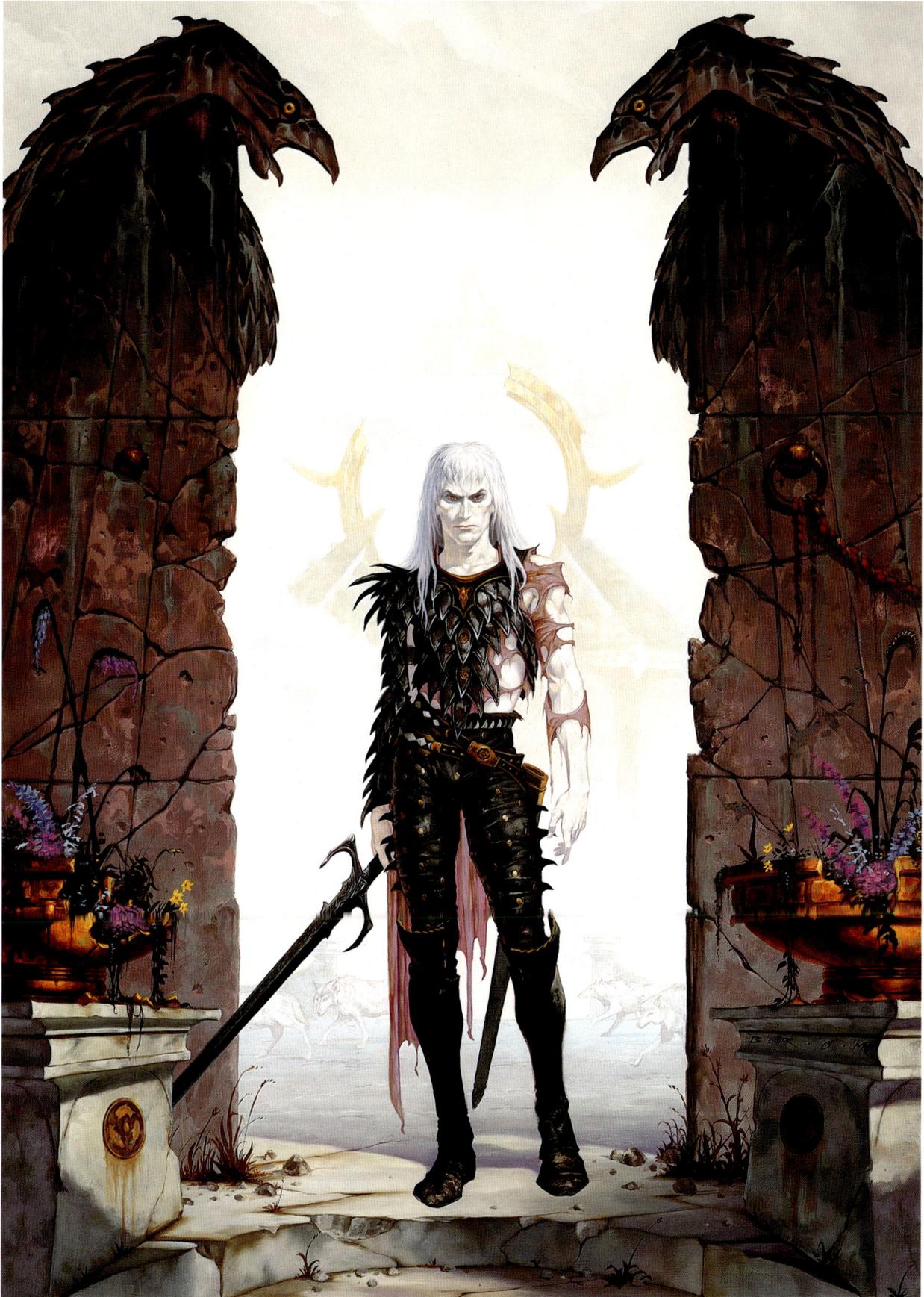

73

74

73
artist: **BROM**
art director: Kevin Siembieda
designer: Brom
client: Palladium Books
title: Crustacean
medium: Oil
size: 21x24

74
artist: **LES DORSCHEID**
art director: Jim Nelson
client: FASA Corporation
title: The Black Thorns
medium: Oil
size: 20x28

75
artist: **JIM BURNS**
art director: Betsy Wollheim &
 Sheila Gilbert
designer: Miles Long
client: DAW Books
title: Hostile Takeover—Profiteer
medium: Acrylic
size: 30x24

76
artist: **BRUCE JENSEN**
art director: Bruce Jensen
designer: Bruce Jensen
client: Byron Preiss Multimedia
title: Spiderman: The Venom Factor
medium: Acrylic
size: 14x23

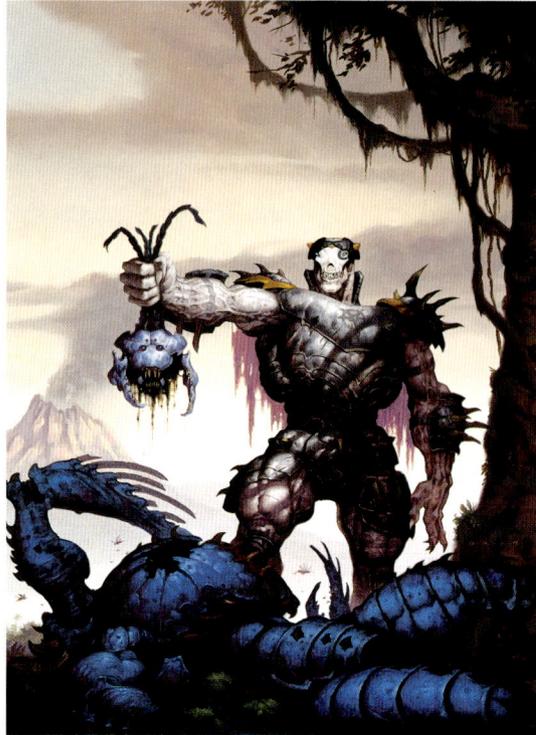
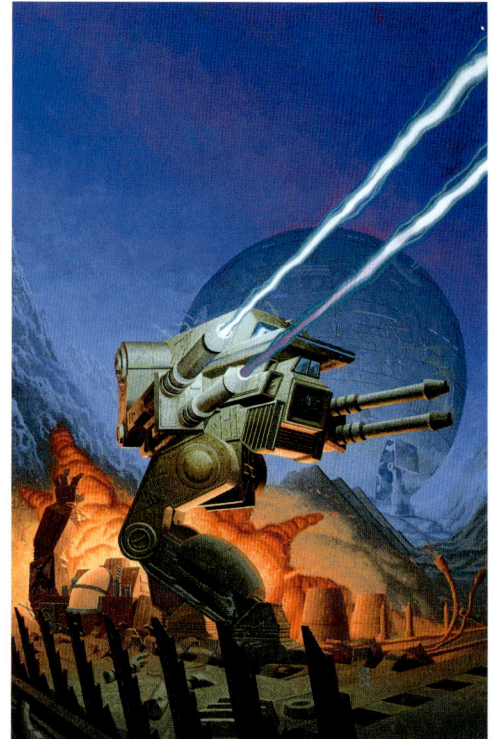
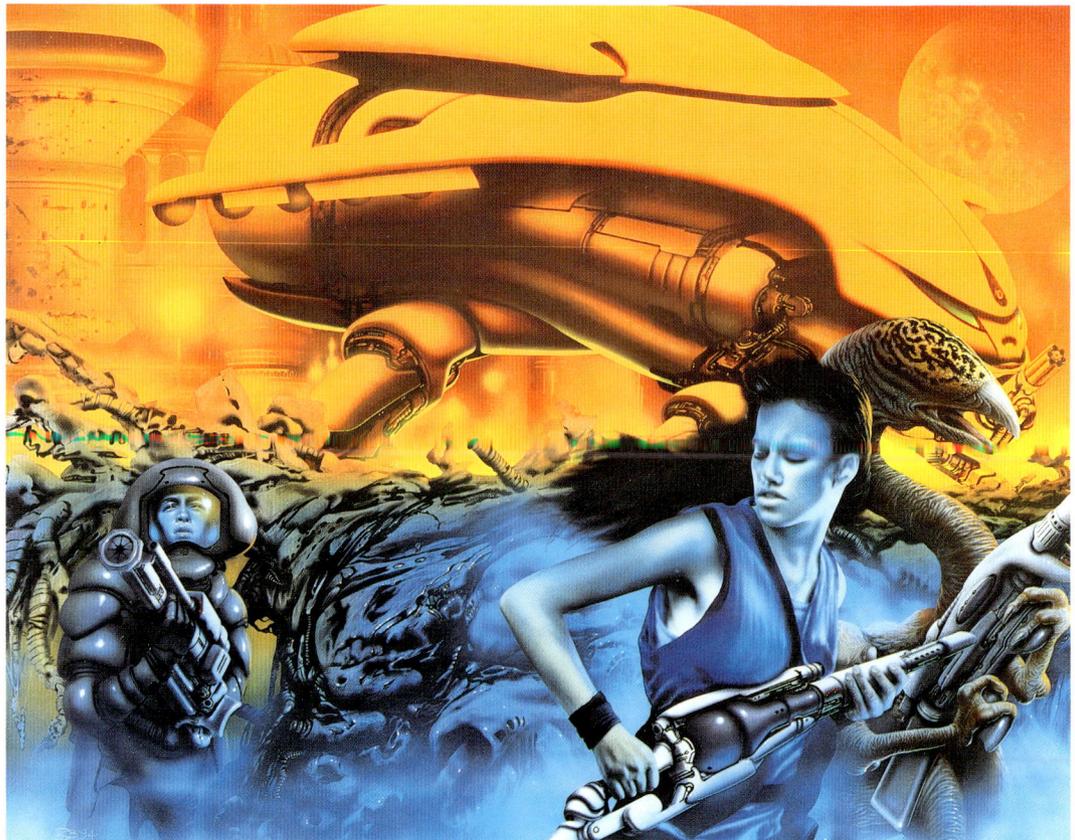

75

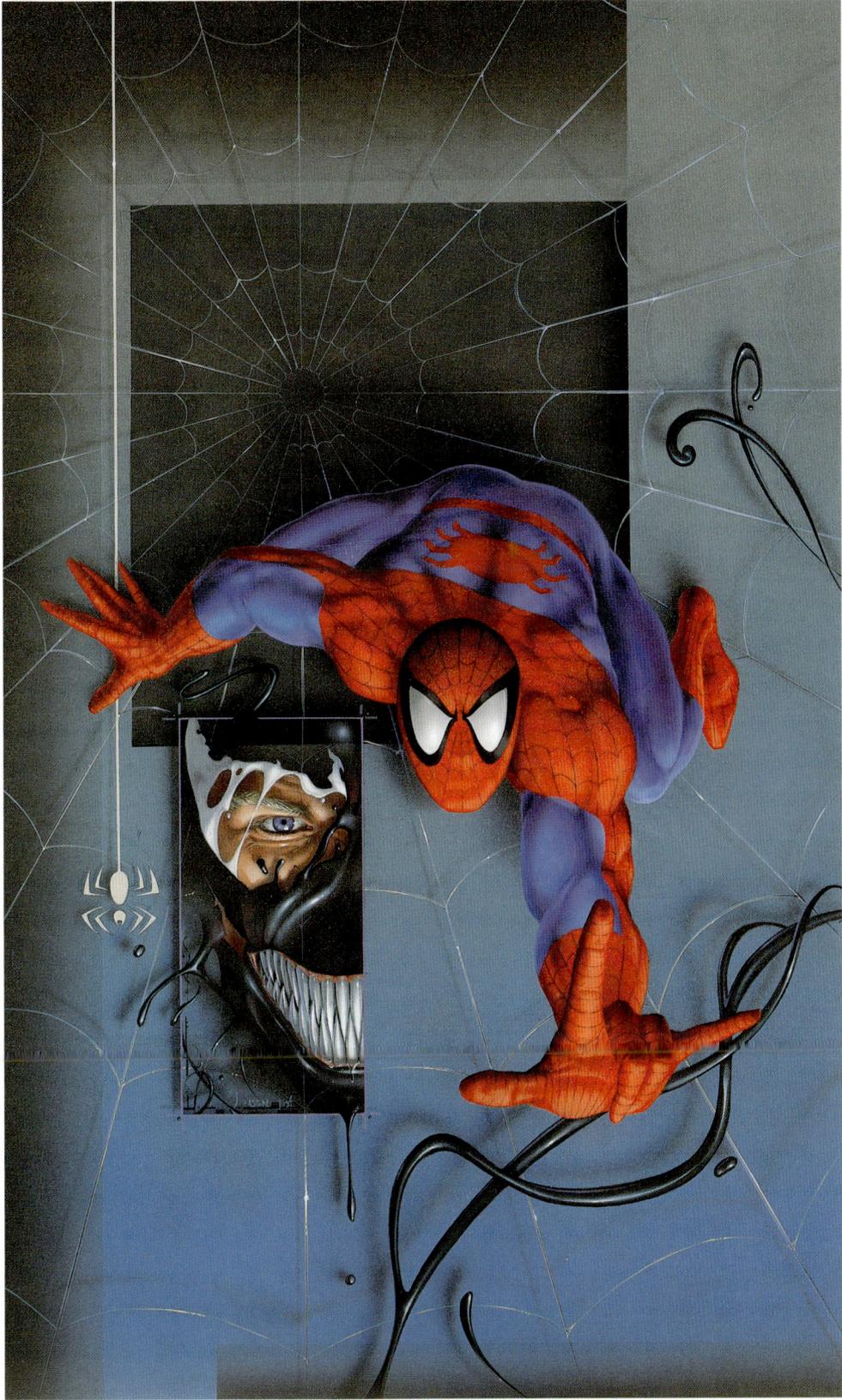

77
artist: **DANIEL HORNE**
art director: Tom Egner
designer: Stephen Bell
client: Avon Books
title: List of Seven
medium: Oil

78
artist: **GARY RUDDELL**
art director: Jamie Warren Youll
designer: Gary Ruddell
client: Bantam Books
title: Fall of Hyperion
medium: Oil on canvas
size: 21x29

79
artist: **DENNIS NOLAN**
art director: Atha Tehon
designer: Dennis Nolan
client: Dial Books
title: A Midsummer Night's Dream
medium: Watercolor
size: 12x15

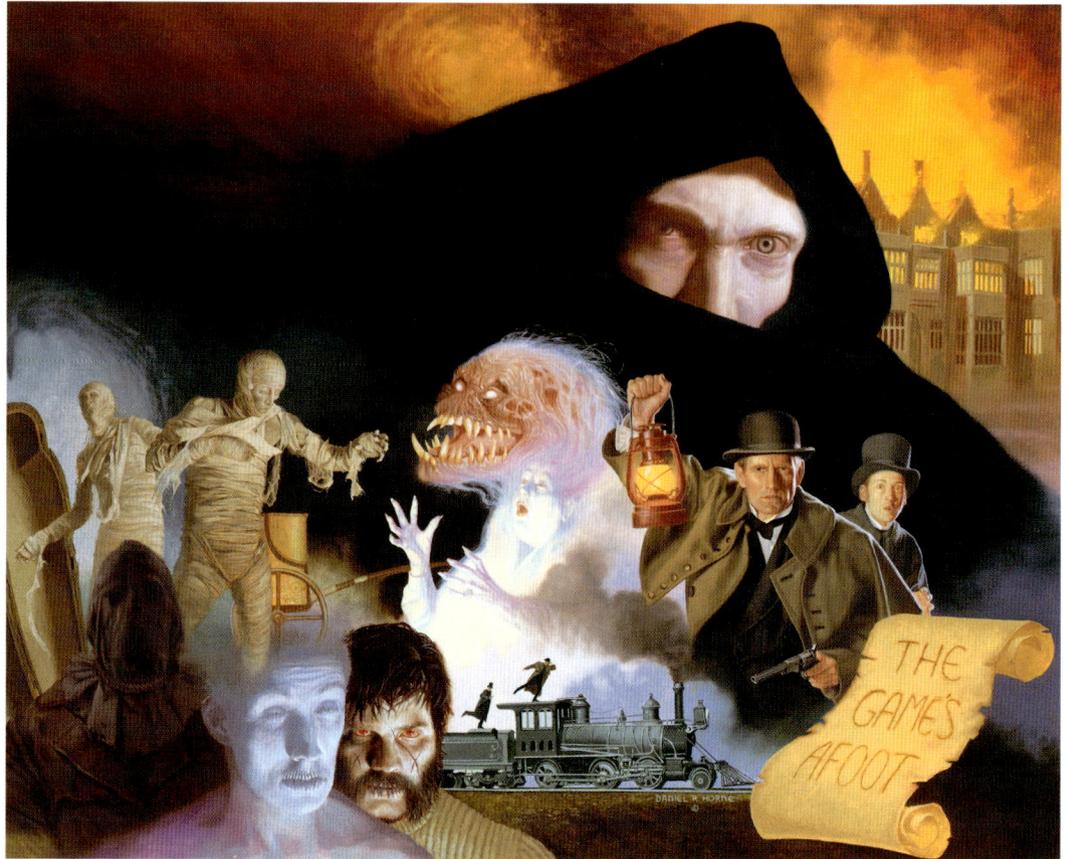

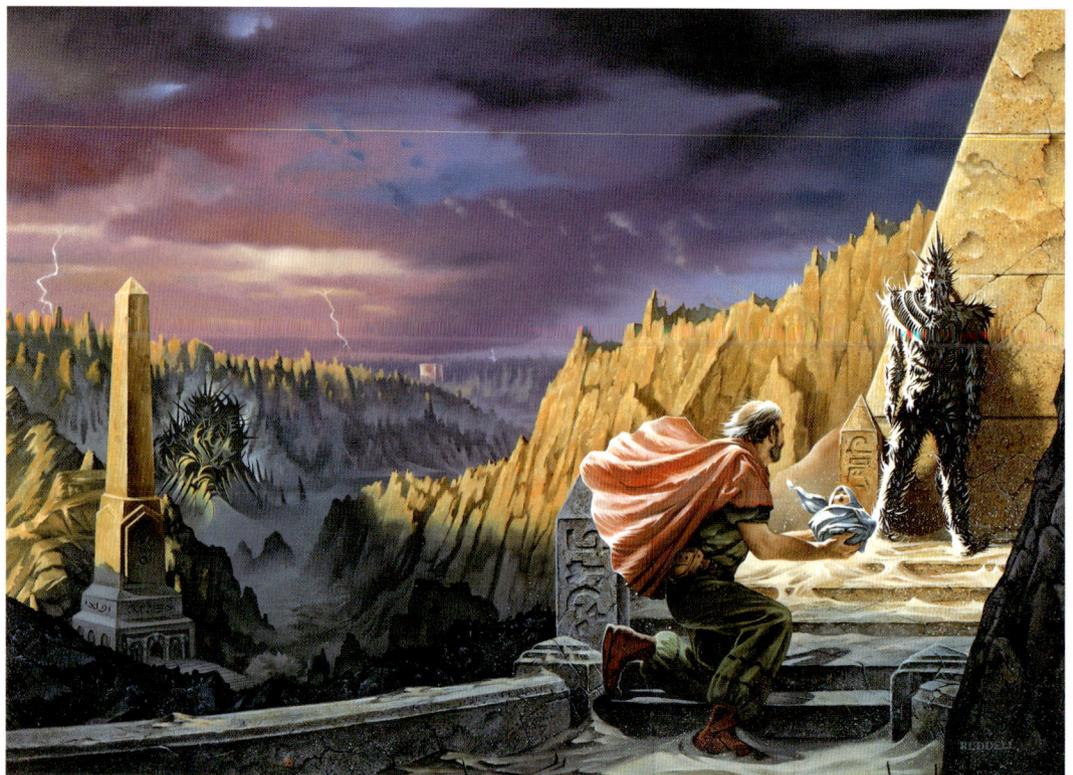

78

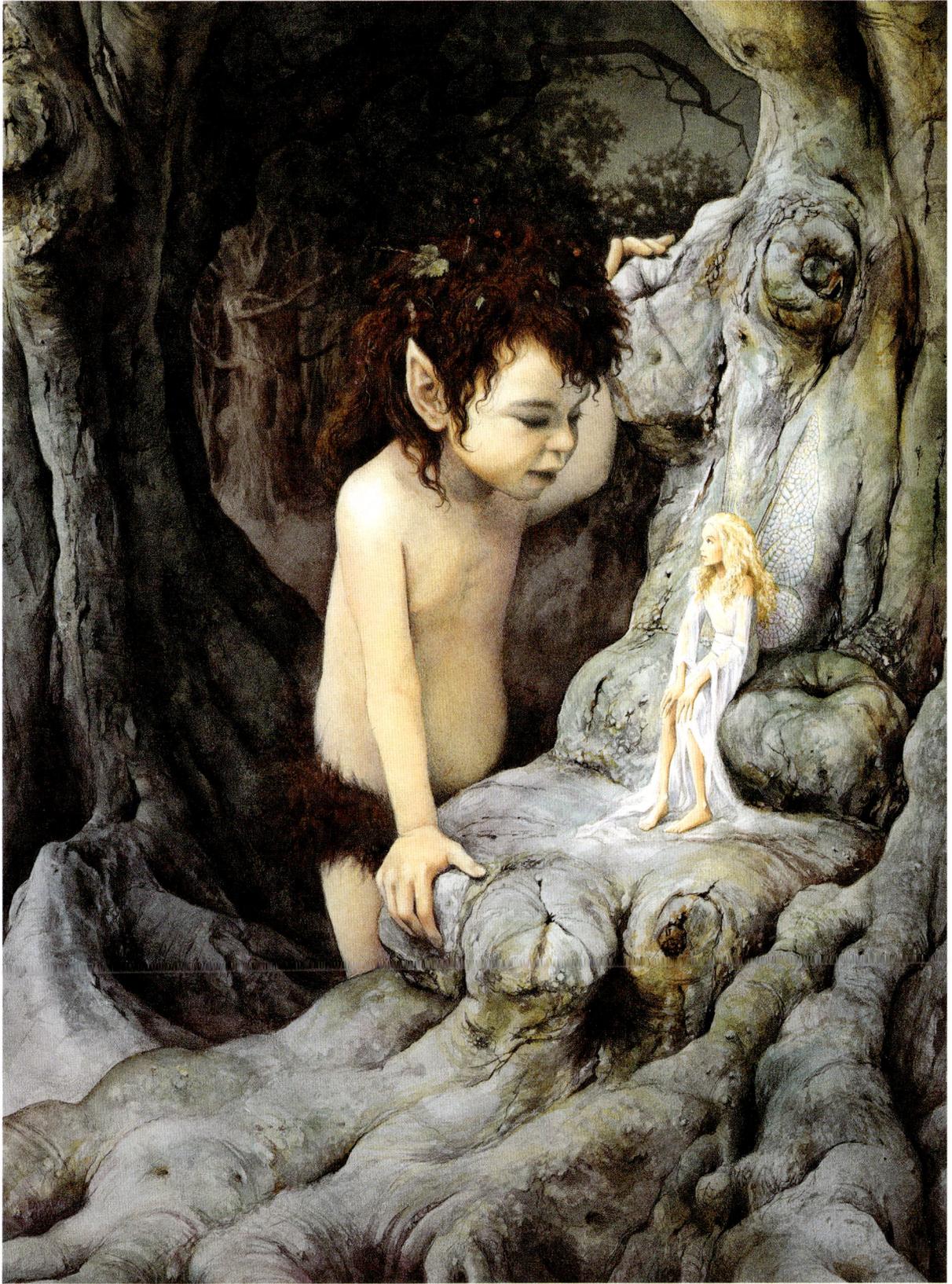

80

81

80
artist: **KEN MEYER JR.**
art director: Richard Thomas
client: White Wolf Games
title: Corpse Child
medium: Watercolor
size: 13x9

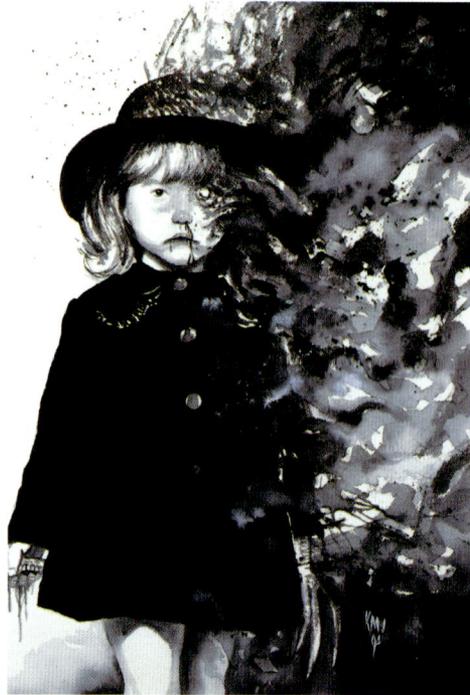

81
artist: **JOSEPH DeVITO**
art director: Janice Schaus
client: Zebra Books
title: Goblins
medium: Oil
size: 15x20

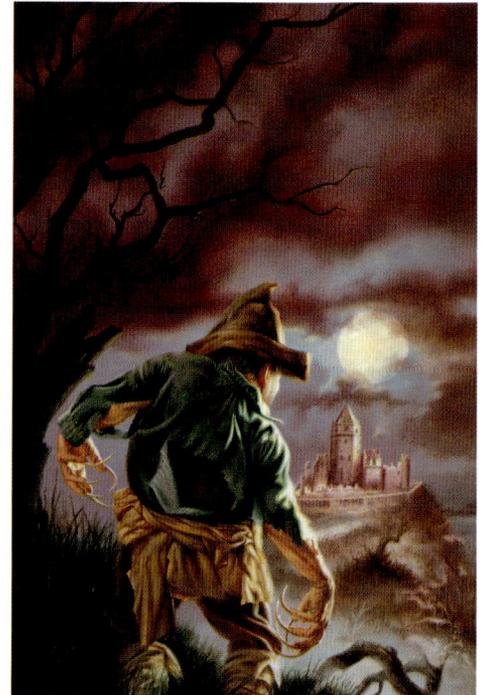

82
artist: **STEVE CRISP**
art director: David Grogan
client: Headline Books
title: All Hallow's Eve
medium: Acrylic & ink
size: 18x24

83
artist: **DORIAN VALLEJO**
art director: Tom Egner
designer: Nadine Badalaty
client: Avon Books
title: Warriors of Blood
 and Dreams
medium: Oil

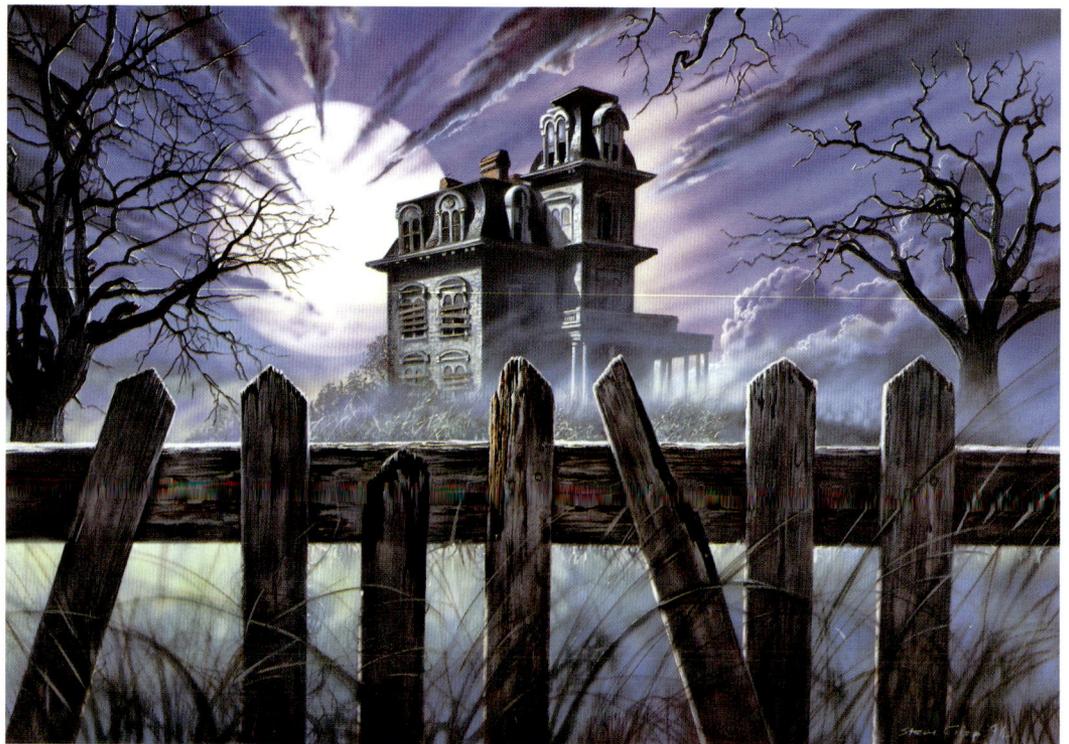

82

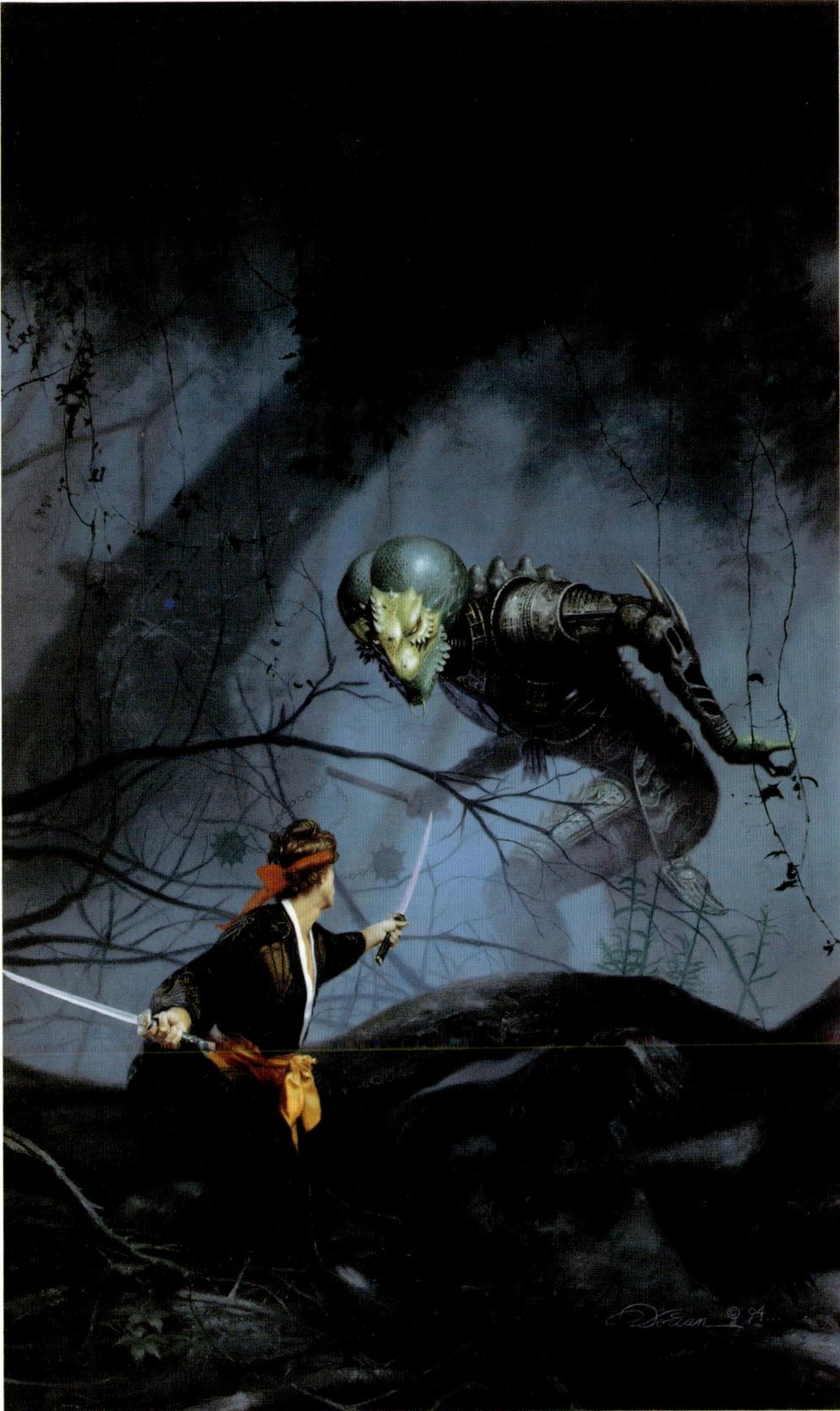

84
artist: **BRUCE JENSEN**
art director: Jamie Warren Youll
designer: Jamie Warren Youll
client: Bantam Books
title: The Diamond Age
medium: Mixed
size: 30x26

85
artist: **NICK STATHOPULOS**
client: Aphelion Publications
title: Blue Tyson
medium: Acrylic
size: 22x16.5

86
artist: **DAVID B. MATTINGLY**
art director: Jim Baen
designer: David B. Mattingly
client: Baen Books
title: The Armageddon Inheritance
medium: Acrylic
size: 14x22

87
artist: **GREG BRIDGES**
art director: Greg Bridges
client: FASA Corporation
title: Battletech Ship
medium: Oil & acrylic
size: 16x18

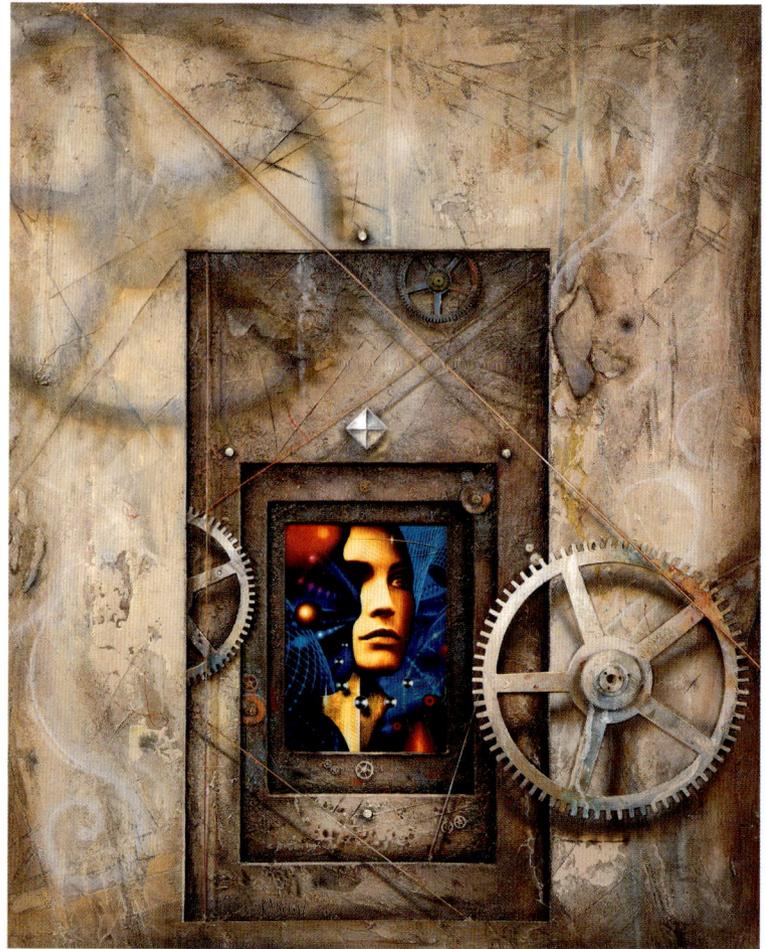
84

85

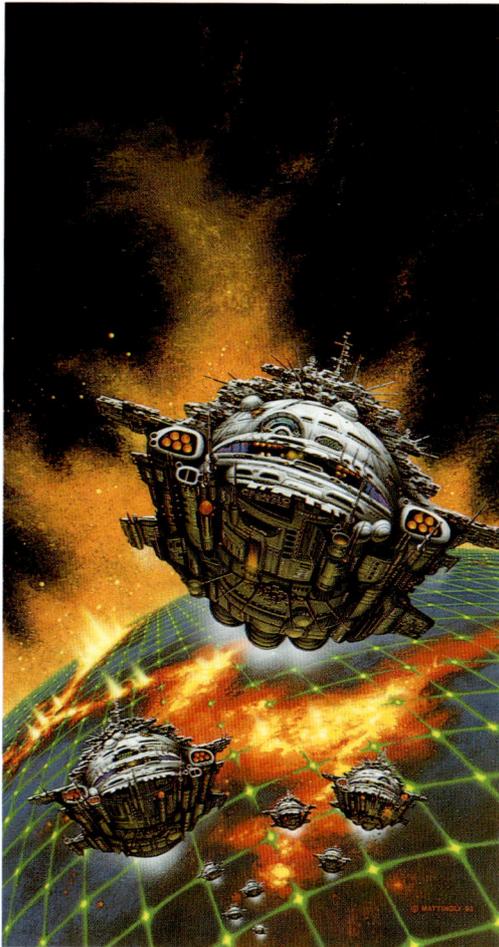

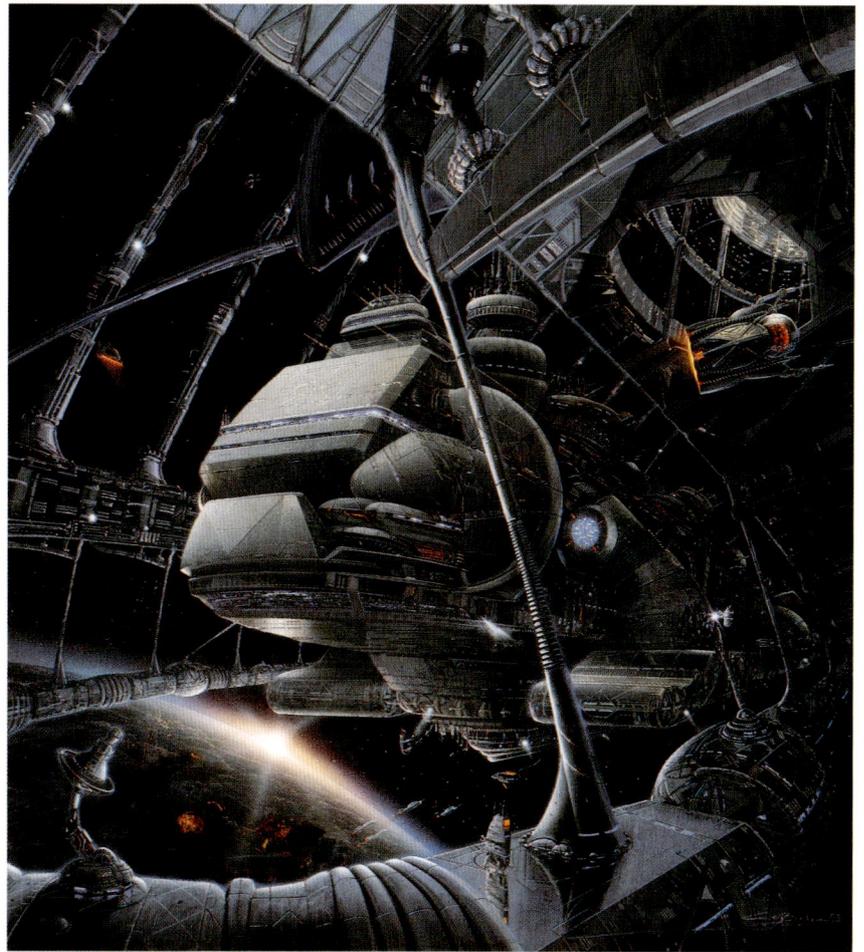

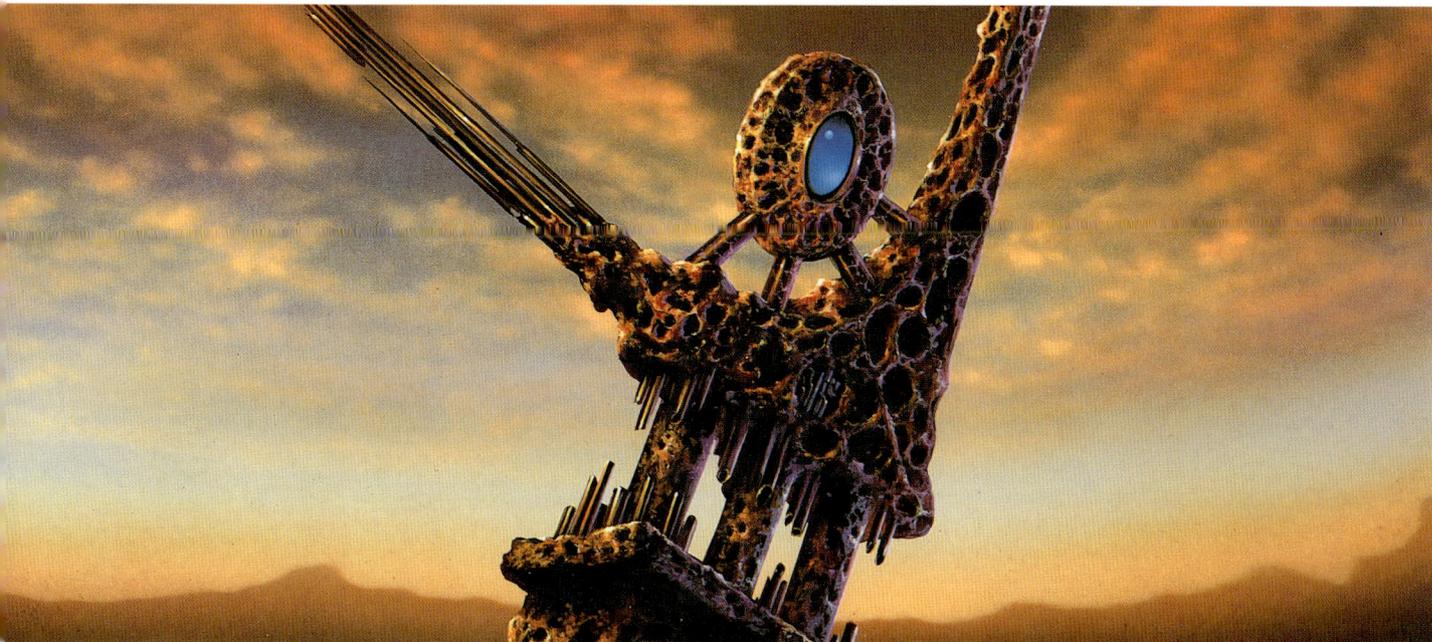

88

89

88

artist: **JODY LEE**
art director: Betsy Wollheim &
 Sheila Gilbert
client: DAW Books
title: The Book of Earth
medium: Acrylic
size: 13.5x20

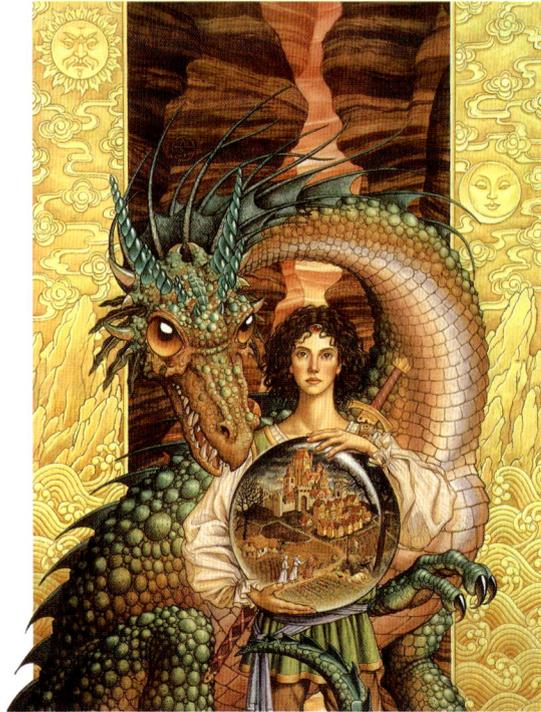

89

artist: **BRIAN FROUD**
art director: Brian Froud
designer: Brian Froud
client: Brian Froud
title: Hestia
medium: Acrylic & colored pencil
size: 16.5x22.5

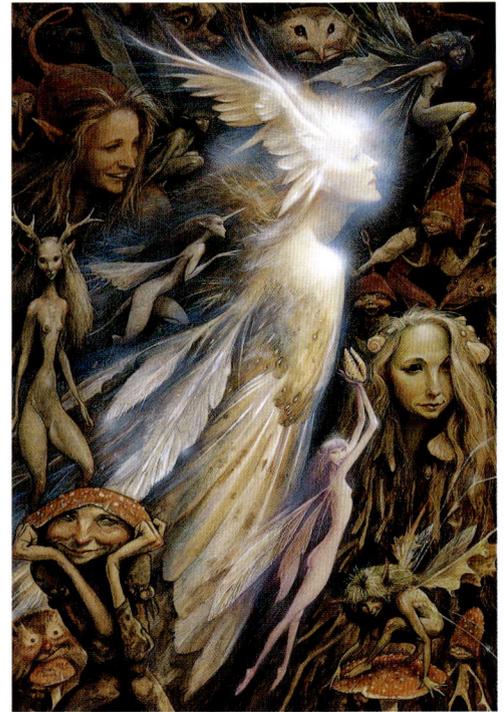

90

artist: **LAUREN MILLS &**
DENNIS NOLAN
art director: Sue Sherman &
 Susan Lu Bussard
designer: Lauren Mills &
 Dennis Nolan
client: Little, Brown
title: Fairy Wings
medium: Watercolor
size: 18x8

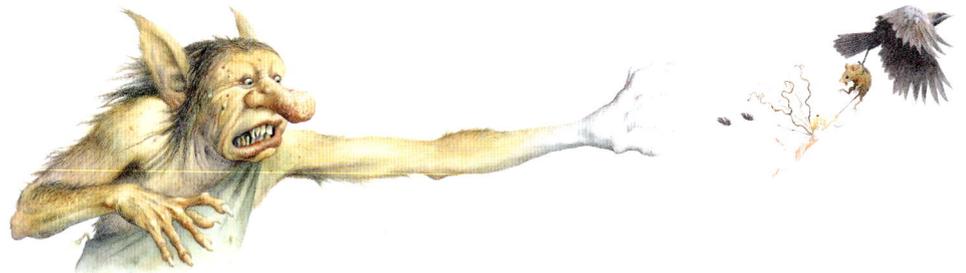

91

artist: **JAMES GURNEY**
art director: David Usher
client: The Greenwich Workshop &
 Turner Publishing
title: Small Wonder
medium: Oil on board
size: 15x15

90

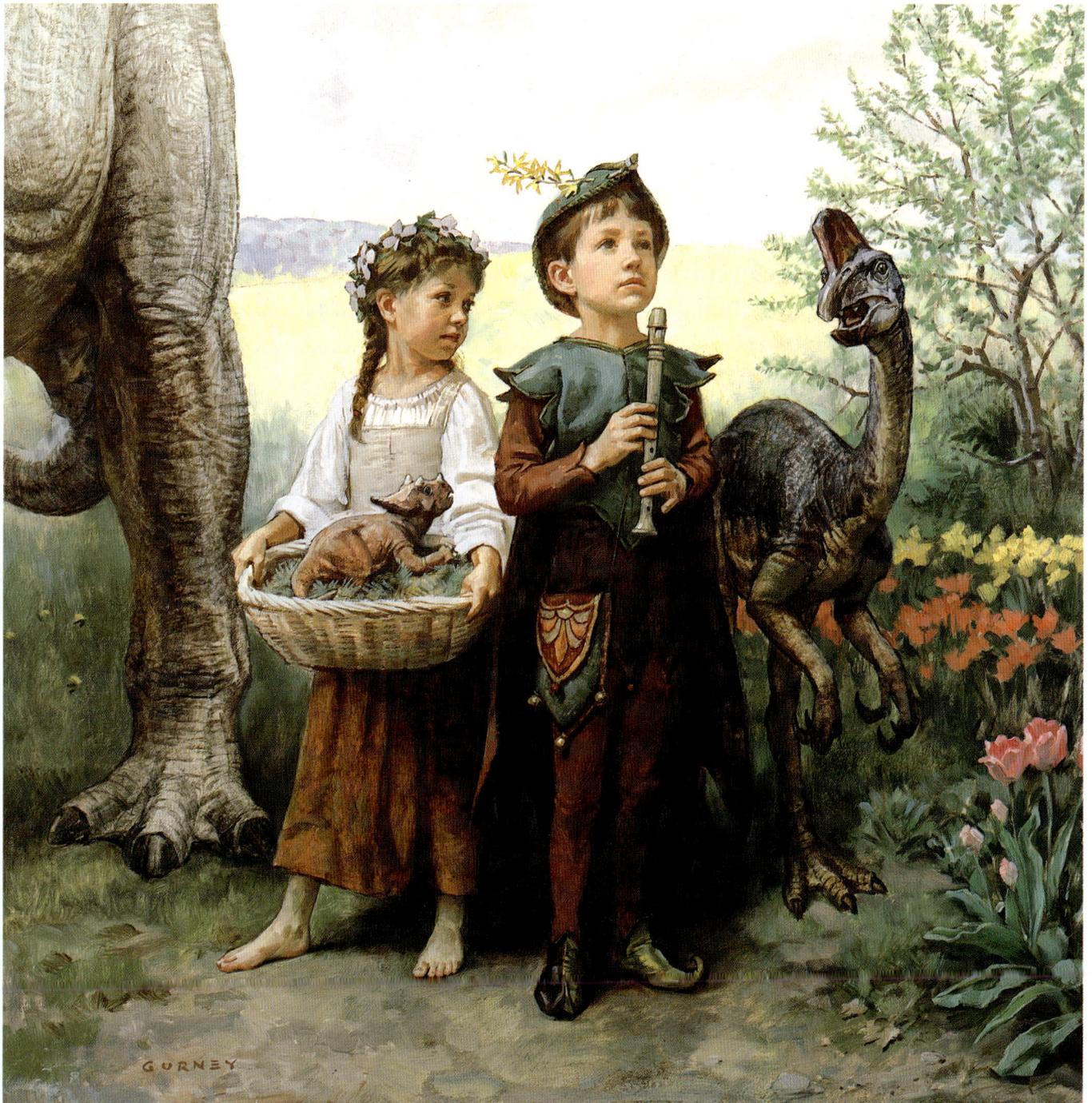

Small Wonder by James Gurney. © James Gurney, courtesy of the Greenwich Workshop, Inc.

92
artist: **JEFF LAUBENSTEIN**
art director: Mike Nystil
client: Pariah Press
title: Romeo Void
medium: Ink
size: 10x3

93
artist: **DAVID MATTINGLY**
art director: Ruth Ross
designer: David Mattingly
client: Del Rey Books
title: Star Trek: Log 6
medium: Acrylic

94
artist: **KEVIN LONG**
art director: Kevin Siembieda
designer: Kevin Long
client: Palladium Books
title: Mindwerks
medium: Acrylics
size: 16x21

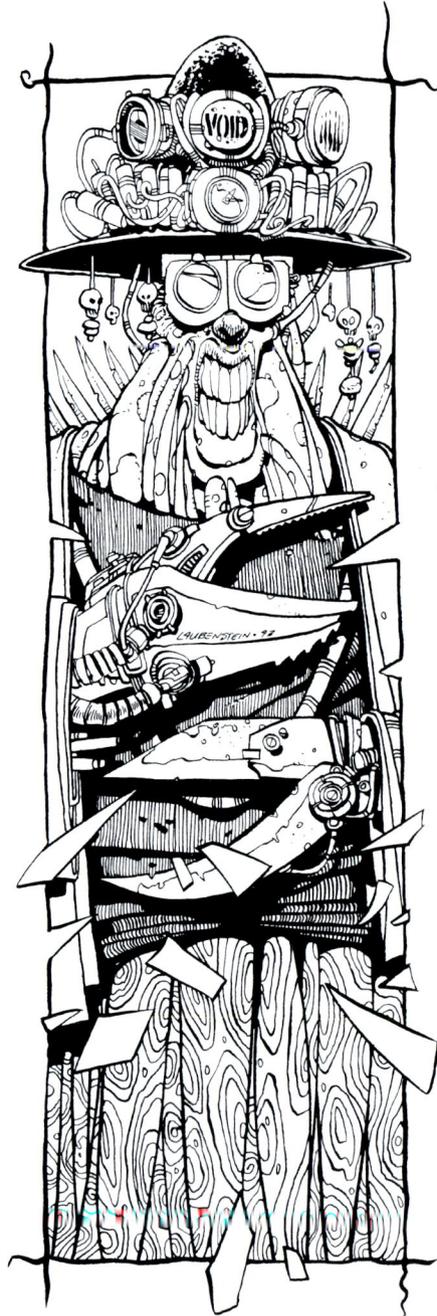

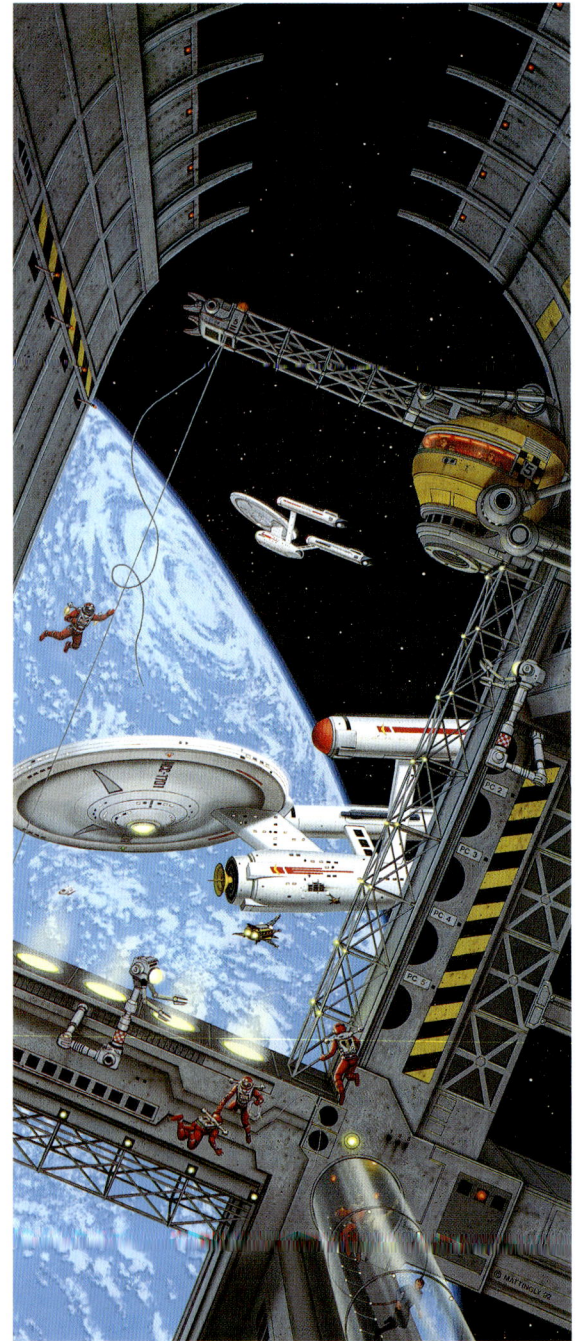

95
artist: **BARCLAY SHAW**
art director: Jim Baen
client: Baen Books
title: Marked Cards
medium: Oil on acrylic
size: 28x21

96
artist: **JAMES GURNEY**
art director: David Usher
client: The Greenwich Workshop &
Turner Publishing
title: Surrounded by Tyrannosaurs
from *The World Beneath*
medium: Oil on board
size: 29x14

97
artist: **DONATO GIANCOLA**
client: Penguin/ROC
title: Construct of Time
medium: Oil on paper
size: 18x30

96

Surrounded by Tyrannosaurs by James Gurney. © James Gurney, courtesy of the Greenwich Workshop, Inc.

138
artist: **SCOTT MACK**
art director: Scott Mack
client: Hallmark Cards, Inc.
medium: Oil
size: 5x7

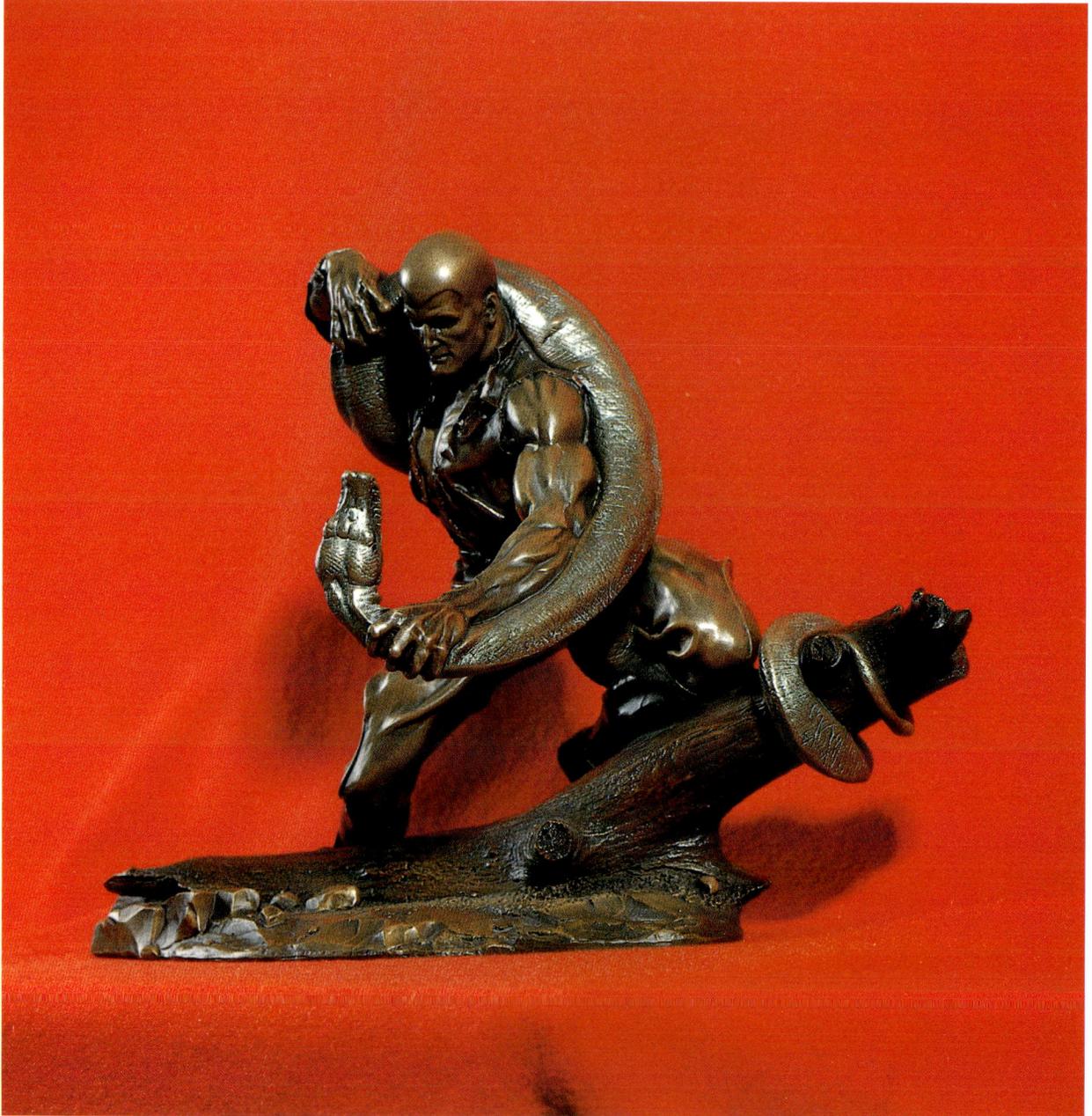

139
artist: **JOSEPH DeVITO**
art director: Bob Chapman
designer: Joseph DeVito
client: Graphitti Designs
title: Doc Savage and the Giant Python
medium: Cold cast bronze
size: 14.5x9.5

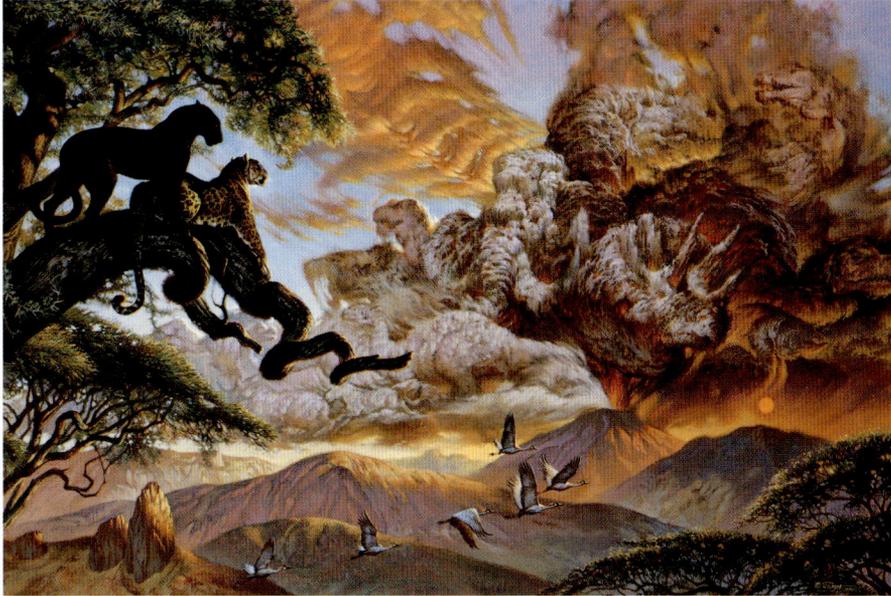

140
artist: **EZRA TUCKER**
art director: Ezra Tucker *client:* Ezra Tucker *title:* Return of the Titans
medium: Acrylic on board *size:* 30x20

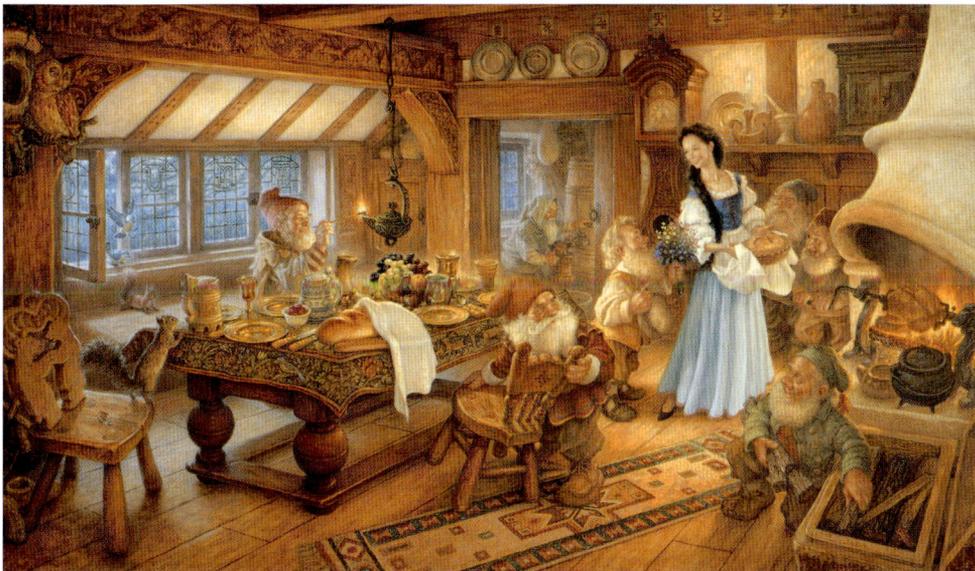

141
artist: **SCOTT GUSTAFSON**
art director: David Usher & Linda Abbett *client:* The Greenwich Workshop
title: Snow White and the Seven Dwarfs *medium:* Oil
size: 48x28

142
artist: **NICK GAETANO**
art director: James Conrad
designer: Nick Gaetano
title: Nurturing the Earth
medium: Acrylic
size: 18x25

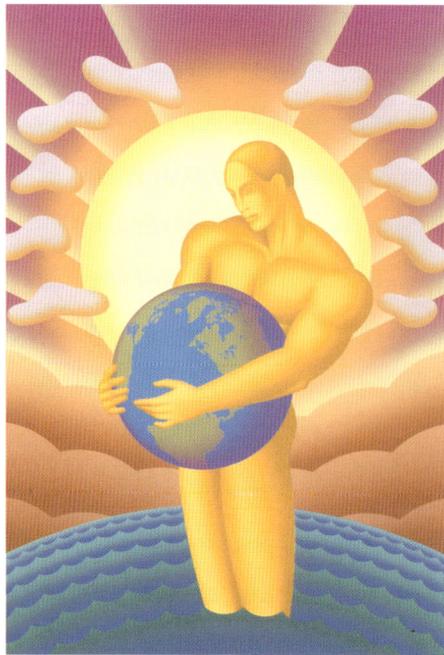

143
artist: **GREGORY MANCHESS**
art director: Gregory Manchess
title: Snow Angel
medium: Oil
size: 26x35

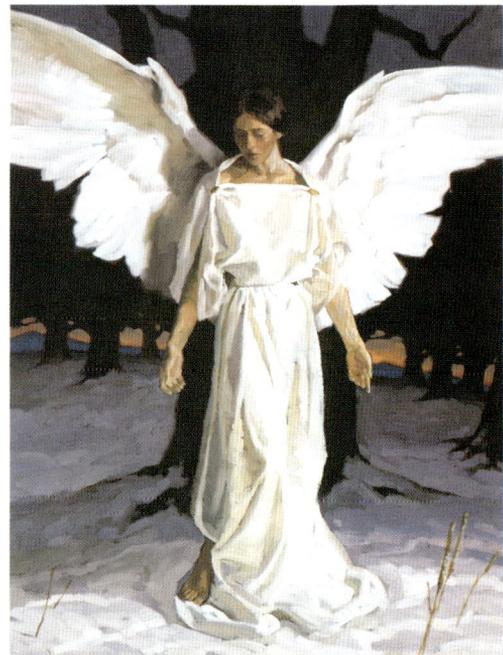

144
artist: **JOHN MATSON**
art director: C. Henry Schulte
designer: John Matson
client: Companion Games
title: Marine
medium: Mixed
size: 7x5

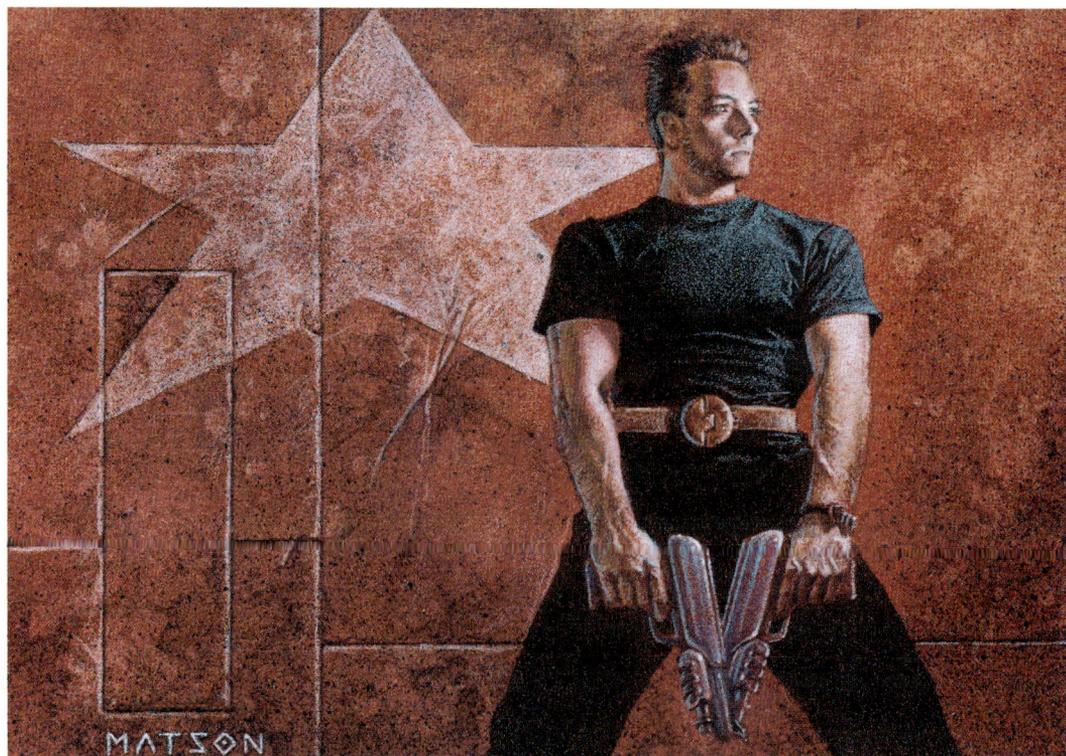

145
artist: **STU SUCHIT**
art director: Kate Anthony
client: The News & Observer
medium: Watercolor, oil,
 and collage
size: 11x14

142

143

144

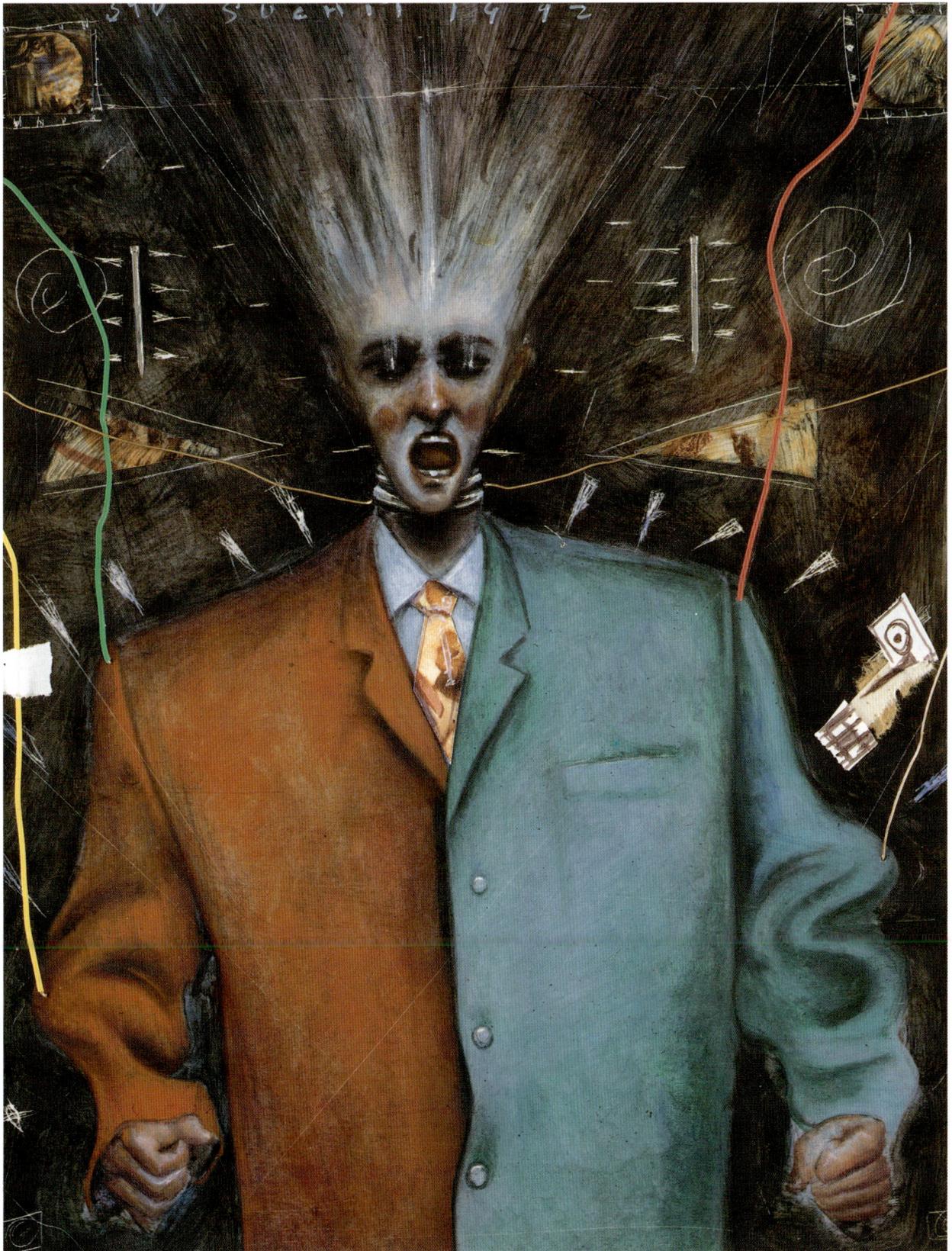

146
artist: **R. WARD SHIPMAN**
client: R. Ward Shipman
title: Canyon of the Ages
medium: Acrylic & airbrush
size: 24x37

147
artist: **JOHN ZELEZNIK**
client: Zeleznik Illustration
title: Alabaster Wings
medium: Acrylic
size: 12.5x32.5

148
artist: **RICHARD BOBER**
art director: B. Klugerman
designer: Richard Bober
client: Elfin Light Press
title: Mad Tea Party
medium: Oil & acrylic
size: 60x72

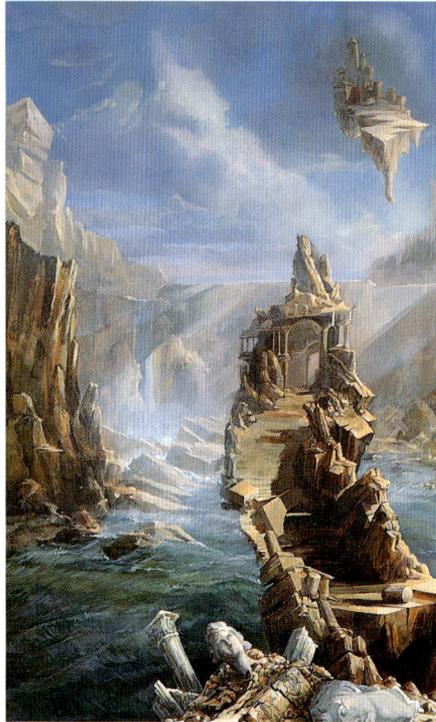

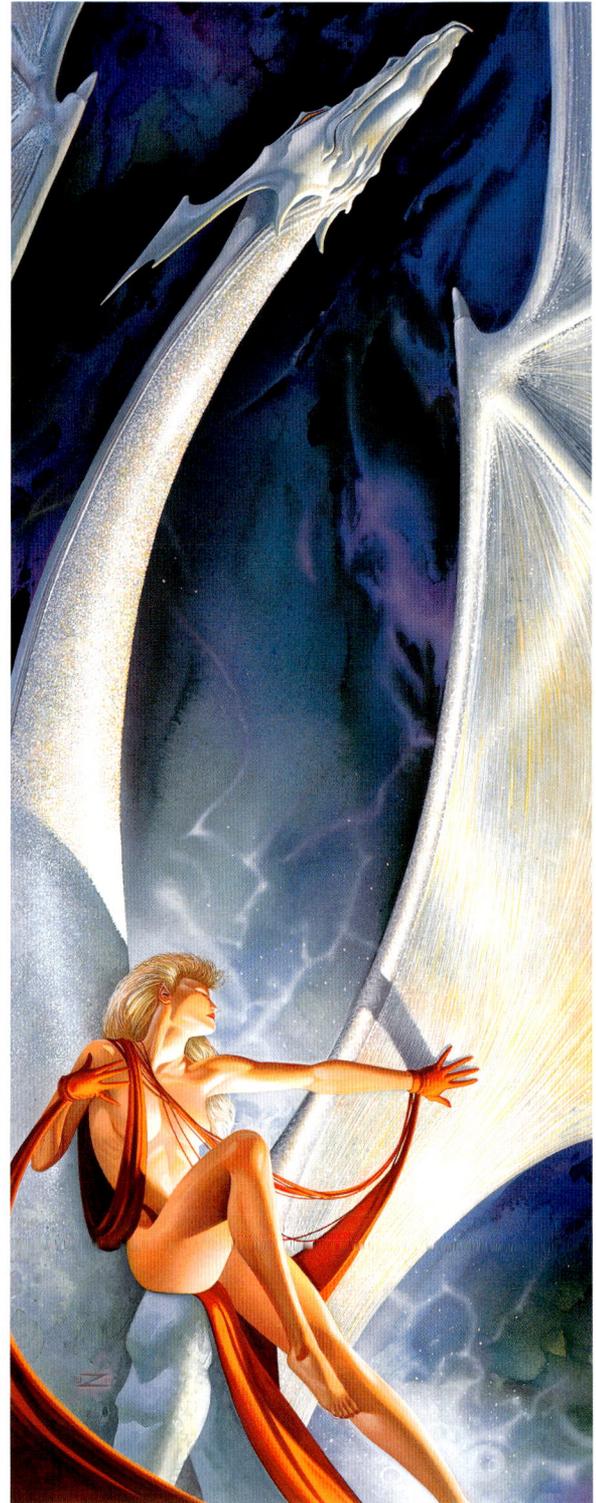

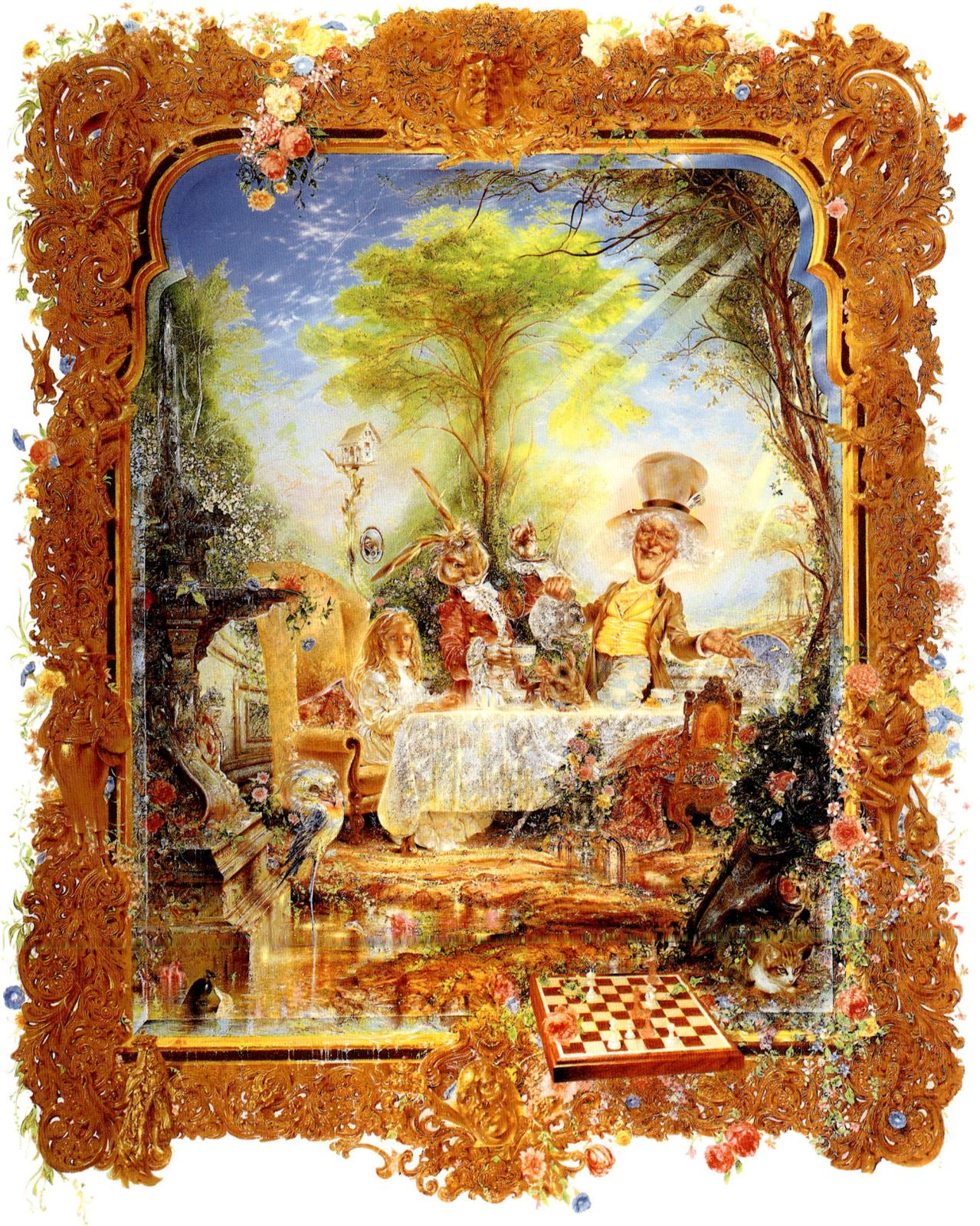

149

150

149
artist: **PATRICK HO**
art director: Patrick Ho
designer: Patrick Ho
client: Self Promotion
medium: Acrylic
size: 6.5x8.5

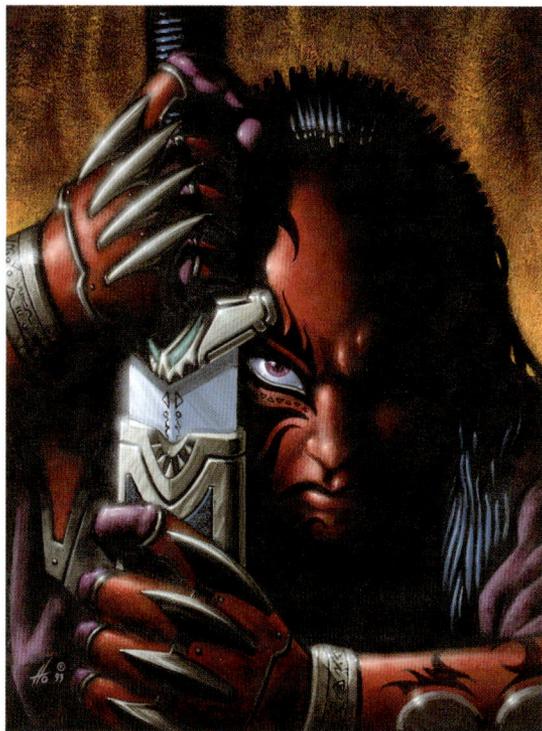

150
artist: **DAVE KRAMER**
art director: Dave Kramer
designer: Dave Kramer
title: Arabian Nights
medium: Mixed
size: 16x24

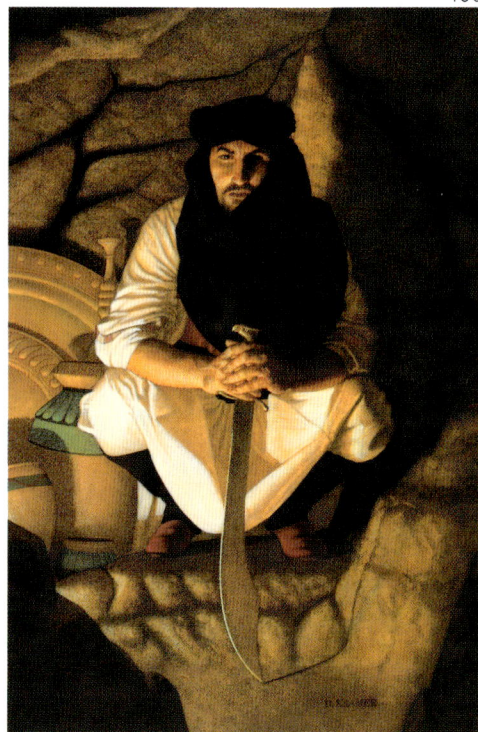

151
artist: **EZRA TUCKER**
art director: Pat Armstrong &
 Tommy Steele
designer: Ezra Tucker
client: Capitol Records
title: Lightning Strikes Twice
medium: Acrylic on board
size: 30x20

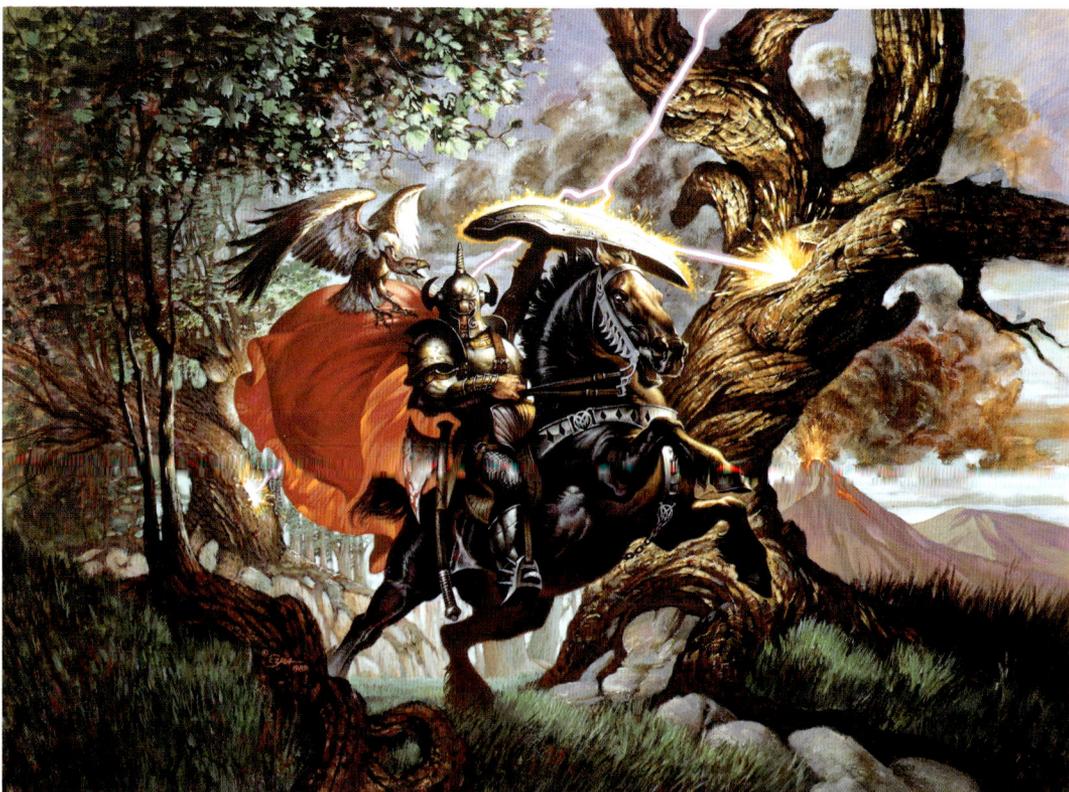

152
artist: **JOSEPH DeVITO**
art director: Dan Raspler
client: DC Comics
title: Lobo: Smokin'
medium: Oil
size: 16x24

151

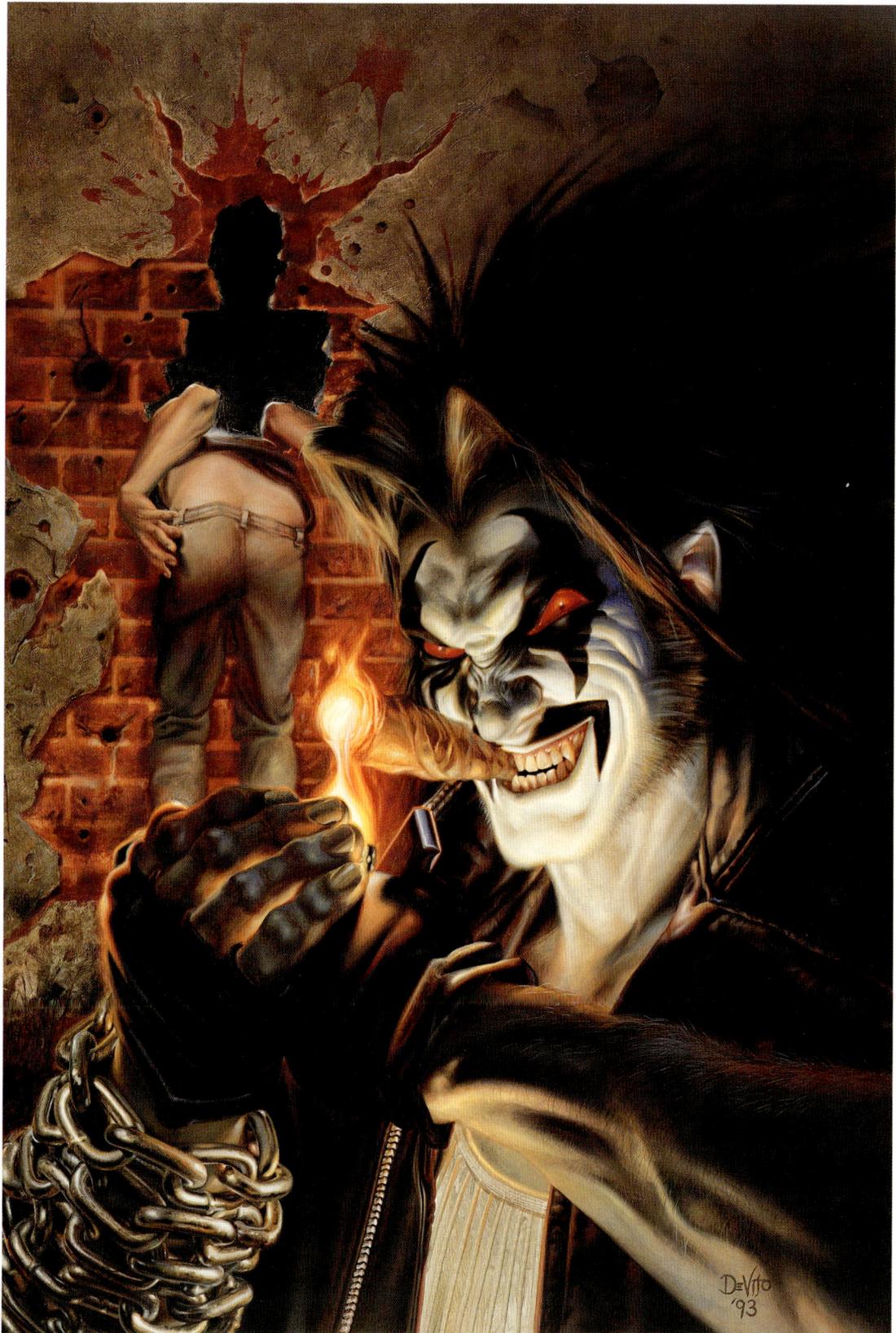

153

153
artist: **GARY W. MONTALBANO**
art director: Gary W. Montalbano
client: Sarka Ltd.
medium: Acrylic
size: 34x21

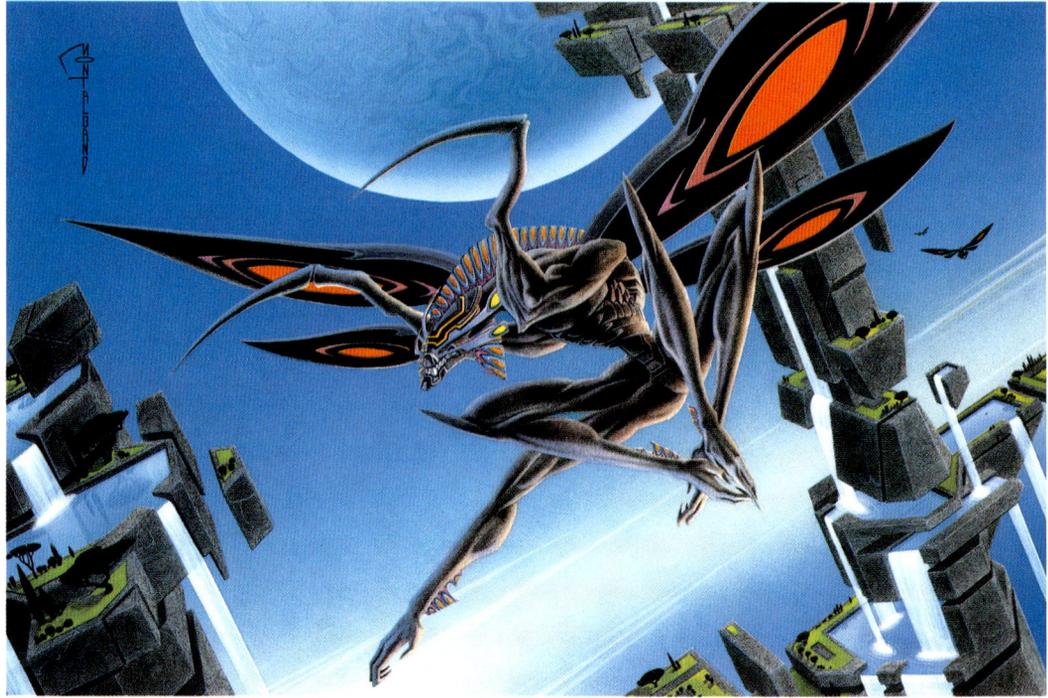

154
artist: **EZRA TUCKER**
art director: Ezra Tucker
designer: Ezra Tucker
client: Ezra Tucker
title: Majestic Sunrise
medium: Oil on canvas
size: 28x18

155
artist: **MICHAEL WHELAN**
art director: Joe Pearson &
 Vartan Kurjian
client: Virgin Records/MCA
title: Back Into Hell
medium: Acrylics on
 watercolor board
size: 20x30

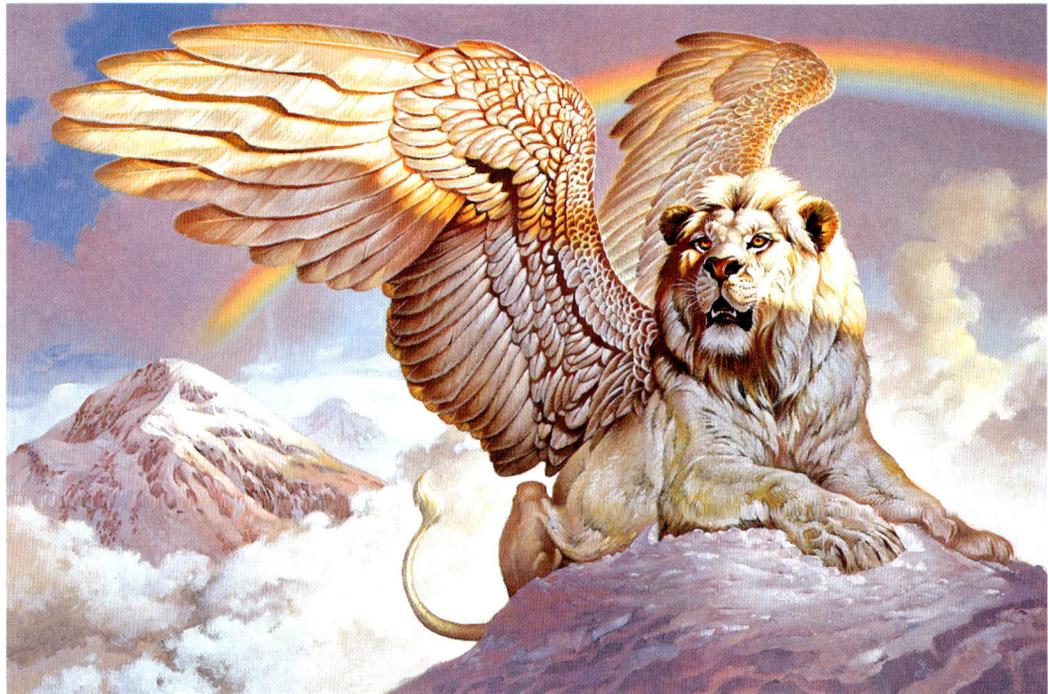

154

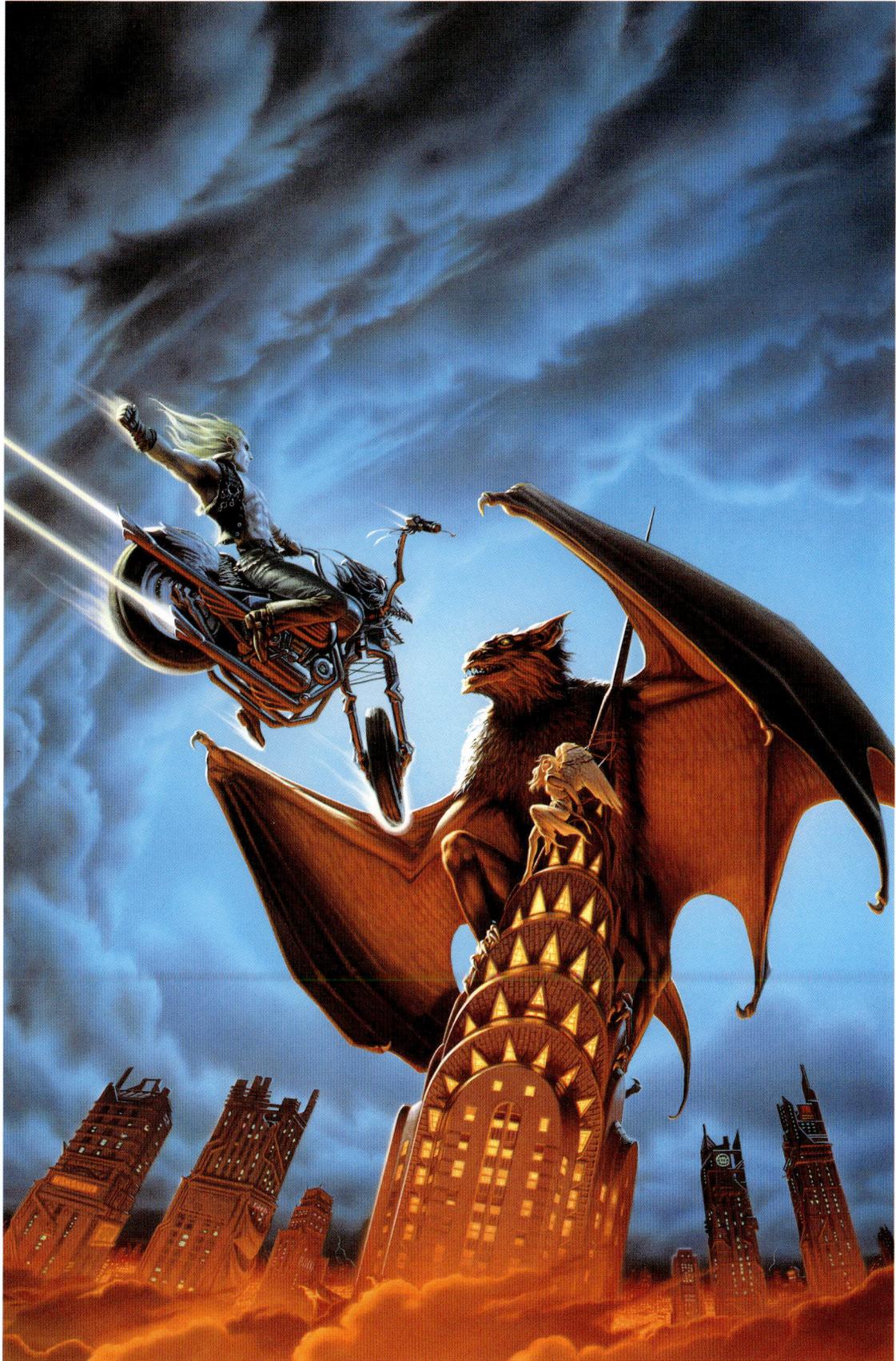

156

157

156
artist: **JOE CHIODO**
art director: Kevin Fitzpatrick
client: Topps Trading Cards
title: Vampirella
medium: Colored inks on
 cell vinyl
size: 7x9

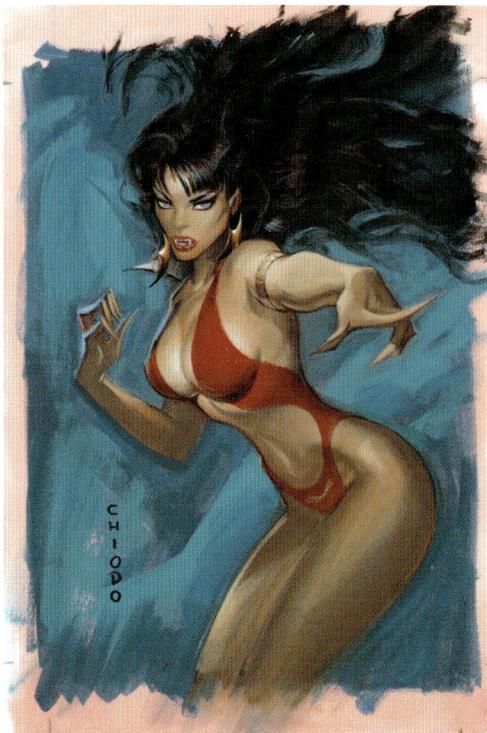

157
artist: **KEVIN KRENECK**
art director: Kevin Kreneck
designer: Kevin Kreneck
client: Fort Worth Star Telegram
title: Ethnic Cleansing
medium: Pen & ink
size: 5x6.75

158
artist: **PATRICK HO**
art director: Patrick Ho
designer: Patrick Ho
client: Self promotion
title: Level 13
medium: Acrylic
size: 28x16

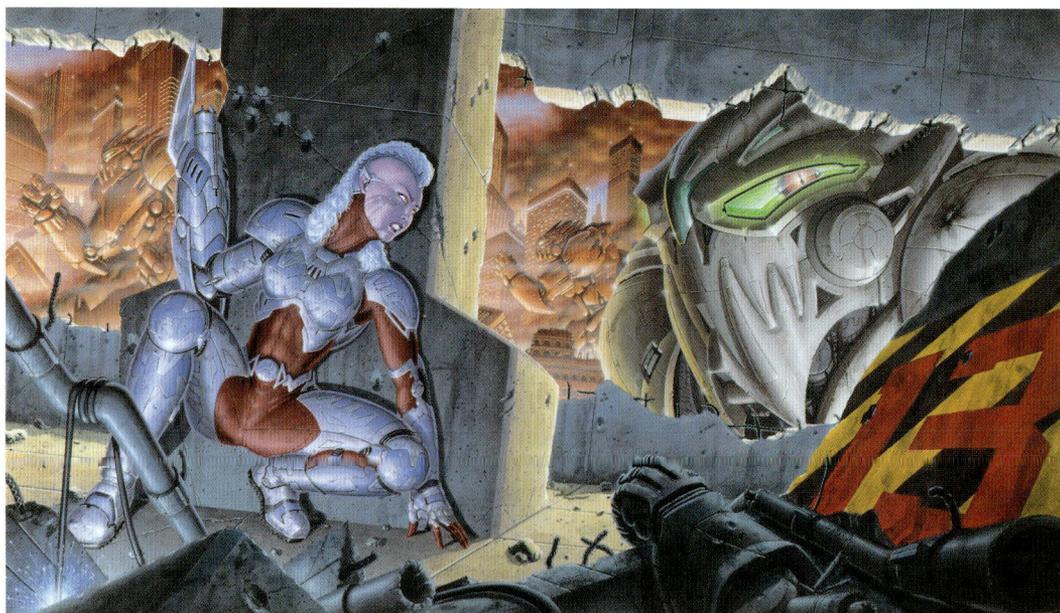

159
artist: **LUIS ROYO**
art director: Luis Royo
designer: Luis Royo
client: Luis Royo
title: The Neverending Sparkle
medium: Acrylic
size: 14x28

158

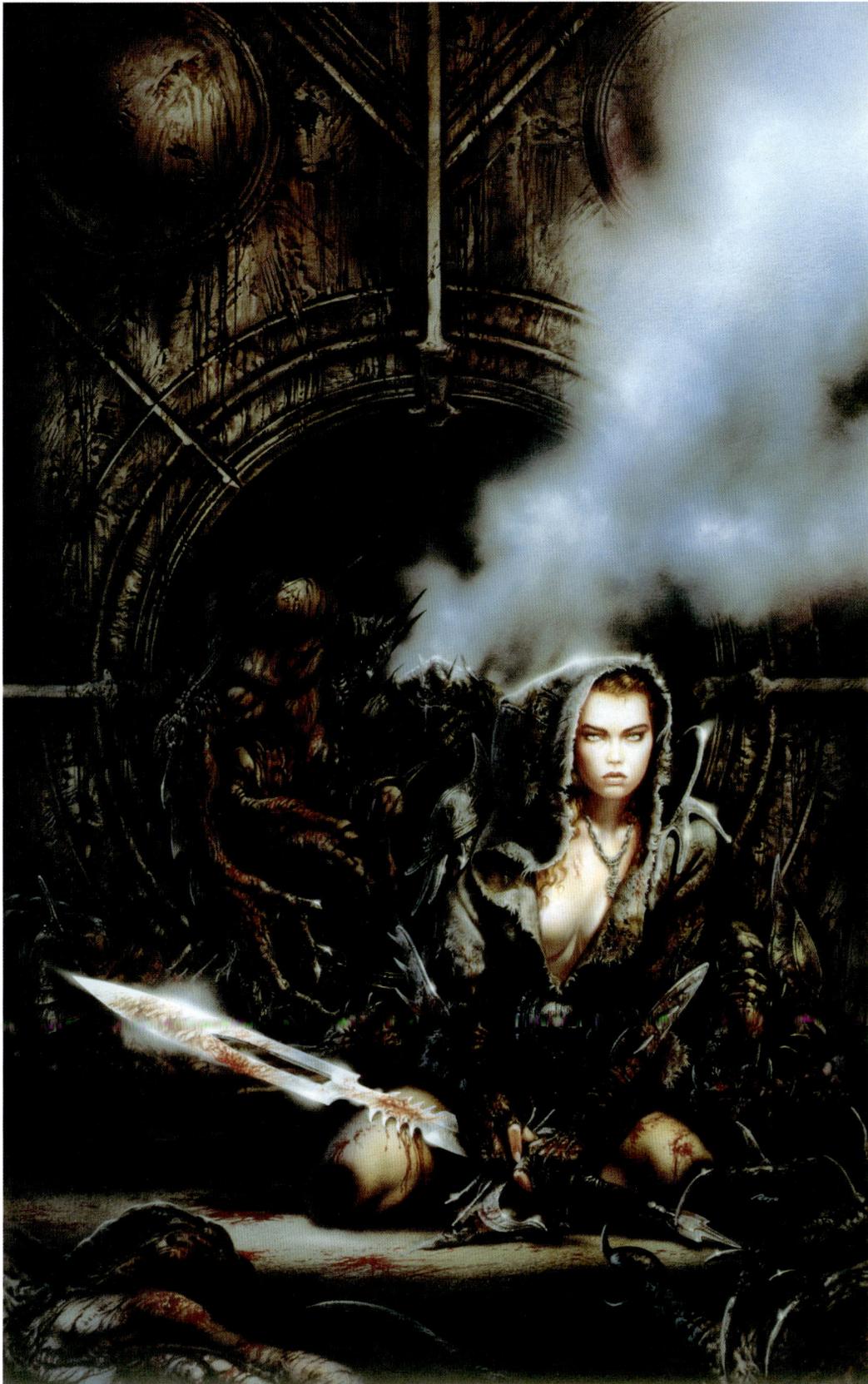

160

161

160

artist: **JAY JOHNSON**
art director: Jay Johnson
client: Self promotion
title: The Story Teller
medium: Scratchboard
size: 6.5x10

161

artist: **RAY LAGO**
art director: Gary Gerani
client: Topps Trading Cards
title: Bad Doings in Chinatown
medium: Watercolor
size: 10.5x13.5

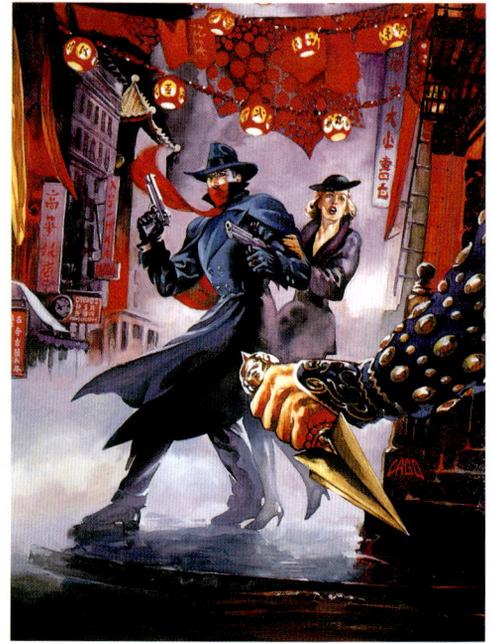

162

artist: **SERGIO MARTINEZ**
art director: Barry Klugerman &
 James Warhola
designer: James Warhola
client: Elfin Light Press
title: Moonlight Serenade
medium: Watercolor &
 colored pencil
size: 14x22

163

artist: **STEPHEN HICKMAN**
art director: David Usher
client: The Greenwich Workshop
title: The Archers
medium: Oil
size: 22x50

162

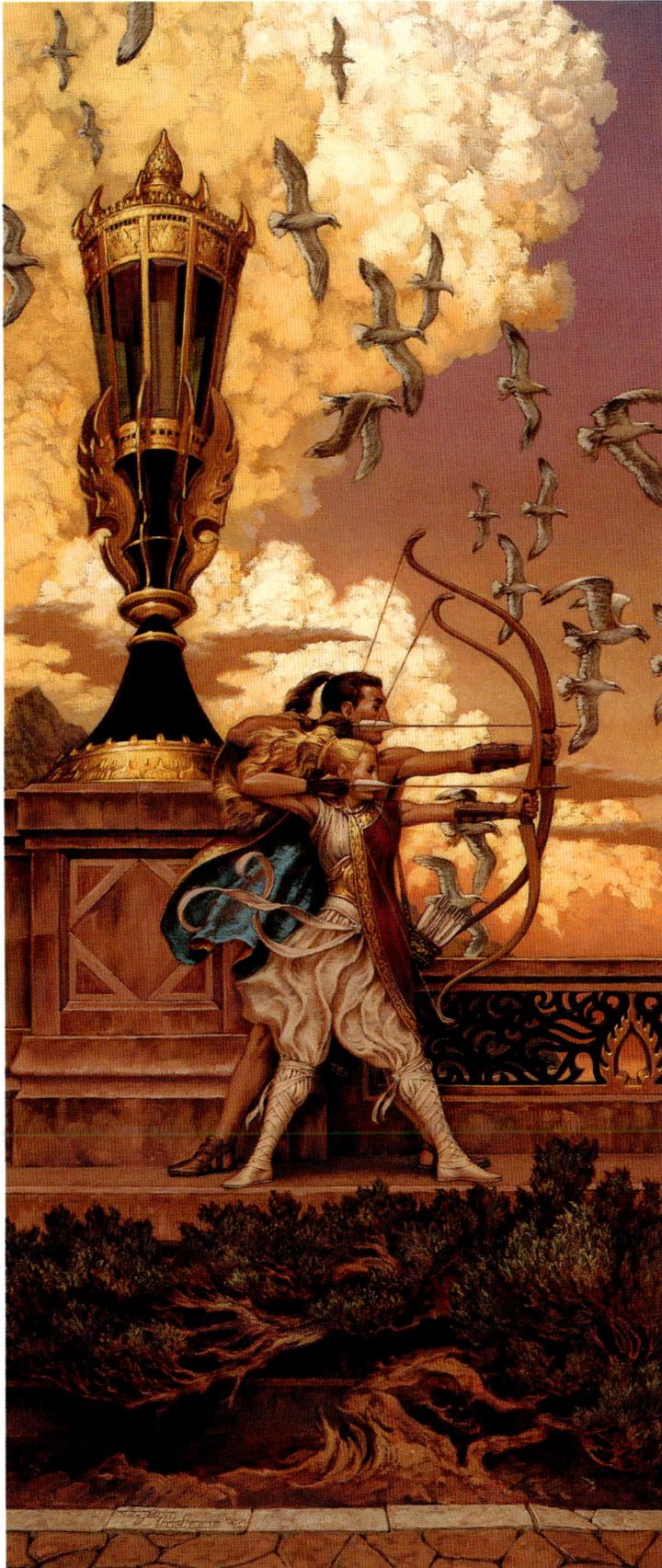

164

165

164
artist: **MARK BISCHEL**
art director: Dea Marks
designer: Tim Lunch
client: Perfection Learning
title: The Ramayana
medium: Acrylic
size: 17x19

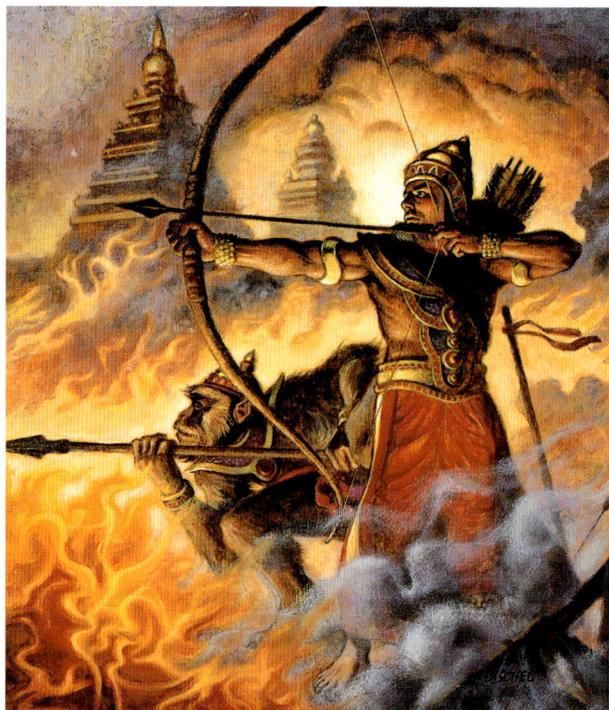

165
artist: **PETER W. CLARKE**
art director: Peter W. Clarke
client: Self promotion
title: Love
medium: Pen & ink
size: 10x19.25

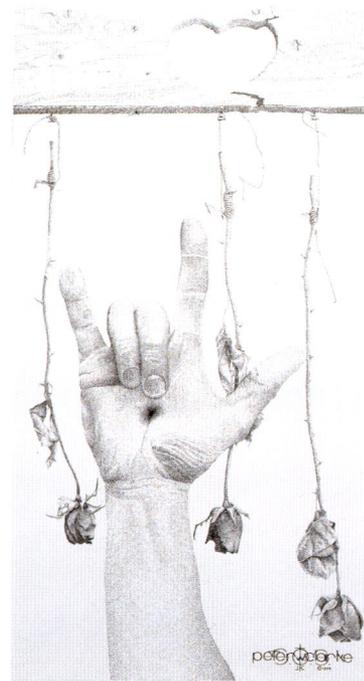

166
artist: **RICK BERRY**
art director: Lou Stathis
designer: Rick Berry
client: DC Comics/Vertigo
title: Little Wing
medium: Digital
size: 5x8

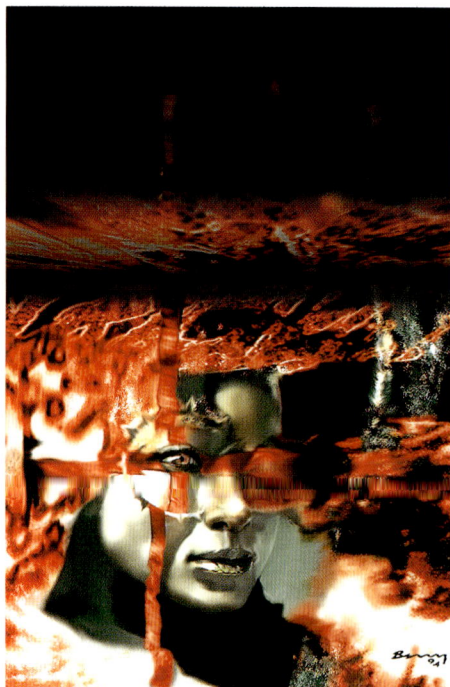

167
artist: **REAL MUSGRAVE**
client: self promotion
title: Financial Wizard
medium: Watercolor &
 colored pencil
size: 14x18

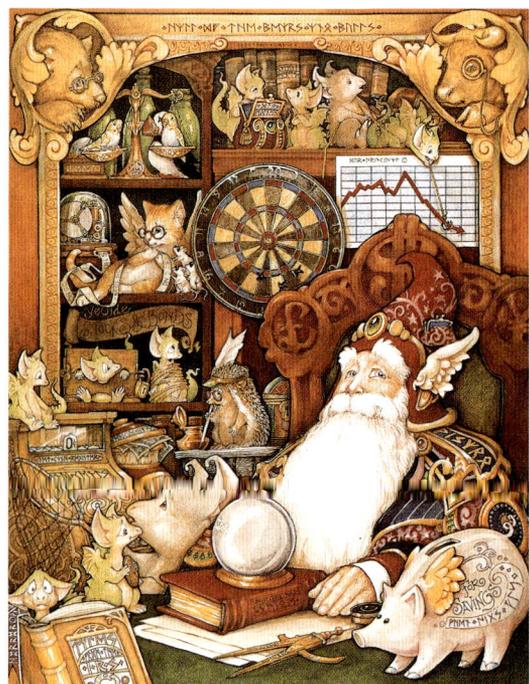

168
artist: **DAVID DORMAN**
art director: Sean Taggart
designer: David Dorman
client: DC Comics
title: Batman: Saga of the
 Dark Knight
medium: Oil on gessoed
 illustration board
size: 24x30

166

167

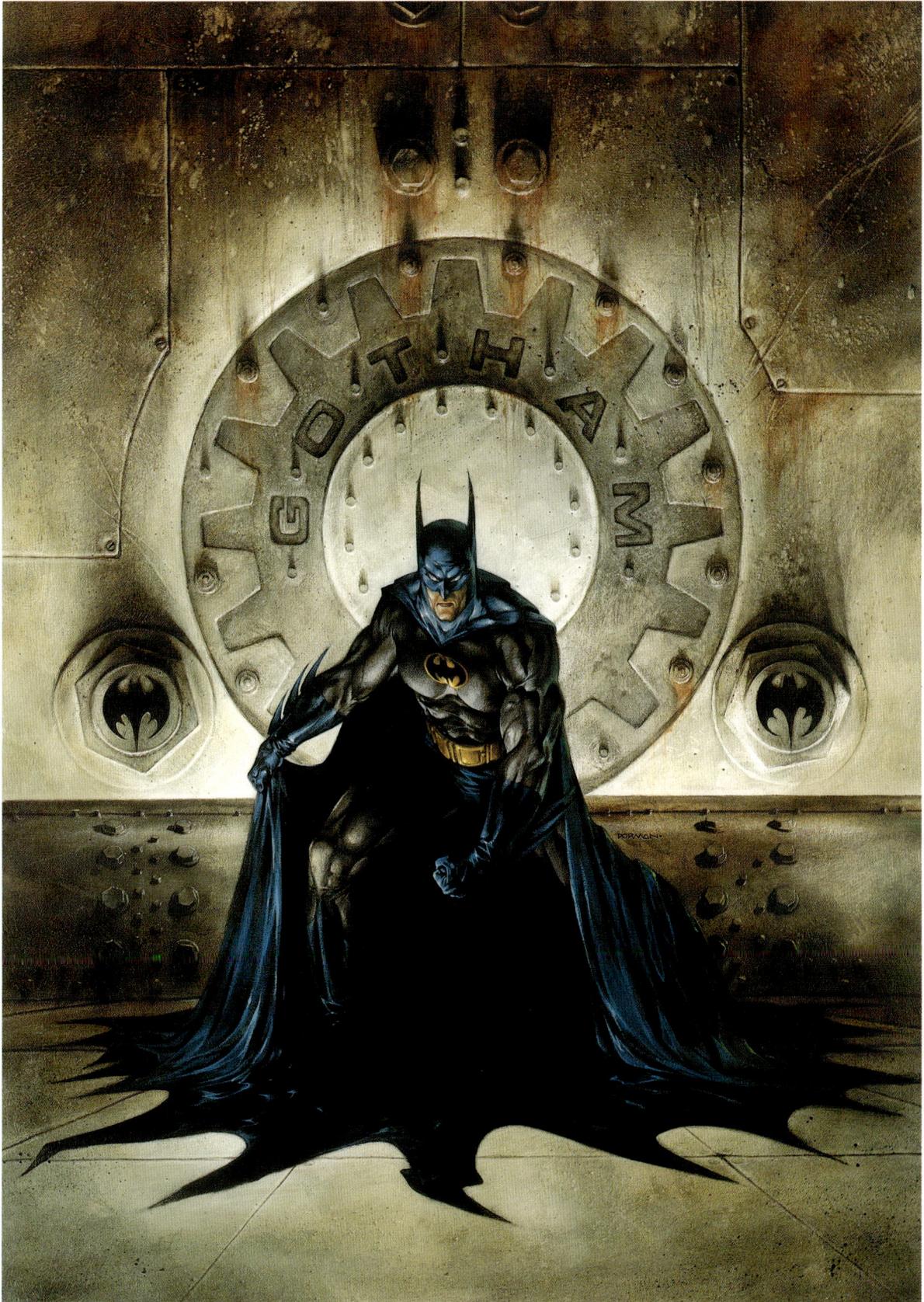

FRANK KELLY FREAS

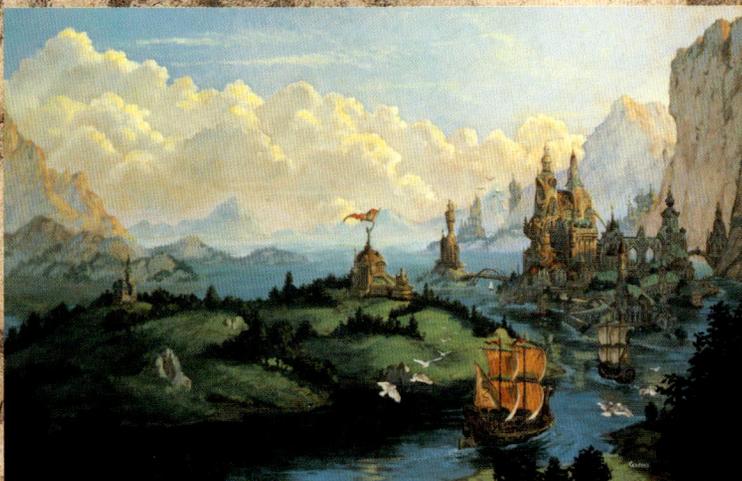

GNEMO

CHESLEY AWARD WINNERS

The Chesley, named for the great astronomical artitst, Chesley Bonestell, was started by ASFA in 1985 as a means for the SF and Fantasy art community to recognize individual works and achievements during a given year. The 1993 awards are for works and achievements in the period from January 1 through December 31 by both ASFA and non-ASFA members.

The categories and winners of The Association of Science Fiction and Fantasy Artists 1993 Chesley Awards are:

Best Color Work, Unpublished:
James Gurney for *Garden of Hope*

Best Cover Illustration, Magazine:
Wojtek Sludmak for *Asimov's* December 1993

Best Monochrome Work, Unpublished:
Carl Lundgren for *Impudence*

Award for Artistic Achievement:
Frank Kelly Freas for Body of Work

Best Interior Illustration:
Alan M. Clark for *"The Toad of Heaven"* (*Asimov's*, June 1993)

Best Three-Dimensional Art:
Jennifer Weyland for *"...and I am the Shining Star"*

Best Cover Illustration, Hardback Book:
Gnemo for *The Far Kingdoms*

Best Cover Illustration, Paperback Book:
Bob Eggleton for *Dragons*

For more information about The Association of Science Fiction and Fantasy Artists write ASFA P.O. Box 825, Lecanto, Florida 34460

SPECTRUM *artist index*

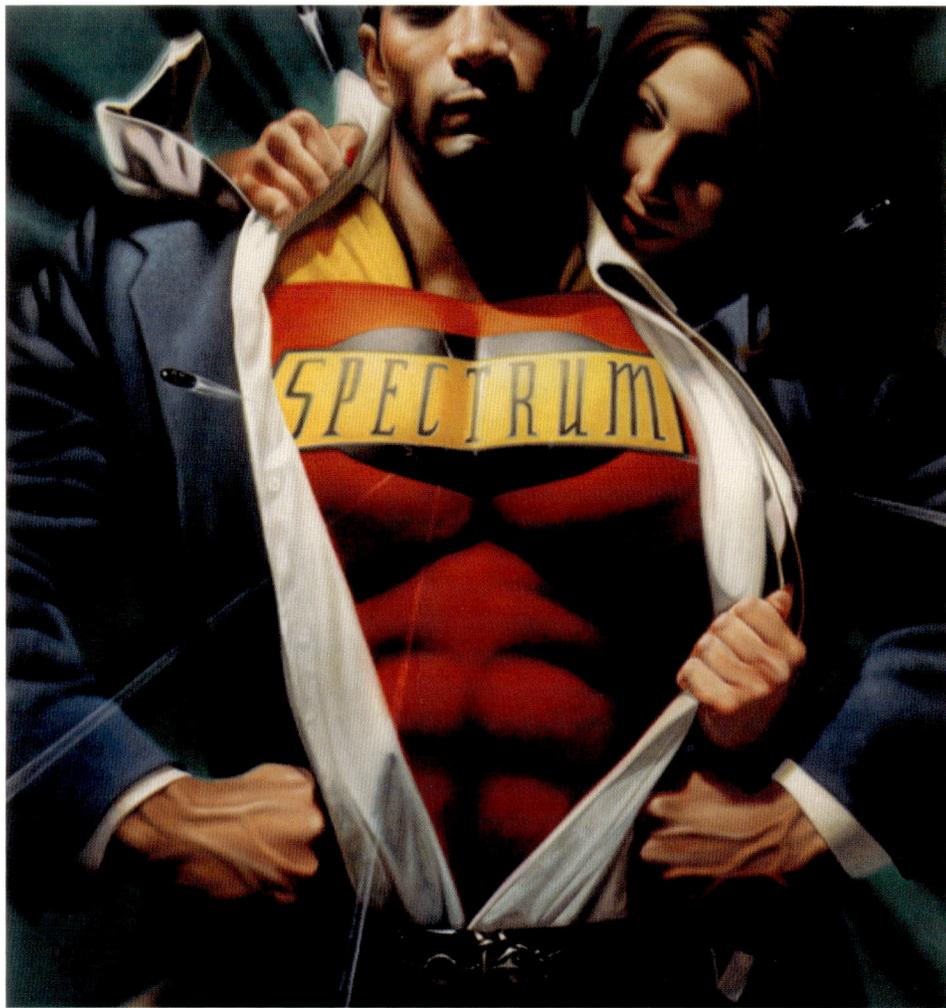

The *Spectrum Annual* is the result of a juried competition sponsored by Spectrum Design. Artists, art directors, designers, students, and publishers who would like to receive a Call For Entries poster (which contain complete rules and forms necessary to participate) can send their name and address to:

SPECTRUM DESIGN
P.O. Box 4422
Overland Park, KS 66204
official website: www.spectrumfantasticart.com

Posters are mailed out in October each year.